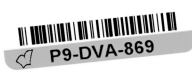

CLAUDE LORRAIN

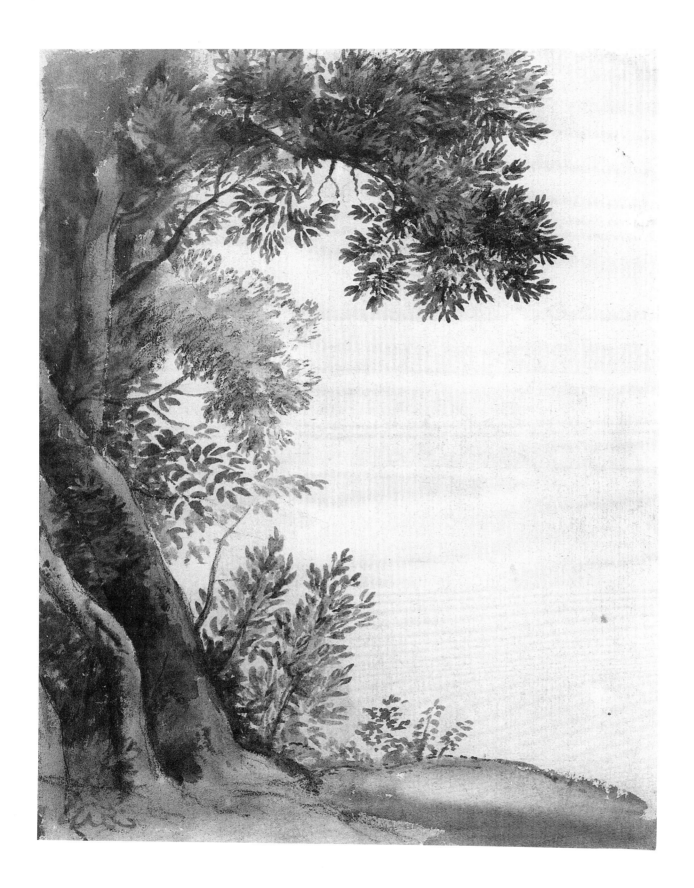

CLAUDE LORRAIN

*Drawings from the Collections of the
British Museum and
the Ashmolean Museum*

J. J. L. Whiteley

Published for the
Trustees of the British Museum
by British Museum Press

Contents

Foreword

Writing about the profound influence of Claude Lorrain on British taste has become commonplace in art history. But it is none the less true. The most spectacular evidence lies in the grounds of English country houses, where the landscapes were remodelled at vast expense to make them look like the vistas seen in Claude's paintings. Almost all of Claude's greatest paintings at some point in their lives have been in English collections, and there are still wonderful examples to be seen in many houses and galleries in this country. Through the eighteenth and nineteenth centuries no artist's works were more often engraved for the London print trade.

What is true of the paintings is also true for the drawings. Claude was a prolific draughtsman and nearly 1,200 of his drawings survive today. Of these, no less than half are in Britain, the greatest concentrations being in the British Museum (about five hundred drawings) and the Ashmolean Museum in Oxford (over thirty drawings). So when Dr Jon Whiteley told us that he was hoping to mount an exhibition of drawings by Claude in the Ashmolean as a sort of sequel to the memorable one of Poussin's drawings held there in 1990, we hastened to invite him to show it in London as well. The selection and catalogue are entirely his work, and the exhibition will be seen first in Oxford and then in London. The catalogue is published by British Museum Press, and the lion's share of the exhibits comes from the British Museum. We have borrowed from no one else – it has not been necessary.

This is the first time in many decades that such a wide-ranging group of Claude's drawings and etchings has been shown in Britain. The last Claude exhibition in the British Museum, in 1977, confined itself to the pages of the Liber Veritatis, which had recently been restored and mounted, and we have to go back as far as 1926 to find a display similar to the present one.

Dr Whiteley has in the following pages given a brief account of the formation of the two collections, and there is no need to repeat it here. They are the consequence not just of the English love of Claude, but of the English passion for Old Master drawings that began at the court of Charles I and has continued into the twentieth century. This has stocked the museums and galleries of the British isles with an extraordinary range of treasures, and it is the task of the great collections such as the Ashmolean and British Museums to display them to the public, together with the necessary information to appreciate them fully.

So it is my duty and pleasure to thank Dr Whiteley for his most interesting and enlightening essay and the information in the catalogue entries. Our collaboration with the Ashmolean is, astonishing to relate, the first of this kind in the history of the print rooms of the two institutions and I very much hope that it will not be the last. I thank all those who have made it possible. In the Ashmolean they are the former Director, Christopher White, and Timothy Wilson, the Keeper of the Department of Western Art (both of them old British Museum hands), as well as Vera Magyar, who has delayed her retirement yet again to handle the administration. In the British Museum I thank my colleague Martin Royalton-Kisch for his advice and help, and Janice Reading for taking care of all the paperwork.

We both wish to thank the photographers in the two institutions, Michael Dudley and Bill Lewis, for their excellent work, and the photographic archivist at the Ashmolean, Anne Steinberg. Sotheby's supplied photographs of the two model drawings in a private collection which are here published for the first time, and it was Alexandra Chaldecott who drew them to Dr Whiteley's attention. He also particularly wishes to acknowledge his debt to the late Dick Godfree, who put the Ashmolean collection of Claude's prints into order in the course of reorganising and indexing the entire print collection.

At British Museum Press our thanks are due to the editor Joanna Champness and the designer James Shurmer.

Antony Griffiths
Keeper of Prints and Drawings, British Museum

List of Abbreviations

H. F. Hollstein, *Dutch and Flemish Etchings and Woodcuts ca. 1450–1700*, Amsterdam 1949–

K. Michael Kitson, *Claude Lorrain: Liber Veritatis*, London 1978

L. Frits Lugt, *Les marques des collectioneurs*, Amsterdam 1921; Supplement, The Hague 1956

LV Liber Veritatis

M. Lino Mannocci, *The Etchings of Claude Lorrain*, New Haven and London 1988

RD. Marcel Roethlisberger, *Claude Lorrain: The Drawings*, Berkeley and Los Angeles 1968, 2 vols

RP. Marcel Roethlisberger, *Tout l'oeuvre peint de Claude Lorrain*, Milan 1986

Introduction

Claude's life

Claude Gellée (or Claude Lorrain, as he is generally known) was born in Chamagne in the Duchy of Lorraine, son of Jean Gellée and Anne (or Idatte) Padose, the third of seven children. According to the inscription on his tombstone he was born in 1600, but this date conflicts with the evidence of a number of early documents which suggest he may have been born in 1604–5.[1] His family seems to have been modestly prosperous. Joachim von Sandrart, his first biographer, tells us that he was trained as a pastry-cook after a false start at school, and subsequently went to Rome, like many pastry-cooks from Lorraine, to look for work. There, after some initial difficulty, he entered the service of the landscape painter Agostino Tassi, eventually becoming his pupil and assistant. Claude's second biographer, Filippo Baldinucci, does not mention his career in cookery and gives a different account of his entry into Tassi's studio. There is nothing improbable in the suggestion that Claude might have been employed by Tassi as a *garzone*, or valet, as Sandrart implies, but Sandrart was writing many years after he had parted company with Claude and his memory or his source may have been inaccurate.[2] According to Baldinucci, Claude left Lorraine before his twelfth birthday, following the death of his parents, and settled for about a year in Fribourg-en-Bresgau with his elder brother, Jean, a maker of intarsia in wood, from whom he learned the rudiments of drawing ornament. At the end of this period, he moved to Rome in the company of a lace-merchant, to whom he was related. A birthdate of 1604–5 would locate his arrival in Rome in 1617–18. He lived at first on a small income from Lorraine, probably from his inheritance, until it was cut off by the impact of foreign wars.[3] He then transferred to Naples where, according to Baldinucci, he worked for about two years with the landscape painter Goffredo Wals, a German artist who does not appear in Sandrart's account. Claude could not have left for Naples earlier than November 1618 when Wals and Tassi, who had worked together for some years in Rome, ended their association. Baldinucci dates Claude's entry into Tassi's studio after he had left Wals and returned to Rome. Claude apparently remained with Tassi until April 1625 when he returned to Lorraine and entered into an agreement with Claude Deruet to work as his assistant for one year. The contract (which survives) expired on 1 October 1626.[4] According to Baldinucci, he was chiefly engaged in assisting Deruet with the decoration of the Carmelite church near Nancy 'for a year or more' and returned to Rome on 18 October 1627 in the company of the painter Charles Errard. As his name appears in the Roman census of Easter 1627, he must have returned earlier than Baldinucci supposed.[5]

Following his return to Rome, he painted a number of murals in Roman palaces and began to make a name for himself by painting port scenes and landscapes for Romans and foreigners. At an uncertain date, possibly in 1633–4, in company with a number of other landscape artists, he supplied a series of paintings for the palace of Buen Retiro, recently completed for Philip IV of Spain near Madrid. At about the same time, he came to the attention of Urban VIII, beginning a long career as a painter to successive popes, cardinals and princes. Urban commissioned four known paintings from Claude, one of which shows the harbour at Santa Marinella which Claude visited for the purpose of studying the site. Marcel Roethlisberger has dated the trip to Santa Marinella to 1638–9 on the evidence of the related copies in Claude's record book. As Claude explained to Baldinucci, the forgeries which his work inspired while he was working for the King of Spain prompted him to compile a record of his work, his Liber Veritatis, a 'book of truth', for the sake of authenticating his paintings. Much of the information which Baldinucci provides about Claude's patrons is taken from the Liber Veritatis, which Claude showed to Baldinucci when the writer visited him, probably in c.1680. The contents of the book, which have been disbound but survive intact in the British Museum, are not only the best source of information about Claude's paintings but a unique record of a seventeenth-century artist's work. Baldinucci's life of Claude, based on details supplied by the artist and by the artist's nephew, Joseph, seems to fit the little about Claude which can be found in the documents. Baldinucci makes a few slips in recording names but the approximate accuracy of these details tends to confirm the general reliability of his account. In 1650 Claude left the Via Margutta and moved into a house in the Via del Babuino. In the late 1650s he adopted Agnese, an abandoned child, born in 1653 of unknown parents, who remained with him until his death. Jean Gellée, Claude's nephew, entered the artist's household in 1662. A second nephew, Joseph, arrived in the late 1670s. In February 1663, severely ill, Claude made his will, adding a codicil in 1670 and two more in 1682.[6] He died in the house in the Via del Babuino on 23 November 1682 and was buried in the church of SS Trinità dei Monti.

English collectors of Claude's drawings

Drawings by Claude Lorrain survive in large numbers. Marcel Roethlisberger's catalogue of Claude's drawings includes 1,129 items of which 497, over 40 per cent, are in the British Museum. The Teyler Museum in Haarlem, with eighty-three drawings, has the second largest collection, followed by the Louvre, the Albertina, the Ashmolean, Windsor, Chatsworth and the Pierpont Morgan Library. The drawings in the Albertina and in Haarlem seem to have come from sources in France and Italy, but the others came largely from English collections formed between c.1720 and c.1850 when most of Claude's drawings and approximately two-thirds of his paintings were imported into England. The first drawing by Claude acquired by the

British Museum, a meagre and untypical scrap (RD. 113), arrived in 1769 in one of the thirty-nine volumes of prints and drawings bequeathed by William Fawkener; a further seven drawings, five of which had once belonged to the *marchand-amateur* Jonathan Richardson, were bequeathed in 1799 by Clayton Mordaunt Cracherode; 274 drawings, by or attributed to Claude, were added through Richard Payne Knight's bequest in 1824; a smaller group, largely derived from the Wellesley collection, was added when John Malcolm's drawings were bought in 1895; and a further two hundred arrived with the transfer of Claude's record book, the Liber Veritatis, from the Devonshire estate in 1957.

Most collections of drawings in England dating from before 1850 contained at least one or two drawings attributed to Claude. Some had many dozens. Three collectors in particular, William Cavendish, 2nd Duke of Devonshire, Richard Payne Knight and Henry Wellesley, between them and at different times accumulated over half of all the items listed in Roethlisberger's catalogue. For want of written evidence, the development of this taste is difficult to access but, in keeping with the fashion for Claude's paintings, it seems to have changed in both character and intensity between 1720 and 1850. Jonathan Richardson and Joshua Reynolds, who collected Claude's drawings, admired him as the prince of landscape painters, but no landscape painter, in their eyes, was equal or superior to the best Italian figure painters; and this, doubtless, applied also in the field of drawings. Although the taste for Claude had a far-reaching and well-documented influence in England in the second half of the eighteenth century, it was only after 1800, in keeping with a growing enthusiasm for the poetry of landscape, that this taste turned into veneration. The novelty of the collections formed by Payne Knight, Chambers Hall and Wellesley between the late eighteenth century and the middle of the nineteenth century was not that they collected Claude's drawings in quantity but that Claude's drawings, in varying degrees, were the soul of their collections.

Little is known about the sources from which William Cavendish, 2nd Duke of Devonshire, acquired his drawings. His association with Jonathan Richardson, who had one of the most important collections of Claude's drawings in early eighteenth-century England, may have enabled him to buy several for his own collection.[7] Their choice nature indicates that the Duke or his agent had access to a good source. The pages of the Liber Veritatis, which the Duke acquired in Paris between 1720 and 1728, and the remaining forty or so loose sheets attributed to Claude, which he seems to have acquired by 1728,[8] suggest a preference for fine, finished composition drawings of a type which attracted collectors in the artist's lifetime and in the decades following his death. Similarly finished drawings were bought by the Earl of Leicester in the mid-century and by Prince Frederick and George III. That is not to say that other kinds of drawings were not also collected, including small, minor sketchbook studies, but they were probably less valued than the composition drawings and seem to have been collected mainly by the eighteenth-century painter-collectors whose marks are found now on many sheets.

The collection which Richard Payne Knight bequeathed to the British Museum in 1824, which included many Italian and Northern drawings, is as comprehensive as the Chatsworth collection, but the importance of the drawings by Claude acquired by Knight seems to mark a deeper and more personal bias. Of 1,144 drawings in the bequest, one quarter are works by or attributed to Claude. About 150 of these drawings were acquired in 1824 in a single album, bought at Colnaghi's, whose agent had found it in a bookdealer's stock in Spain or Portugal. It is difficult now to distinguish the drawings which were once in the album from those which were already in his collection, but some idea of what he had acquired before the acquisition of the album can be formed from the list of thirty-eight drawings from his collection which are reproduced in John Boydell's volume of facsimiles of Claude's drawings, published in 1819, and from the marks of previous English collectors, Lankrink, the Richardsons, Reynolds, West, Barnard and Spencer, which appear on several of the sheets. It is not possible to say when any of the drawings outside this small selection were acquired, let alone which of them were taken from the album, but Boydell's list allows some room to speculate on the direction in which the collection developed after 1803, when the facsimiles were made. Almost half the drawings from Knight's collection in Boydell's volume represent historical subjects. Setting aside the figure studies, which were probably omitted as works of lesser interest, and a few sheets in poor condition, there are only about eight drawings in the bequest in this class which might have been reproduced by Boydell, of which two, *Queen Esther at the Palace of Ahasuerus* (cat. 83) and *Aeneas Hunting* (RD.991), are such obvious candidates that one suspects they must have been acquired later. These figures also prove that few historical compositions were added to the collection after 1803 and very few, if any, could have been in the album acquired in 1824. The omission of Knight's most spectacular nature studies, including all the drawings from the Campagna Book and all but one of the drawings from the Tivoli Book, suggests that they were later additions. One cannot prove that Knight acquired these with the album but it seems not unlikely.

Knight was wealthy enough to buy what he wanted and his choice of drawings can be taken as an indication of his taste. In contrast to the Duke of Devonshire, he seems to have been drawn to the working studies, the nature sketches and the slighter drawings. His belief that the discriminating eye would find 'as little difficulty in tracing the characteristic excellence of Titian, Claude, and Rembrandt in a pen and bister sketch, as in the most finished of their oil pictures' may partly explain the predominance of nature studies among his drawings and a relative lack of the finished compositions of the type which feature more prominently in the collections of the Duke of Devonshire and the Earl of Leicester and in Boydell's volume of facsimiles.[9]

Knight's collection was the first of a series of nineteenth-century English collections in which Claude's drawings formed an increasingly large part. The most notable of these collections were based on a single core of drawings assembled by

the dealer Samuel Woodburn, which passed through the hands of successive collectors, Thomas Dimsdale, Thomas Lawrence and Henry Esdaile, increasing as it went and concentrating, finally, in the collection of the omnivorous Henry Wellesley. Claude's drawings, of which Wellesley owned approximately two hundred, were only part of a large, eclectic collection of Old Master drawings but they were by far the most important part, 'unequalled in point of beauty and interest' as the otherwise reticent author of his sale catalogue described them in 1866. It included not only nature studies, and slight, working drawings but also finished compositions of the kind which Knight did not acquire to the same extent and rare states of many of the etchings.

Henry Wellesley held a number of livings in the Church of England, as well as the headship of New Inn Hall at the University of Oxford where his uncle, the Duke of Wellington, was Chancellor. He was a respected student of languages but published little and his posts, which were both lucrative and undemanding, allowed him ample opportunity to indulge his passion for collecting prints and drawings. His involvement with the new University Galleries in Oxford began, sensationally, when he initiated the successful campaign to buy the group of drawings by Michelangelo and Raphael from Woodburn which had formerly belonged to Thomas Lawrence. In 1846, he was appointed to one of the three curatorships at the Galleries, the present Ashmolean. There might, one imagines, have been some expectation that part, at least, of his huge collection of Old Master drawings or his substantial library of art books would one day have come to his museum, particularly the Claude drawings, many of which had once belonged to Lawrence and might have been reunited with the drawings by Raphael, Michelangelo and the Carracci from Lawrence's collection which had already come to Oxford through Wellesley's efforts. Not a single drawing, however, passed from Wellesley's collection to his museum. The growing influence of John Ruskin in the affairs of the Galleries in the 1860s and Ruskin's doubts about the value of Lawrence's Raphaels and Michelangelos may have played a part. Wellesley can hardly have been unaware of the passage in *Modern Painters* in which Ruskin condemned Claude's drawings in terms which he must have found deeply offensive. Whatever the reason, it deprived the museum of a potential benefaction which would have transformed the importance of Oxford as a centre for the study of Old Master drawings and for the study of the work of Claude in particular. The more notable collections of Claude's drawings, formed in the second half of the nineteenth century by Charles Fairfax Murray (now in the Pierpont Morgan Library), John Malcolm (now mostly in the British Museum) and John Postle Heseltine (now in the Louvre), were to a large extent derived from Wellesley's collection, following its dispersal in 1866.

Although none of Wellesley's Claudes came to Oxford, it was through Wellesley's influence that the Galleries acquired the smaller but choice collection of Claude's prints and drawings which his friend, Chambers Hall, presented in 1855, along with fine drawings by Leonardo, Dürer, Guardi, Raphael, Rembrandt, Wilson

and Watteau, etchings by Rembrandt and Ostade, paintings, mostly of small size, by Rubens, Wilson, Guardi and Canaletto, and antique bronzes. Like Wellesley, Hall had a particular taste for the work of Rubens, Claude and the Venetians. He liked landscape painting – he was himself an accomplished watercolourist – but confined his patronage to one or two contemporary painters in Southampton, where he lived, and to an equally select number from the past, among whom Claude was a clear favourite. The part which Claude played in Wellesley's collection is repeated *in parvo* in that of Chambers Hall. These were not didactic collections but were formed on the basis of wide-ranging tastes in which an unfettered liking for the work of Claude gave a pre-eminent place to his prints and drawings. Unlike Wellesley, Hall did not acquire any of the finished composition drawings, preferring the slighter, smaller, more informal works. His choice of drawings seems to anticipate a tendency in the literature on Claude in the second half of the nineteenth century to prefer the studies to the more elaborate drawings. Mrs Mark Pattison, author of the first substantial biography and catalogue of Claude's work, published in 1884, detested the late, literary composition drawings. In this, she was followed by Arthur Hind who attempted to answer Ruskin's sweeping condemnation of the drawings by distinguishing between the nature studies, which Hind associated with the work of later watercolourists and Impressionists, and the composition drawings, which he found inferior to the paintings, adding that even the best of the paintings seemed to him inferior to the nature studies.[10] This defence of Claude would have surprised the collectors of the eighteenth century who seem to have valued the neat, tight copies and compositions more highly than the others but prized him as a painter above all.

Sketchbooks and albums

The sketchbooks from which many of the surviving drawings derive must have formed part of the contents of his studio. An inventory of Claude's possessions, drawn up at the time of his death in 1682,[11] lists twelve books of drawings, in addition to the Liber Veritatis, and a small book with thirty-two drawings entitled *La vita di S. Niccolò*, about which nothing more is known. It also describes a case, approximately one foot high by four feet wide, filled with loose drawings and prints. The inventory does not indicate whether any of the books were albums – books with isolated sheets stuck down on pages – of a type in which many of Claude's drawings have been preserved until recent years. That Claude might have mounted his drawings in albums is not impossible; he had a systematic mind and it is clear from the inscriptions on many sheets that he spent time in his later years imposing order into his stock of drawings.

Of the books mentioned in the inventory, only the Liber Veritatis can be identified today. Bequeathed by Claude to his ward, Agnese, it reverted to his nephew, Joseph, from whom it passed, by way of a jeweller in Paris, to the second Duke of

Devonshire.[12] Following the acquisition of the Liber by the British Museum in 1957, the drawings, which were no longer in their original binding, were removed in the mid-1970s, conserved and mounted separately. The history of the remainder of the books in the period immediately after the artist's death is not known for certain. Roethlisberger has published an inventory of the possessions of Prince Livio Odescalchi, compiled in 1713–14, which lists three volumes of Claude's drawings one of which, the so-called Animal Album, reappeared at Sotheby's in 1957 and has since been dismembered.[13] A second volume, originally containing eighty-one drawings and clearly identifiable with one of the Odescalchi books, was acquired by Georges Wildenstein in 1960 and has also been broken up.[14] Roethlisberger has suggested that the third volume, 'an oblong book bound in vellum with one hundred and fifty-two drawings by Claude Lorrain', formed the basis of the drawings in Haarlem, purchased for the Teyler Foundation from the Odescalchi family in 1789–90, although if this volume was the source of the Teyler drawings, it must have been previously dismembered as the number of drawings in Haarlem falls well short of the total mentioned in the inventory.[15] Livio Odescalchi also owned an unspecified number of loose sheets by Claude some of which may have been included in the drawings acquired for the Teyler Foundation. Drawings from the Odescalchi collection may also have found their way into the contents of the album of Claude's drawings which passed from an unknown source in Spain or Portugal via Richard Payne Knight to the British Museum in 1824. The pinkish glue marks which appear on the backs of many sheets in the British Museum, on the backs of several in Haarlem and on the backs of the drawings from the two albums with a proven Odescalchi provenance indicate a common origin, although one cannot demonstrate categorically that the drawings had not already been glued down when Livio Odescalchi acquired them.

Roethlisberger is inclined to believe that the three Odescalchi volumes had been compiled by Claude's heirs, possibly for Odescalchi or else for Queen Christina of Sweden with whom Claude's drawings in Haarlem have been linked, albeit on the flimsiest of grounds. The only certain information about the early history of the drawings from the Odescalchi albums, gleaned by Roethlisberger from an analysis of the paper types and inscriptions, indicates that they had been assembled, in part, from a number of earlier books of nature studies of which the finest sheets were mainly divided between Knight's album, the Wildenstein album and the collection bought for the Teyler Foundation. The Animal Album, which has been assembled on the basis of a theme, could have been made by the artist as a source of useful motifs, but the other albums seem to have been choice compilations of Claude's work of a type which suggest they were made for or by collectors of fine drawings. The details of this brief episode in the history of the drawings are far from clear but, on balance, it seems likely that the albums of Claude's drawings were made up by or for Livio Odescalchi from the stock of drawings which Claude bequeathed to his nephews.

Per Bjurström has suggested that all twelve volumes mentioned in the inventory of 1682 might have been sketchbooks of which seven can be reconstructed, in part, from surviving drawings.[16] These include the Stockholm sketchbook, an insignificant collection of notes and ideas (not all of which are by Claude), dated by Michael Kitson to the 1650s;[17] a sketchbook, possibly of the 1640s, of which there are a few pages in the British Museum;[18] the Animal Album, or the original sketchbook from which many of the animal studies in the album had been removed; two large volumes, known as the Campagna and Tivoli books, which Roethlisberger has reconstructed from the evidence of scattered sheets; a dismembered 'Early Sketchbook' of small pages, mostly divided between the British Museum and Windsor; and a possible sketchbook of the late 1630s which Roethlisberger associates with a number of scattered sheets of uniform size and type.[19] Bjurström suggests that the remaining five or six books mentioned in the inventory may have been small sketchbooks, containing unimportant drawings of the type found in the Stockholm sketchbook. This would explain the apparent loss of many of the drawings which were in Claude's studio at the time of his death, but it is not consistent with the 'five or six great books of these drawings of views of nature ... and some bundles of loose sheets'[20] which, according to Baldinucci, passed to Claude's heirs. These may have included the Campagna and Tivoli books but evidently also included other large books of a similar kind which may or may not have been sketchbooks but were certainly more imposing than the insignificant notebook bought by the Nationalmuseum.

The Early Sketchbook, which has been partially reconstructed by Roethlisberger and dated by him to *c*.1630, contained views of Roman buildings and landscape sketches, several with figure studies on the backs in pen and ink. A number of the sheets are smudged with faint traces of red chalk. Seventeen pages of this type are in the British Museum and twelve at Windsor. In addition to the nine scattered sheets listed in the catalogue raisonné, Roethlisberger has since added a single sheet,[21] another has appeared on the London art market (Phillips 3 July 1996, lot 77) and Kitson has identified a further eight single pages and two double pages among the sheets inserted loose into the sketchbook purchased by the Nationalmuseum in Stockholm in 1982.[22] The number of pages which have now been attributed to this group - over fifty – suggests that Claude may have used two or more sketchbooks of this type during his early years. As one sheet of the early sketchbook type belonged to Richard Houlditch, who died in 1736 (RD. 36), the sketchbook from which this page had been removed must have been dismembered at an early date. Several pages belonged to Jonathan Richardson; others, now at Windsor, seem to have arrived in England, at an unknown date, from a source in Italy.

The two most imposing of Claude's books of nature drawings, named the Campagna Book and the Tivoli Book on account of the studies of the Campagna which were in one and of the studies drawn in or near Tivoli which were in the

other, have been reconstructed by Roethlisberger from dozens of numbered pages, most of which are in Haarlem and in the British Museum. Of approximately two dozen identifiable pages from the Campagna book, numbered between four and fifty-six, most are finished nature studies and landscapes, beginning on page four with a view of Velletri and continuing with a view of Lake Bracciano, studies drawn in the park of the Villa Madama, views of Civitavecchia and many tree studies made in the Campagna. From the upright format of many of the drawings and from the crease marks along the left edges of the rectos, Roethlisberger has deduced that this was a large, upright sketchbook, measuring approximately 330 × 235 mm. Roethlisberger has dated the book to *c*.1638–*c*.1640 on account of a group of drawings of Civitavecchia which he has associated with Claude's visit to the neighbouring port of Santa Marinella to make studies for the painting in the Petit Palais. From the location of the copy in the Liber, the painting can be dated to *c*.1639.[23]

The Tivoli Book was an oblong volume, with a number of views of Tivoli at the beginning and at the end. Roethlisberger has identified thirty-five pages, inscribed with numbers from two to sixty-nine and monogrammed by Claude in red chalk on the *versos*. It had probably approximately seventy pages. One of the drawings in the book, a view of St Peter's (cat. 57), originally on page 21, can be dated to 1641 by the appearance of Bernini's tower on the south-east corner of the façade. This provides Roethlisberger with a fixed point for dating all the drawings to a period between *c*.1640 and *c*.1645, apart from the last known page, which he links with a painting of *c*.1660. While the sites represented in the Tivoli Book are less varied than those in the Campagna Book, there is a greater variation in the styles of drawing. Roethlisberger is inclined to believe that the Tivoli Book was also a sketch-book but this is somewhat contradicted by the use of papers, taken from at least three different moulds, which suggest that it may have been an album, compiled by Claude from a number of different sources mainly illustrating the scenery of Tivoli and the surrounding district.

The Liber Veritatis

The contents of the Liber Veritatis, which have survived intact since Claude's death, include 195 compositions, most or all of which were copied by Claude after his paintings as a record of his work.[24] Five drawings, added at the end of the book after Claude's death, were probably taken from the bundles of loose sheets at a later date to bring the number of drawings to a round 200. The first five drawings appear to have been added by Claude as a record of paintings which predate the existence of the book. The main volume of bound sheets, consisting of alternating groups of four white and four blue pages, begins on page 6 and ends on page 185, which Claude inscribed on 25 March 1675. Claude added a further ten sheets before his death in 1682. In about 1650, Claude began to inscribe the backs of

the drawings with the names of his patrons or the names of the towns in which his patrons lived, filling in the details on the earlier pages retrospectively. The drawing on page 112 is dated 1647 and all subsequent dated drawings were added in chronological order.

In a series of articles, published in 1959, Roethlisberger and Kitson persuasively argued that the Liber originated in a bound sketchbook of blank leaves into which all the drawings, including those in the first half, had been entered chronologically, beginning in c.1635 and continuing until 1680. Diane Russell has pointed out that it is difficult to prove conclusively that the drawings in the first half follow the chronology of the paintings;[25] but, allowing Claude some flexibility in making records of the work of a busy studio in which there must have been several pictures on the easel at one time, it is more difficult to prove that they do not. Russell also suggests that the peculiar composition of the book in alternate white and blue pages was devised to allow Claude to choose a ground colour in keeping with the light effects of the original. This would have introduced a possible discrepancy of up to four pages in the chronological sequence of the compositions; but the evidence is not clear cut. Several of the sunsets and sunrises in the first thirty pages are on blue paper; storms at sea are drawn on blue; but two conspicuous sunset compositions, LV 14 and 28, are on white. Russell's suggestion that Claude intended to use it in this manner is, however, very plausible. Kitson and Roethlisberger have neatly demonstrated why a quarto sketchbook made up of alternate sheets of white and blue paper, folded in four, produces a book of four white and four blue pages, but no one has ever proposed a better reason for the peculiar choice of a book composed of successive pages of white and blue.

In the absence of dated inscriptions in the Liber, the paintings have provided a framework for dating the related drawings. Conversely, in the absence of other evidence, the book has been used for dating paintings. It provides a point of comparison for following the evolution of Claude's style of drawing over a period of nearly fifty years, although, in this case, its value is to some extent confined to what it tells us about the development of his work when making copies. It also helps to date tendencies which are evident in his preparatory composition drawings but it is of least use in helping to date his nature studies.

According to Baldinucci, Claude began to keep his record book at the time he was working for the King of Spain. Both Kitson and Roethlisberger are inclined to date this episode to c.1636, partly because the first page of the sketchbook proper, page 6, records a painting, now lost, which was apparently dated 1636. The previous drawing on page 5 records a painting which is undated but corresponds to an etching of 1634. The painting recorded in the third drawing is lost but the main motif reappears in an etching of 1633 or 1635 (the last digit is difficult to read). The earlier pages belong to the group of five sheets which predate the creation of the book as a bound volume and were added later, presumably by Claude himself after he had begun to keep a consistent record of his work. Independent evidence for

dating Claude's first paintings for Philip IV of Spain would help in establishing the origins of the Liber, but none of the three known paintings in the group is dated and only one of the three is recorded in the book where its location suggests a date of c.1638. Roethlisberger has tentatively suggested that Claude omitted the companion pictures of St Maria de Cervello and St Onofrio, because there was little likelihood that copies would have been sold as originals.[26] Kitson, among other possibilities, suggests that the third painting might have been a later addition to the earlier pair which could have been completed before Claude had begun to keep a consistent record of his work.[27] This suggestion has been strongly upheld by Diane Russell who has proposed dating the paintings of St Maria de Cervello and St Onofrio to c.1633 on the evidence of a document of 1634 concerning the purchase of a consignment of landscape paintings for the palace of Buen Retiro from Giovanni Battista Crescenzi (1577–1635) which Enriqueta Harris has cautiously connected with Claude's commission.[28] As Harris has emphasised, the document does not mention any artist's name and if Claude's pictures had been included, this would push back the dating of the Spanish paintings further than Roethlisberger and Kitson suppose. The early date, nevertheless, finds some support in the etching of the *Landscape with Brigands* (cat. 17) in which Claude reused the background of the *Landscape with St Onofrio*. This is, unfortunately, the etching with the troublesome date which Russell, Mannocchi and Jean-Richard read as 1633, although 1635 seems to fit the inscription slightly better. The latter date is consistent with a date of 1633/4 for the Spanish pictures and also with Baldinucci's claim that Claude began the Liber while he was working for Philip IV. This does not imply that the bound volume was begun earlier than c.1636 but that Claude dated the inception of the book from the time of the loose sheets, inserted later, on which he had made his earliest record drawings.

According to Baldinucci, the Liber originated as a means of authenticating Claude's pictures and exposing imitations. It has been pointed out more than once that it would have been of little use in distinguishing between originals and copies, but it is clear from Baldinucci's text that Claude was chiefly concerned to identify compositions painted from memory by visitors to his studio rather than direct copies. Michael Kitson has drawn attention to the correspondence of the details between drawings in the Liber and the related paintings, in keeping with Baldinucci's claim that the detail of the copies provided the best evidence for identifying pastiches. Exceptions to this rule, listed in the articles of 1959, have been largely explained away with the subsequent discovery of variants which correspond more closely to the drawings. As far as it goes, the Liber has proved to be a reliable, increasingly accurate survey of Claude's work but it was not comprehensive enough to provide the owners of Claude's pictures with the kind of guarantee which Baldinucci claimed for it. In particular, Claude's habit of recording the existence of a variant by inscribing a note on the back of the original record drawing must have lessened the book's value as a means of

authenticating variants which sometimes vary significantly from the original. The omission of variants, on the other hand, would not have been inconsistent with a role as a more straightforward record of his compositions. In this sense, Baldinucci's memorable title, *Libro di verità* (which he may have had from Claude), has diverted attention from the alternative title, also supplied by Baldinucci, *Libro d'invenzioni*, a book of inventions which Claude used as a record of reusable motifs. It cannot be proved that Claude intended it as such but it is evident that from an early stage in its history he used it for developing successive compositions. On several occasions the drawings in the Liber provided him with the basis for the variants. In the second half of the Liber, Claude occasionally included drawings of variants of paintings already represented in the book. Two or three of the earlier drawings (cat. 32 and 33), which correspond to isolated details in his paintings, have been ingeniously explained by Roethlisberger as records of the changes introduced into compositions which had been previously entered into the Liber. That they are record drawings seems certain but, if Claude drew them for the sake of identifying imitations of the painting to which they seem to relate, it seems odd that they are not simple copies but have been adjusted to give them the appearance of self-contained compositions. The most altered of the motifs in one of these subsidiary copies (cat. 32) reappears without significant changes in a model drawing (fig. 9), probably submitted to Urban VIII, and later, lightly developed, in the final painting which Claude recorded in a separate drawing in the Liber (RD. 360). Whether or not Claude adjusted the original motif for possible future use is difficult to decide. Claude's habit of developing his figure studies beyond their immediate purpose in the preparatory process means it is often difficult to identify the reason for many of his drawings. The same ambiguity surrounds the nature of the Liber. It may have served one or more practical functions but, as Michael Kitson has emphasised, it also constitutes an independent work of art which Claude compiled and prized for its own sake.

Early drawings

Black chalk, graphite, pen and brush were Claude's favourite drawing instruments; white body colour, which makes an early appearance in the Liber on the blue pages, is used with increasing frequency; red chalk appears rarely and is used sparingly although it is found in the landscape studies of the late 1630s and early 1640s in the form of pinkish wash and may have been used commonly in his early studies from the life, a few of which have been preserved on the back of other drawings. Within this range of possibilities, Claude tended to prefer pen and contrasting brown wash over preliminary indications in black chalk or sharp pen for nature studies; pen and a light wash or pen only for preliminary compositional studies or for studies where clarity of detail was of more importance than effects of light; pen and wash or soft black chalk with or without wash for studies of animals and figures; pen, wash and

Fig. 1
Study of an Antique Statue.
Pen and brown wash.
RD. 82,
British Museum.

body colour for finished compositions. He used these materials throughout his life but, with the passage of time, the manner in which he handled them underwent a marked change. The flamboyant use of dark brown wash, which is characteristic of his work in the 1630s, gave way, in his later work, to an increasingly controlled and punctilious manner of drawing with the pen, contradicting the common view that an artist's 'late manner' is freer and more improvised than his early work. It is not difficult, in general, to distinguish between his early and late drawings although there is scope for uncertainty in the period between, particularly in his nature drawings. Claude could employ different effects in different drawings at any one time, depending on the purpose of the drawing, making it unwise to rely on technique alone as an indication of chronology.

The little pages of the Early Sketchbook type are chiefly characterised by the use of pen and wash, although they also show extensive use of pen alone for the purpose of recording buildings. Wash is used chiefly to convey the effects of sunlight and shadow which preoccupied Claude in his finished work. The influence of Agostino Tassi and of Filippo Napoletano has been noticed in his early pen drawings[29] and would probably figure more prominently in an account of his artistic origins if more drawings from the 1620s could be firmly attributed to him. An inconsequential study in the British Museum from an antique statue in the Capitoline (fig. 1) can be dated to the early years since, as Roethlisberger has pointed out,[30] it seems to have been used in a recently rediscovered port scene which is undated but is so strongly marked by the influence of Tassi that it must be one of his earliest known works, probably dating from not long after 1626 when he returned to Rome from Nancy. The hesitant manner of this little drawing, delicately touched with the pen, differs from most of Claude's known drawings, including the Early Sketchbook studies, which are sometimes gauche but never timid. Judging from the Early Sketchbook drawings and from a few drawings in a related style, Claude drew away from the influence of Tassi in favour of a new, luminous naturalism, practised by several younger Netherlandish painters who worked in Rome in the 1620s. Claude's early use of flat washes of brown ink, contrasted with scattered patches of light ground colour which give a sunlit vitality to drawings of rocks and ancient ruins, recalls in particular the work of Bartholomeus Breenbergh who may have been the chief instigator behind this tendency among the Northerners in Rome. Evidence of the same influence appears in several drawings of the Early Sketchbook type which are touched with streaks of wash, applied with the tip of the brush in a manner which is common in the work of Breenbergh and his followers. Claude must have known Breenbergh, who was in Rome from 1619 to c.1629, but may also have been influenced by others in Breenbergh's circle. Joachim Sandrart, who accompanied Claude on sketching expeditions in the early 1630s and whose drawings show some awareness of Breenbergh's work, might have been an influence on Claude's drawing style, but the evidence is very slight.

The case of Herman van Swanevelt is more intriguing. The evidence is, again,

fragmentary but there is enough to suggest that their association may have been productive. Kitson has proved that Claude's painting of the Campo Vaccino of *c*.1636 follows Swanevelt's earlier painting of the same view, now in the Fitzwilliam, and (unless there was a common source) must have been based on Swanevelt's composition.[31] Diane Russell's comparison between Claude's *Landscape with St Maria de Cervello*, painted for Philip IV, and Swanevelt's *Christ Appearing to the Magdalen* in the Doria-Pamphili collection points in the same direction.[32] The drawings which Swanevelt made following his return to the North are characterised by a neat finish and mechanical touch which show little kinship with Claude's drawings, but the few Roman drawings which have been attributed to him are closer to the world of Breenbergh than his later work and are also deceptively Claudian. The best evidence of their friendship is found in the Early Sketchbook drawings, three of which closely correspond, in reverse, to sections of three etchings in Swanevelt's *Diverses veues de la ville de Rome*, published later in Paris. The drawings are not copied from Swanevelt's preparatory drawings (which survive in the Uffizi) but were probably drawn on one or more sketching expeditions in Swanevelt's company. Ekhard Knab has noticed a link between one of these drawings, an inconspicuous detail of an arch, and a print by Jean Morin after a painting, attributed on the print to Claude.[33] The slanting view is characteristically Breenberghian. Similar rows of arches appear in the work of Cornelis van Poelenburch and Lorenzo Barata[34] and the same view, with a different foreground, figures in Swanevelt's *Diverses veues* (fig. 2). The painting has since come to light, composed in the same direction as the drawing but in reverse to the etching and somewhat cut down by comparison with both prints. The painting is undated but it is similar in character to a composition with an antique ruin belonging to the Spencer Museum of Art in Lawrence, which is generally dated to 1629–30, and must be approximately contemporary.[35] The link confirms the date of *c*.1629–30 which Roethlisberger has always attached to the Early Sketchbook drawings, providing a useful point of departure for a chronological analysis of Claude's drawings from nature which are, in general, less easy to date than his other drawings.

Drawings from nature

According to Sandrart, Claude did not, at first, habitually make drawings from nature but prepared his paintings by observing natural effects in the open air and painting them from memory in the studio. He changed his practice after meeting Sandrart who was painting from nature at Tivoli, 'brush in hand', among the rocks of the cascade, and began to paint similarly in front of the motif.[36] This account, which was written long after Sandrart had parted company with Claude, refers to the period after Sandrart had arrived in Rome in 1629 and cannot be reconciled with the existence of a body of drawings, many from nature, dating from 1629–30;

but Sandrart cannot be wholly wrong. He consistently states in his references to Claude that the latter had no talent at all in drawing, but was particularly skilled in painting. In his autobiography, Sandrart again mentions their excursions to Tivoli and the pictures of 'large trees, landscapes and cascades' which Claude painted in the garden of Prince Giustiniani.[37] Baldinucci's account of Clement IX's difficulty in persuading Claude to sell a painting done from nature in the park of the Villa Madama somewhat confirms the existence of this class of paintings. These were probably the 'pictures in colour after nature' which Baldinucci saw in Claude's studio of which almost nothing now seems to survive.[38] The loss of all, or nearly all the pictures of this type constitutes the single most serious gap in our knowledge of Claude's work. The practice of painting out of doors, in gouache or in oil on prepared paper or canvas, doubtless goes part of the way to explain the difference between the nature drawings of the Early Sketchbook type which belong to a clearly defined class of Northern landscape drawing and the majestic studies from the Campagna and Tivoli books which cannot be so easily matched in the work of his contemporaries. The addition of pink wash, the increasing use of body colour, the frequent use of blue paper and the introduction of pink and yellow grounds gave increasing body and complexity to his later landscape drawings which often have the appearance of small paintings. It is impossible to believe that Sandrart could have forgotten drawings of this type when he emphasised the poverty of Claude's drawings, and the absence of any reference in the biography seems to endorse the evidence that Claude's mastery in the art of nature drawing largely developed after Sandrart had left Rome in 1635.

The increasing complexity of Claude's drawings from nature makes it difficult to distinguish between drawings done in the open air and studio compositions. Examination of the drawings suggests that Claude often completed his more impos-ing nature drawings in the studio, leaving blanks along the lower edge of the page for the insertion of framing motifs which would have been added later in pen and dark wash. The framing lines which enclose many of his nature drawings were probably added after the preliminary work in black chalk but before the added work in pen and ink. The famous study of an oak tree in the British Museum (cat. 40) bears the clearest signs of this but there is nothing to suggest that the framing lines were not added in the open air. Claude could rarely resist the temptation to add framing trees and foreground detail to give his views something of the formality of a finished composition. These also could have been added in front of the motif, but from a number of nature studies in which there are unfinished indications of figures and other detail in the foreground, it seems likely that these were usually com-pleted at a later date. As the drawings became more intensely wrought, the added work probably increased. Comparison between a finished view of the Palazzo del Sasso of 1649 and an unfinished view of the same buildings in Oxford (fig. 18), inscribed 'Dal naturale', probably indicates the extent to which Claude sketched his first outline in black chalk, finishing the essential detail on the spot in pen and

ink but leaving the foreground, the figures and most of the inessential detail for a later date.

In Roethlisberger's catalogue, nature drawings dated later than the mid-1640s are increasingly uncommon. The picture may be unbalanced by the quantity of surviving work deriving from the Campagna and Tivoli books which, from the evidence of a number of sheets, have been dated from the late 1630s to the mid-1640s. Roethlisberger suggests a relatively short time difference between the two, partly because the view of St Peter's in the Tivoli Book implies that it was in use in 1641, but if, as the contents imply, the Tivoli Book (cat. 57) was not a sketchbook but an album compiled from drawings of different periods, the date of this drawing would have less significance in dating the contents of the volume as a whole. The view of St Peter's conforms in technique to a group of nature studies in the Tivoli Book, all of which are drawn with broad strokes of black chalk and touched with wash. Several of them are drawn on sheets of paper watermarked with a fleur-de-lis. A second group, drawn with pen and wash, including a number of woodland scenes, recalls the woodland studies and river scenes of the late 1630s (RD. 284, cat. 23). Most are coloured with the pinkish wash which is found in a number of the drawings in the Campagna Book and elsewhere, suggesting they may be close in date. The homogeneity of both groups would not be inconsistent with the contents of two sketchbooks but this conflicts with the evidence of the different paper types which do not correspond to the differences in the types of drawing. One class of sheets, distinguished by the use of thick and thin wire lines in alternation, is used for both. The pink chalk wash drawings are fairly close in style and probably in date but the black chalk drawings are more varied and may have been drawn over a wider time-span than is commonly believed. The evidence that the book was a composite compilation is confirmed by the last pages of the book, numbered between 59 and 69, all of which are on blue paper and form a group apart from most of the drawings which are in an earlier style. Three of the four pages in this group are views of Tivoli, outlined with a sharp pen applied with a small, busy touch which is not found in drawings of the 1640s but can be matched in a handful of views inscribed with dates in the 1660s. This date is supported by the final page on similar blue paper, dated c.1660 by Roethlisberger, although he is inclined to think that, as a late addition, it is an exception to the rest. The view of Tivoli which was formerly on page 4 of the Tivoli Book is similar in style to the later sheets, giving Roethlisberger some grounds for his early dating of the latter, but if the book was not a sketchbook but a late compilation, there remains no barrier to thinking that it too is much later than is commonly supposed. The blue pages may have been removed from a sketchbook and added to the Tivoli book in keeping with the general theme. The survival of these later sheets through their insertion in the Tivoli Book again draws attention to the possibility that there were once further books of this kind which might have significantly altered our knowledge of the development and chronology of Claude's work from nature. Was there once a Subiaco Book or

a San Benedetto Book? Or a second, later volume of Campagna drawings? It is pointless to speculate except to bear in mind that the evidence which survives may be not only fragmentary but also unrepresentative of the whole.

There is nothing to show that the Campagna Book was not a sketchbook. The drawings are more consistent in their style than those in the Tivoli Book and the pages seem similar in paper type with chain lines separated by varying widths of between 27 and 30 mm on each sheet. The book begins with a series of drawings (RD. 276, 280, 282, 283, 284), all of which share elements in common with the drawings of the early 1630s but combined with a new density and breadth in the use of chalk, pen and wash. The original volume seems to have been an upright, portable drawing-book which Claude kept for use on excursions, several of which – to Velletri, Lake Bracciano, the Villa Madama, Civitavecchia and Lake Nemi – are recorded in inscriptions on the sheets. None of the pages is dated but Roethlisberger has persuasively linked the views of Civitavecchia which appear on the versos of two pages in the book to Claude's visit to neighbouring Santa Marinella to prepare the background of the view of Santa Marinella, painted for Urban VIII in c.1639. From the numbers inscribed on the sheets, the views of Civitavecchia fell near the middle of the book from which it follows that Claude had reached the half-way point by c.1638.

The view of St Peter's from the Tivoli Book provides a useful date for assessing the emergence of black chalk combined with pale wash as one of Claude's favourite techniques. To judge from the shift from pen and wash to black chalk and wash in his figure drawings, he seems to have used it increasingly from the early 1640s onwards, not just as an underlying framework for pen and wash, but as a supplement or alternative to the wash which had dominated his earlier nature drawings. He used it, as he used wash, to define form and shadows but with increasing delicacy, washing it with a wet brush which left a pale grey trace across the paper. Grey wash in Claude's drawings, either on its own or in combination with brown wash, is often the result of the dissolution of black chalk in the thin, watery application of the brush which Claude increasingly used in his drawings from nature. A number of drawings of the 1660s, some dated (RD. 894, 912, 1001), others dateable by their links with paintings (RD. 913, 922), use soft black chalk in the background as a foil to the penwork, added later in the foreground.

Claude used wash and black chalk to record effects of light, but when light was not the main objective he used more appropriate means to achieve his purpose. Page 4 of the Tivoli Book, a view of Tivoli (cat. 74), outlined in an unusually neat, sharp, detailed manner, was, as Roethlisberger has pointed out, drawn primarily as a record of the buildings. Pen is used for a similar purpose in several pages of the Early Sketchbook type and, later, to reproduce the buildings of Tivoli (RD. 87, 489, cat. 76), the Palazzo del Sasso (cat. 70, fig. 18), the tomb of Cecilia Metella (cat. 93) and the buildings at Nemi (RD. 982, 983). These drawings which span the entire length of Claude's known work, emphasise the extent to which Claude matched his

technique to the purpose of the drawing. Each group of these drawings has more in common with contemporary drawings than they have with each other but the way they differ from other drawings of the same date is relatively consistent. Wash is restricted relatively early in the development of these drawings; sometimes it is used as a secondary element to clarify form; eventually, in the 1660s, it is largely eliminated.

Tree studies

Tree studies, which were to the landscape painter what figure studies were to the history painter, form one of the most important aspects of Claude's work from nature. Several tree studies of the Early Sketchbook type are drawn with a scribbling, looping pen line, others are drawn wholly or mainly with the brush, anticipating a number of larger sheets of trees, probably of the mid-1630s, drawn with a bold, broad wash over slack outlines in sharp pen and executed with a rapidity and freedom which seems to have been unparalleled in his later work. Several tree studies, drawn with curly pen outlines and spotted and dotted touches of the brush, can be grouped round a single study (RD. 63), dated 1633 by the artist. This combination of pen and brush which Claude used in most of his early tree studies develops into the majestic pages from the Campagna and Tivoli books in which the pen touches have become precise and descriptive and the washes acquire a new, evocative subtlety. In selecting trees in the parks of Rome and the Campagna, Claude was thinking primarily perhaps of the flanking trees and central groups which feature as compositional motifs in many of his paintings. It is not difficult to match the types of trees in Claude's drawings to trees in his painted compositions but it is difficult to make any specific links. This is not surprising as the least adjustment which Claude might have made to the details of his trees when transferring them to his paintings would have made the process of identifying them in his studies very difficult. Roethlisberger has pointed out the affinities between a group of pines in two early drawings (fig. 6 and cat. 22) and the trees in the *Pastoral Landscape* (LV 18) of 1637 and between a later study of a pine (RD. 903r) and the huge tree in the background of *Apollo and the Sibyl* (LV 164) of 1665. The evocative study in the British Museum of an artist seated on an overturned tree (cat. 36), as Hind first noticed,[39] gave Claude a detail for a later river scene (LV 115). In each case, Claude did not go out in search of a motif that might have been appropriate for his immediate need, but turned instead to his stock of drawings for something suitable. The late study in the British Museum of a huge tree, drawn with indications of the figures in the foreground (cat. 89), was certainly drawn for the purpose of a particular composition but, in this case, it cannot be proved that it was not drawn in the studio.

Between eighty and ninety studies of trees are known but the original number must have been far higher. Even this total is misleading since several of the

drawings of trees are copies or inventions, made in the studio, which are sometimes difficult to distinguish from drawings made in the open air. One of the trees in the Campagna Book (RD. 305r) reappears in a drawing in the British Museum (cat. 41) and, again, in a tracing on the verso of the page from the Campagna Book (RD. 305v) which, in turn, is copied in a fourth study of the tree in Haarlem (RD. 306). One of these drawings was presumably made before the motif, probably the drawing in the Campagna Book which Claude seems to have used chiefly on sketching expeditions, but without the existence of the correspondence all four might, on their own merits, have been described as studies after nature. There is a similar correspondence between one of Claude's studies of a tree from the park of the Villa Madama, also from the Campagna Book (cat. 39), and a drawing of the same tree in Cambridge (RD. 292) which, as Roethlisberger has pointed out, is not a tracing but a free copy of the other, including the flanking tree on the left and the wedge of foreground wash which Claude habitually introduced into his nature studies. In general, Claude seems to have drawn his tree studies from the motif in black chalk, applied fairly loosely and finished in brown wash and pen. Studies which rely less on effects of brush may, in several instances, fall into the class of later copies, although a number of tree studies, drawn mainly or entirely in black chalk, seem to have been made in the open air at a time when Claude was using black chalk as an alternative to wash. These copies from the Campagna Book are best explained as a convenient method of extracting models for reuse in compositions. Tracing the original allowed Claude to use the tree as a flanking motif on either left or right. There are similar tracings on the backs of a number of Claude's landscape drawings (eg. cat. 49, RD. 475, 482, 537, 575), in each instance isolating the trees which, alone, would have served Claude's purpose in preparing his painted compositions.

Excursions

Sketching expeditions in the company of fellow artists gave Claude the mastery of natural detail and of effects of light which contemporaries admired in his paintings. Sandrart mentions trips to Tivoli and to several remoter sites but, to judge by the evidence of his drawings, his favourite sketching ground lay along the left bank of the Tiber, as far as Acqua Acetosa about two miles upstream from Rome. Almost all of Claude's Tiber views can be located at sites along this road, which was a popular country walk for Romans and foreigners alike. Views from along the road appear among the Early Sketchbook drawings, possibly drawn, on occasion, in the company of Swanevelt whose etchings record several of the sites, and appear in Claude's work at intervals over the following thirty years. Claude would have left the city by the Porta del Popolo, close to his own quarter, taking the Via Flaminia to the point where it first touched the high, unstable river bank. Claude drew the river on a number of occasions from this spot, looking back across the farmland on

the right bank and downstream towards St Peter's and the Castel Sant'Angelo (RD. I, IOI, II5); he continued along the Via Flaminia to the Ponte Molle, the ancient Milvian bridge, where Claude drew several views of the bridge and in the immediate vicinity (RD. 426, 427, 736, 859, 860, 908, cat. 88); from the Ponte Molle, he continued along the left bank to Acqua Acetosa, stopping frequently to make sketches of the scenery, looking upstream or downstream or across the river to the west. The Torre Lazzaroni, an antique monument, fortified in the Middle Ages, appears in two drawings seen from across the river (cat. 2, RD. 317), and in the background of many views taken in the neighbourhood; the Torre di Quinto, a square tower set further back from the Torre Lazzaroni on a slight hill, seems to feature in at least four drawings (cat. 2, RD. 277, 424, 425); from the Sassi di San Giuliano, a rocky spur upstream from the Ponte Molle round which the river bends, Claude drew several views looking in the direction of Acqua Acetosa (cat. 8, RD. 165, 172) and, from the other side of the rock, looking downstream in the direction of the Ponte Molle (RD. 278, 279, 488). The little chapel, perched on a projecting rock between the road and the river, appears on the edge of a number of these views, and reappears in the distance in the views looking downstream from Acqua Acetosa which were taken from one of Claude's favourite sites (RD. 109, 591, 874, 875, 876). The fortified manor house at Acqua Acetosa features in several views, seen either from the river, looking north (RD. 13, 165, 172), or in the fore-ground, looking back in the direction of Rome from the hill above the buildings (RD. 876). Acqua Acetosa, which takes its name from the mineral spring enclosed by Paul V in 1613 with a modest structure, was a popular spot for Claude's contemporaries. Neither the old nor the present fountain, built by Alexander VII in 1661, features in Claude's views although he visited the site on several occasions in 1662. This was the furthest extension of Claude's regular excursions along the Tiber, but he occasionally went over the hill to the confluence of the Tiber and the Aniene (RD. 876), passing the Ponte Salario (RD. 166) and continuing at least as far as the Ponte Nomentano (RD. 872). The river south of the Aventine seems to have had no attractions for Claude and views from the left bank are difficult to identify, apart from the celebrated wash drawing in the British Museum (cat. 34) which Roethlisberger has identified as a view of the river, looking downstream from Monte Mario, above the Ponte Molle and near the park of the Villa Madama which was one of Claude's favourite sources of woodland scenery. On a number of occasions, Claude crossed the Tiber at the Ponte Molle, taking the road towards the fifteenth-century fortified manor house at La Crescenza, crossing two little streams which converge near the Ponte de Quinto before entering the Tiber. The road, which passes below the famous cliffs of red tufa, the *saxa rubra* of the ancients, continues towards Subiaco, which Claude visited on several occasions.

It is difficult to date Claude's excursions along the Tiber with precision. Before the 1660s, the only views which Claude dated were those which were drawn somewhat further afield than his usual walks; a visit to Subiaco and views on the road to

Subiaco are recorded in 1637, 1640 and 1647; two views of Tivoli are dated 1647 and 1651; two of Sasso are dated 1649. Many sheets, including several from the Campagna and Tivoli books, are inscribed with the names of places which Claude visited, but they are not dated. Identifying the site for future reference would have been of more importance to Claude than remembering the date, although dates were occasionally added to recall a particular expedition. There are twelve views or nature studies in Roethlisberger's catalogue that are inscribed with dates within the period from c.1631 to c.1661, most of which are in the 1640s. In 1662, by contrast, Claude began to date his drawings made on his excursions with regularity. There are seven dated 1662 alone, recording visits to La Crescenza (cat. 86, 869–71), the Villa Madama (RD. 869), the Ponte Nomentano (RD. 872) and Acqua Acetosa (RD. 874). He seems to have been accompanied by a young girl who appears in a number of the views, perhaps his young ward, Agnese, to whom he left the Liber Veritatis in his will. There are few dated views later than 1662; two in 1663, two in 1667, one in 1669, one in 1671 and one in 1673; but there are also few nature drawings of any kind which can be linked to this period when Claude was afflicted with gout and probably found it difficult to travel far from Rome. Apart from a view of the Aventine (cat. 96), which is an oddity, done with a particular painting in mind, there are no certain nature studies from the last ten years of Claude's life. Excursions on foot or on donkey had once, no doubt, been a source of pleasure, but by the time they had become troublesome they were no longer necessary for his art. Like his fellow Northerners, Breenbergh, Poelenburch and Swanevelt, who had left Rome many years earlier, he had long since assembled a stock of images of Rome and the Campagna which he could turn to for a rich source of background detail.

Drawings for and after compositions

Many of Claude's drawings tend towards or derive from his painted compositions. Each of Claude's paintings must have produced a number of drawings of different types – preliminary compositions, figure studies and final model drawings – most of which have disappeared. The accidental survival of a number of exploratory drawings on the backs of other drawings (RD. 62, 95, 165, 523, cat. 30 and 41), provides the proof that drawings of this type were made by Claude in the first stages of compositions. Claude continued from this point by developing the setting, with or without figures, in pen and wash, with tentative black chalk or with the pen only. The choice of medium seems linked to the purpose of the drawing: black chalk or pen for preliminary sketches; pen, applied with a rapid, searching touch, for working out the details; pen and wash for effects of light.

The pen drawings, in which Claude often refined his compositions, evolved from a type of drawing which Claude practised from an early period, using rapid, slanting pen lines in place of wash. Drawings of this kind from the 1630s, chiefly finished compositional drawings (RD. 56, 58, 73r, 74), are not common and seem

to owe something to his work as an etcher. In the 1640s, as he began to use the pen more extensively, the pen lines became more open, the hatching became more regular and cross-hatching, when it makes a rare appearance, is applied in small, deliberate patches. These drawings differ from the earlier pen drawings, which are drawn with a variety of cutting strokes and touches in the manner of an etching, but the purpose is the same, to clarify a composition as a whole or in the details. In two or three cases (e.g. cat. 30 and cat. 60) he may have used this type of drawing to record a finished painting, possibly as an aid to making a variant, or as a basis for the copy in the Liber. There is a drawing of the kind with added wash, without figures, for the *Pastoral Landscape* of 1642 (RD. 507); another, relating to the wall in the foreground of *Mercury and Aglauros* (RD. 680), must date from 1642–3, the date of the painting. Several other subsequent compositions or details of compositions seem to have been prepared with similar drawings (RD. 581, 847, 934, cat. 87 and 90); but most drawings of the type cannot be connected with other works, despite their general resemblance to fragments of compositions or their general compositional appearance. Nearly all drawings in this category are pastoral subjects and all were probably composed in the studio.

In 1923 Louis Demonts attributed the change in Claude's manner of drawing in the 1640s towards a dryer, less atmospheric handling of the pen to the influence of Titian and his contemporaries,[40] but it is probably better explained as Claude's growing response to the drawings of Grimaldi and Grimaldi's Bolognese contemporaries. The same tendency towards an Italianate, classicising tradition is also visible in the figures in his paintings from the early 1640s onwards which show a new awareness of Domenichino, Poussin, Annibale Carracci and, above all, Raphael and his followers from whom he borrowed specific, identifiable motifs. The frescoes in the Vatican, as Roethlisberger has pointed out, gave him a source of several compositions. Marcantonio provided him with the idea of the *Judgement of Paris* (RD. 597–8) and the Master of the Die supplied figures for *The Enchanted Castle*[41] and *The Father of Psyche Sacrificing at the Oracle of Apollo*. Direct copies are rare among his drawings, but, to judge from the borrowed figures in his paintings, must have been commoner than they are now. Roethlisberger's catalogue lists single drawings after Polidoro da Caravaggio (RD. 762), Raphael (RD. 330), Deruet (RD. 331), Domenichino (RD. 499) and Annibale Carracci (cat. 69) to which Ann Sutherland Harris has added a copy from a painting by Pietro da Cortona.[42] Apart from the copy after Deruet, Claude's borrowed figures confirm his readiness to take lessons from the Roman and Bolognese artists to whom Poussin had turned a decade earlier in reaction against his own warmer and more expansive manner. In Claude's case, the change marked the end of the Northern influences from which he had drawn many of his favourite motifs in the 1630s and on which his early successes had been securely based.

From the slender evidence of the surviving preliminary sketches, it is evident that Claude had the place of the figures in his mind from the beginning, although he

often developed the setting in drawings from which the figures had been eliminated, like empty stage sets which he occasionally reused in different compositions. The figures in his compositions from the 1640s onwards seem to have been worked up in separate sheets; probably this was also the case in earlier compositions but figure studies prepared for paintings of the 1630s are impossible to find. There may be a lost album of figure studies to match the Animal Album which came to light in 1957, but Claude did not have a reputation for figure drawing and it is also possible that the artist or his heirs destroyed them. The earliest sheet of figure studies which might have been made in preparation for a painting, the spectacular drawing of St Ursula and her companions in the British Museum (cat. 56), corresponding to the main figure group in *The Embarkation of St Ursula* of 1641, may alternatively have been copied from the painting and adjusted to fit the sheet; one cannot always tell with Claude, who made a habit of adapting figure studies to make independent compositions. The drawing of St Ursula and her companions is chiefly a study of an effect of light, realised with Claude's early mastery in the use of wash, differing somewhat in this respect from the finished picture, but the question of priority is difficult to answer with certainty. There is a similar ambiguity associated with a couple of sheets of isolated groups (RD.461 and 522) close in date to the painting of St Ursula.

The distinction between studies and copies becomes clearer as the sequence of figure studies continues and the technique of pen and wash gives way to an increased use of black chalk. From this time onwards, there survive about three dozen figure studies linked to his paintings, mostly in black chalk and wash, with or without added pen, sometimes adjusted with the addition of landscapes and accessories to convert them into little independent compositions. The results are sometimes peculiar, particularly in the drawings of the 1640s in which the obviously added detail draws attention to the original purpose of these studies; but, from about 1650, Claude seems to have conceived his preparatory figure studies from the first as independent works of art in which their origin in the preparatory process is concealed more effectively. A few figure studies are known, relating to paintings of 1672 to 1674, adjusted in the manner of the studies of the 1640s (RD.989, 1059, 1067, 1068), but most of his latest figure drawings are presented as independent compositions which cannot always be identified as either preparatory studies or later derivations. There may have been a body of more conventional figure studies which has been lost or destroyed but this does not lessen the idiosyncratic character of the remaining work which indicates, more clearly than any other category of Claude's drawings, the extent to which he thought of his studies beyond the limits of their immediate purpose.[43]

One imagines that each of Claude's major paintings must have been based on a finished composition drawing but there are very few drawings which might be classified as such before the 1650s. An early drawing in the Fitzwilliam (RD.47) appears to be the immediate source of a painting dated 1630; otherwise, drawings

which are this close to paintings are not common outside the pages of the Liber, at least until the 1650s. There are a number of finished drawings from the late 1640s onwards which are sometimes close to the corresponding paintings but which, on closer inspection, seem rather to be later copies, based on the drawings in the Liber, or, more rarely, on the finished painting (RD.640, 653, 758, 760). However, finished compositions survive in some abundance from the last decades, providing ample evidence for the care with which Claude prepared his late commissions through a sequence of elaborate drawings which developed on occasion through considerable variation towards the final painting. These late drawings include several compositions, dating from the 1650s to the 1670s, carefully completed on large sheets with chalk, wash, pen and white body colour, of which three (RD.815, 832, 833) are not represented in the Liber. The size of these sheets and the careful finish bring to mind five large drawings (RD.1030a, 1030b, 1035a, 1035b, cat.91), each of which represents one half of a major painting. These may represent stages of revision undertaken at a late stage on the basis of discussions with the patron but, as always, Claude's purpose is frustratingly elusive. They were more probably drawn as independent works of art.

Model drawings, submitted for approval to Claude's patrons, certainly exist, probably more commonly than is realised. Two compositions survive, one in Melbourne (RD.963), the other in Cape Town (RD.962), which Claude sent to Henri van Halmale in Antwerp in 1665 with a request to select one as the basis of a promised painting. The drawing in Cape Town corresponds fairly closely to the painting in the Hermitage, but without the inscriptions on the verso one would have assumed that both drawings belonged within the larger process of preparatory work. It must be the case that other model drawings of the kind are to be found among the drawings, presently identified as studies for paintings, dating from the late 1640s to the early 1680s, although, even at the time, the distinction between studies and model drawings may not have been always very marked, particularly when Claude dealt with Roman patrons with whom he could have discussed the development of a composition without much formality. Roethlisberger has suggested that a neatly drawn view of the castle at Palo, in the Louvre (RD.324), may have been a model drawing for a composition which does not appear to have been taken further. From the evidence of a slight pen drawing of the site on the *verso* of a page in the Campagna Book (RD.282), Claude must have had a composition of this type in mind during his trip to neighbouring Santa Marinella in *c*.1638, possibly for Paolo Giordano Orsini, who owned the castle and for whom Claude composed a painting of a storm at sea approximately at the time of his visit to Palo. Some support for the idea that the drawing in the Louvre was a model drawing for submission to a patron can be found in two previously unpublished drawings (figs 8 and 9), kindly drawn to my attention by Alexandra Chaldecott, similar in type to the view of Palo, one of which is an otherwise unknown composition with a view of Civitavecchia in the background, and the other a companion

drawing corresponding closely to the painting of Santa Marinella in the Petit Palais in Paris.[44] These compositions, drawn in black chalk, pen and wash on faded blue paper, cut to octagonals of the same size as the copper in Paris, must be models for a pair of proposed paintings on copper, submitted to Urban VIII, similar to the view of Castel Gandolfo painted for the Pope some years earlier. The group of figures in the view of Santa Marinella has been closely copied from one of the drawings in the Liber, itself based on a detail of the painting of the *Country Dance* in Paris, and reappears, with insignificant changes, in the final painting which must have been based directly on the drawing. The view of Civitavecchia also owes something to an earlier painting of a coast scene of *c.*1637, recorded in the Liber (LV 17), with a draughtsman added in the foreground, drawing with a quill pen in a sketchbook, presumably similar to the Campagna Book which Claude took with him to Civitavecchia and in which he made notes for the proposed painting. A somewhat similar draughtsman appears in a painting of a coastal scene, dated 1639, recorded in LV 44, the page immediately before the drawing which records the Santa Marinella composition. Both of the model drawings record sites associated with papal building projects, of which only the view of Santa Marinella was completed, possibly because the war of Castro intervened or for other reasons.

Like Watteau, Claude did not plan every composition through a series of preparatory drawings, but turned habitually to his existing stock. The Liber Veritatis, in particular, provided him with an instrument which enabled him to create increasingly imaginative variations on a limited number of motifs. He used it when he required scenery for a new composition or for painting variants. The value of his drawings, as a source of ideas, made him reluctant to part with them, as Jacopo Salviati explained to Cardinal Leopold de' Medici, evidently in response to an attempt by the Cardinal to acquire some drawings for his collection:

Mr Claude has some old drawings, but in small number, and he does not want to part with them, saying that he uses them. Now that he is old it seems tiresome to him to make new things; he therefore offers to copy two of them and to give us the copies. Morandi does not want to accept, saying that nowadays his works contains weaknesses and are more than a hundred miles from the quality of the old ones. Now what is worse, he will have to be paid generously, since he only fixes a price to persons of lower class.[45]

On the face of it, the statement is misleading as we know that Claude had a large number of drawings in the studio, especially nature studies; but presumably the drawings which Salviati hoped to acquire were composition drawings, not the nature studies which are more highly thought of nowadays than they would have been in Claude's lifetime. Most of the composition drawings available in 1662 were in the Liber, which the artist probably had in mind when emphasising that his old drawings were still of use.

As Salviati's letter confirms, Claude could have made a copy from the Liber without difficulty. Several of Claude's copies, most of which seem to date from after 1662, may have been drawings of this type. A distinct group, all dating from 1670

(RD. 1012–15, 1030), was perhaps drawn for the sake of reinforcing a stock of copies from which Claude might have selected drawings for clients like Leopold de' Medici. Salviati's letter has often been given as evidence that Claude did not willingly part with his drawings but, while it does not give the impression that he was ready to oblige his visitor, it also implies that he was willing, on occasion, to make drawings for sale on a scale of charges which corresponded to the wealth and importance of his customers. On at least a dozen occasions he gave drawings as presents to friends and acquaintances, inscribed with dedications on the back, choosing works which were probably extracted from his collection of loose sheets, or else finished composition drawings, based on the Liber (RD. 649, 652, 890, 917, 927, 929, 931, 969, cat. 66). We know that, in addition to a number of collectors in Claude's immediate circle, Peter Lely and Evrard Jabach owned drawings by Claude during the lifetime of the artist. Lankrink, who died in 1692, may also have acquired his Claudes before 1682, and there must have been others whose collections cannot be so easily identified. The drawings owned by Lely (cat. 13) and Lankrink are working studies for compositions of the type which Claude sometimes gave to friends but Jabach's drawing is a finished composition of *The Rape of Europa* (RD. 640), the kind of drawing which Claude based on the pages of the Liber and which Jabach, as a person of a wealthier class than most, might have commissioned directly from the artist.

Etchings

In addition to using the Liber as a source of motifs for paintings, Claude also drew upon it for etched compositions, probably using an intermediary drawing or tracing and printing the image, often, but not always, in reverse. The few surviving preparatory drawings for his early etchings are outlined with a sharp point of red chalk which may have facilitated the process of transfer to the copper. The earliest of these (cat. 4), dated 1631, is highly finished, like a little painting. It does not relate to any known painting in particular and is too worked up to be a simple copy but represents an ambitious attempt to translate the effects of light which feature prominently in a number of the early paintings into an etched contrast of black and white. At first, his etchings developed, in parallel to his painted work, through a process of recombining figures and backgrounds to create new compositions but, in the mid-1630s, he etched three of his major compositions of the period – *The Country Dance*, *The Rape of Europa* and *The Roman Forum* – all of approximately the same large size, closely reproducing the appearance of the originals and probably intended to commemorate three of the most important commissions of the early years. He also etched a series of seven smaller prints after his paintings, one dated 1634, the others all dated by Lino Mannocci between 1637 and 1641. Six of these etchings, based upon the Liber, could have been made at any time after they had been added to the book, but the evident availability of the painting of *Rebecca and*

Laban, which Claude completed in 1641, allowed him to copy the seventh directly from the original. The etching from the painting and the absence of any later compositions suggests that the series was completed in the course of 1641. Claude added these seven etchings to five of his earlier etchings, all numbered in the left margin in a series from one to twelve. Mannocci has plausibly suggested that Claude intended to publish these prints as a small set, reusing five existing plates, with added numbers, and turning to the Liber and to the painting, which was then on the easel in his studio, to make up a round dozen.[46] Mannocci further suggests that Claude omitted *The Flight into Egypt* from the set because the religious theme would have been out of place among secular landscapes, but it is evident that *The Flight into Egypt* and the three large reproductive prints were omitted chiefly because they were the wrong size. It is also evident from the order of the numbers that Claude envisaged a series of six coast or harbour scenes alternating with six landscapes, beginning with *The Tempest* and the *Dance by the Edge of the Water* and ending with the *Harbour with the Rising Sun* and the *Return from the Fields*. The nature of the sequence explains why Claude turned back to an early drawing in the Liber, the *Coast Scene* of *c.*1634, for a final composition, dated 1641 on the plate, to complete the arrangement in contrasting pairs. *The Embarkation of St Ursula* of 1641, which appeared on folio 54 of the Liber, two sheets after *Rebecca and Laban*, would probably have been employed instead if it had been available, and its omission from the series confirms the likelihood that the series had been finished in the course of the year and before *The Embarkation of St Ursula* had been completed.

Apart from the print of *Rebecca and Laban*, the reproductive etchings in the series relate closely to the drawings in the Liber. Unlike the earlier etching of *The Roman Forum*, these do not seem to have been based on tracings and must have been taken from an intermediary, such as the preparatory drawing for *The Harbour with the Large Tower* in the Uffizi (RD.154), a careful but freehand copy from the drawing in the Liber, neatly outlined in red chalk for transfer to the copper plate. The question of whether these drawings were traced or not is not of much significance. The drawing of *The Roman Forum* is similar in character to the drawing of *The Country Dance*, and also, despite the greater degree of finish, to the early drawing for *The Tempest*, all of which bear a self-explanatory relationship to the related etchings. Drawings by Claude which correspond closely to the later etchings of Claude and Dominique Barrière, with whom Claude seems to have collaborated in the 1660s, survive more commonly but these are less obviously working studies. Two of these etchings, Barrière's *Seaport with Ulysses and Chrysis* and *Seaport with the Embarkation of Ulysses*, as Roethlisberger has pointed out, were both taken directly from the drawings in the Liber; the remaining five etchings correspond with only minor variations to a series of five highly finished drawings recording known paintings, which passed into the possession of the family of Claude's patron, Clement IX, and may have been acquired from Claude by the Pope before his death

in 1669. Through a close analysis of the different states, Diane Russell has suggested that the two drawings which relate to Claude's prints were not models for the original etchings, as is generally supposed, but intermediary studies for later states.[47] While it is hard to believe that Claude could have taken so much trouble for the sake of trying out minor adjustments which he could have made either by working directly on the plate or by reworking a proof with pen and ink (see cat. 79), the proposal is a valid comment on the nature of the differences between the prints and the drawings which cannot be entirely explained by the kind of minor changes which both Claude and Barrière might have introduced in the process of transferring the design to the copper plate. The five drawings, which still belong to the Pallavicini–Rospigliosi families, may have been close variants of the drawings etched by Claude and Barrière, but whether Claude gave them to the Pope for advice (he thanked him in his will of 1663 for having always given him 'il buon consiglio') or as gifts, commissioned drawings or models for compositions, is impossible to say. The recent discovery of a painting on copper, seemingly based on the drawing of *Time, Apollo and the Seasons*, somewhat strengthens the hypothesis that these originated as model drawings for Cardinal Rospigliosi who owned Poussin's *Dance to the Music of Time* on which Claude based his composition. One of the remaining drawings, *Mercury, Hercules and Aglauros*, was also based on a painting belonging to Rospigliosi, commissioned from Claude in 1643, but the other three were for different patrons. Claude's painting on Poussin's theme was not recorded in the Liber and was still in the studio in 1682, abandoned, perhaps, by the artist when the Pope died in 1669.

The last works

Claude's paintings became fewer in the last decade of his life but also more monumental in conception and more carefully prepared. The number of drawings related to each painting increased in keeping with the time spent on his late major works, which sometimes occupied him over a period of years. Most of his surviving preparatory drawings of the period are variations on a current theme, often complete in themselves. A survey of these preliminary drawings seems to indicate a period of extreme hesitation on Claude's part before he discovered his definitive composition, but this protraction in the preparation of his commissions in the final years is more likely explained by his more painstaking manner of applying paint and his ill-health, both of which must have slowed down the rate at which he could complete his paintings. While this would have caused delays in the time it took him to begin work in painting his commissions, it would not have prevented him from taking them up from time to time in a series of exploratory drawings.

Claude's last drawings are among the most original and surprising of his works. In general, from Salviati, writing in Claude's lifetime, to Arthur Hind, who published a catalogue of Claude's drawings in the British Museum in 1926, they

have been unfavourably compared to his earlier work, particularly in the past hundred years when critics have tended, in any case, to prefer his nature studies to any other aspect of his drawings. The freedom of the early works has vanished without trace but the last manner has its own charms and its own *raison d'être*. Claude no longer drew nature studies and, to some extent, no longer required them for the paintings of the last decade in which naturalism is more generally sacrificed to poetic or theatrical effects. Often painstakingly crafted, with a crawling application of the pen and little movement of the wrist, occasionally simpler or more allusive, the late drawings have an existence of their own, typifying a long tendency in Claude's drawings to blur the traditional distinction between a working drawing and a finished work of art. There is a finite difference between the study and the copy but, in Claude's case, the difference, which was not clear cut in his own mind, is sometimes frustratingly hard to recognise. With few exceptions each of his compositions is a preparation for another. Studies for paintings and studies after paintings become confusingly similar. Both are often difficult to distinguish from drawings derived from the work in hand but drawn for their own sake and, even when the preparatory nature of a drawing is not in doubt, the semi-autonomous character which Claude habitually imposed on his studies makes it sometimes impossible to ascribe to them a single, simple, functional purpose. Drawing, for Claude, was a pleasure and an end in itself. As his career advanced, it seems to have taken the place of printmaking as his preferred medium for creating small-scale imagery. This tendency, which is particularly marked in his work after 1660, was surely encouraged by the growing interest among collectors of the period in drawings of this type. In the course of Claude's lifetime, the fashion for collecting drawings, which had been common among artists for a century or more, moved into the world of wealthy connoisseurs among whom Claude's reputation as a painter stood very high. However reluctant he might have been to break into his stock of composition drawings, there is nothing to show that he did not provide copies and variants on demand. Despite the lack of evidence which makes it difficult to document the practice of collecting drawings in the seventeenth century, the existence of many drawings of this type from the last twenty years of his life suggests that he provided them with regularity.

NOTES

1 See M. Kitson in *Claude to Corot*, New York, Colnaghi's, 1990, p. 30; in the annual census returns for 1635 and 1649, Claude's age is given as thirty and forty-five. Further documents, published by M. Sylvestre in 'Claude Gellée entre Chamagne et Rome', *Mélanges de l'Ecole Française de Rome*, 94, 1982–3, pp. 929–47, point in the same direction: Claude's younger brother, Denis, gave his age as twenty in November 1632; as there were two further children in the family, this suggests that Claude did not lose both his parents at the age of twelve in 1612, as Baldinucci implies; if he was orphaned at twelve, he could not have been born in 1600. Roethlisberger suggests that Denis was either lying about his age or did not know it ('From Goffredo Wals to the beginnings of Claude Lorrain', *artibus et historiae*, no. 32, Vienna 1995, p. 35, n. 28); but while this may be, Denis's declaration of age was probably intended to establish that he had reached the age of majority, confirming Sylvestre's suggestion that the age of majority in Claude's family was twenty; Claude, therefore, had not yet reached the age of twenty in 1621 when he and his elder brother were listed as minors in a series of legal transactions; Baldinucci's statement that Claude was aged twenty-five in 1625 was probably calculated on the assumption that he was born in 1600 and cannot be taken as confirming evidence that the date which he provides elsewhere is right.

2 Joachim von Sandrart knew Claude in the early 1630s; his life of Claude, based on distant memories, appears in *Teutsche Academie*, Nürnberg 1675; Filippo Baldinucci's biography, written before 1696, appears in his *Notizie de' professori del disegno*, vol. 6, Florence 1728; translations of the relevant sections of both texts are conveniently printed in M. Roethlisberger, *Claude Lorrain: The Paintings*, New Haven 1961, vo. 1, pp. 47–62.

3 Jacques Thuillier has suggested that this refers to the uprising of the Valtellina in *c.*1620 (*Claude Lorrain e i pittori lorenesi in Italia nel XVII secolo*, Rome, Accademia di Francia a Roma, 1982, p. 283).

4 G. Pariset, *Georges de la Tour*, Paris 1948, p. 121.

5 As Roethlisberger has pointed out; op. cit., p. 55, n. 12.

6 Ibid., pp. 64–71.

7 See the introduction, reprinted in each of the four volumes of Michael Jaffé's *The Devonshire Collection*, London 1994, pp. 11–25.

8 Jaffé cites a letter from a M. Foucheroux, dated 1728, following a visit to Devonshire House in London, mentioning the Liber Veritatis, which the writer had seen previously 'chez la Nièce de Claude Lorrain' in Rome; the reference is similar to the statement found in Dezallier d'Argenville's *Abrégé de la vie des plus fameux peintres*, Paris 1742, vol. 2, p. 268; in addition, Foucheroux mentions 'environs quarantaine desseins separez du même',

confirming the early provenance of the loose sheets in the Devonshire collection; ibid., p. 23.

9 Michael Clarke, 'Collecting paintings and drawings', in *The Arrogant Connoisseur: Richard Payne Knight 1751–1824*, Whitworth Art Gallery, Manchester 1982, p. 98.

10 A. M. Hind, *The Drawings of Claude Lorrain*, London 1925, p. 18; this tendency has already been emphasised by Michael Kitson in 'The place of drawings in the art of Claude Lorrain', *Acts of the Twentieth International Congress of the History of Art*, vol. 3, Princeton 1963, p. 96; Claude's tumble from his place of eminence among the Old Masters is strikingly illustrated by the account of Chambers Hall's collection which appeared in *The Art Journal* in 1856, p. 91, listing many of his drawings but omitting any reference to the work of Claude.

11 Claude's inventory is published by F. Boyer in the *Bulletin de la Société de l'Art Français*, 1928, pp. 152–62; a convenient translation is found in M. Roethlisberger, *Claude Lorrain: The Paintings*, New Haven 1961, pp. 72–6.

12 Dezallier d'Argenville, *Abrégé de la vie*, p. 268.

13 M. Roethlisberger, *Animal Drawings from Nature by Claude Lorrain*, New York, Seiferheld Gallery, 1961; M. Roethlisberger, *Claude Lorrain: The Drawings*, Berkeley and Los Angeles 1968, vol. 1, pp. 57–9.

14 M. Roethlisberger, *The Wildenstein Album*, Paris 1962; Roethlisberger, *Claude Lorrain: The Drawings*, vol. 1, pp. 65–6.

15 M. Roethlisberger, 'The drawing collection of Prince Livio Odescalchi', *Master Drawings*, vols 13–14, 1986, pp. 5–30.

16 Per Bjurström, *Claude Lorrain Sketchbook Owned by Nationalmuseum, Stockholm*, Stockholm 1984, pp. 10–11.

17 M. Kitson, 'A small sketchbook by Claude', *Burlington Magazine*, vol. 124, 1982, pp. 698–703.

18 Roethlisberger, *Claude Lorrain: The Drawings*, vol. 1, p. 120.

19 Ibid., p. 57.

20 Roethlisberger, *Claude Lorrain: The Paintings*, vol. 1, p. 62.

21 M. Roethlisberger, 'More drawings by Claude Lorrain', *Master Drawings*, 1990, 4, pp. 411–15.

22 Kitson, 'A small sketchbook', pp. 701–2.

23 M. Lavin, *Seventeeth-Century Barberini Documents and Inventories of Art*, New York 1975, pp. 100, 478. Marilyn Lavin has proposed an earlier date, based on a

mention of four paintings on copper by Claude in a record of transfer in the Barberini archives, dated April 1638, but there is nothing to indicate that this transaction included the view of Santa Marinella or the view of Castel Gandolfo in Cambridge, as she suggests. The four coppers mentioned in the archive may be identical with four landscapes attributed, probably in error, to 'Claudio Veronese' in a Barberini inventory of 1686 in which 'due piccoli di Claudio Lorenese', probably the views of Castel Gandolfo and Santa Marinella, are separately listed. The views of Castel Gandolfo and Santa Marinella are clearly described for the first time in an inventory of Cardinal Antonio Barberini, dated April 1644, without mention of the author. The exact delivery date is unknown but, to judge from its position in the Liber, the view of Castel Gandolfo was completed in 1638–9, approximately one year before the painting of Santa Marinella.

24 M. Kitson and M. Roethlisberger, 'Claude Lorrain and the Liber Veritatis', *Burlington Magazine*, vol. 101, 1959, pp. 14–24, 328–37, 381–8; especially M. Kitson, *Claude Lorrain: Liber Veritatis*, London 1978.

25 D. Russell in *Claude Lorrain 1600–1682*, National Gallery of Art, Washington 1982–3, pp. 76–7.

26 Roethlisberger, *Claude Lorrain: The Paintings*, vol. 1, p. 156.

27 Kitson, *Claude Lorrain: Liber Veritatis*, pp. 72–3.

28 E. Harris, 'G. B. Crescenzi, Velazquez and the Italian landscapes for the Buen Retiro', *Burlington Magazine*, vol. 122, 1980, pp. 562–4.

29 See M. Chiarini's review of Roethlisberger's catalogue in the *Art Bulletin*, 1971, p. 258.

30 M. Roethlisberger in *France in the Golden Age: Seventeenth Century French Painting*, Walpole Gallery, London 1996.

31 M. Kitson, 'Swanevelt, Claude Lorrain et le Campo Vaccino', *Revue des Arts*, vol. 8, 1958, pp. 215–20, 258–66.

32 Russell in *Claude Lorrain 1600–1682*, p. 78.

33 E. Knab, 'Die Anfänge des Claude Lorrain', *Jahrbuch der Kunsthistorischen Sammlungen in Wien*, 1960, pp. 154–5.

34 A. Chong, 'The drawings of Cornelis van Poelenburch', *Master Drawings*, 1987, 1, p. 17.

35 See Russell in *Claude Lorrain 1600–1682*, pp. 72–3 for a discussion of the Spencer painting and the version in the Metropolitan Museum of Art.

36 Roethlisberger, *Claude Lorrain: The Paintings*, vol. 1, p. 48.

37 Ibid., p. 51.

38 Ibid.

39 A. M. Hind, *Catalogue of the Drawings of Claude Lorrain*, London 1926, no. 212.

40 L. Demonts, *Les dessins de Claude Gellée dit le Lorrain*, Paris 1923, p. 7.

41 As Michael Wilson has pointed out in *Claude: The Enchanted Castle*, National Gallery, London 1982, pp. 11–12.

42 A. Sutherland Harris, 'Claude Lorrain et Pierre de Cortone', *Revue de l'Art*, no. 11, 1971, pp. 85–86.

43 See M. Kitson, 'Claude Lorrain as a figure draughtsman', in *Drawing: Masters and Methods: Raphael to Redon*, ed. Diana Dethloff, London 1992, p. 81.

44 *View of Civitavecchia* and *View of Santa Marinella*: both black chalk with pen and brown ink and faded brown wash, heightened with white body colour on faded blue paper, 270 mm × 350 mm (octagonal), laid down; provenance: Nicola Francesco Haym (L. 1970 on old backing); private collection.

45 Published in F. Boyer, 'Documents d'archives romaines et florentines sur le Valentin, le Poussin et le Lorrain', *Bulletin de la Société de l'Histoire de l'Art*, 1931, p. 238; translated in Roethlisberger, *Claude Lorrain: The Drawings*, vol. 1, p. 21.

46 L. Mannocci, *The Etchings of Claude Lorrain*, New Haven and London 1988, pp. 20–21.

47 Russell in *Claude Lorrain 1600–1682*, p. 405.

The Catalogue

1. View of a Ruined Arch

Pen and brown ink with brown wash on off-white paper, evenly foxed, torn upper right and backed with paper, 91 × 123 mm

Stamped: Chambers Hall (L. 551); University Galleries (L. 2003)

Provenance: presented by Chambers Hall, 1855

Ashmolean Museum, 1855.72; RD. 31

Eckhart Knab has drawn attention to a similarity between the arch in this little drawing and a row of arches in an etching by Jean Morin, inscribed *Claude Lorrain pinxit*[1]. Roethlisberger was initially unwilling to add the etching to the list of prints after lost paintings by Claude because of its uncharacteristic composition but now agrees that the corresponding painting (which has since come to light) is one of the earliest surviving works by Claude, dating from 1625–30.[2] The Oxford drawing also relates to a similar detail from an etching by Herman van Swanevelt (fig. 2), published in Paris many years later in a series of twelve Roman views (H. XXIX, no. 39). The painting attributed to Claude corresponds to the right side of the etching, in reverse direction. The connection with the print tends to confirm the evidence of the style of the Early Sketchbook drawings, several of which are marked to a high degree by a manner of handling the pen and brush which was common among the Dutch artists in Rome from Breenbergh to Jan Asselyn. The relationship between the etching and the present drawing might have been fortuitous but is substantiated by the existence of two further drawings from the Early Sketchbook (RD. 9 and 12) which also correspond, in reverse, to two different etchings in the same series (H. XXIX, nos 44 and 46).

2. A Farmhouse by the Tiber

Pen and brown ink with brown wash; pen and black ink in the sky, with a smudge of red chalk in upper right, 119 × 92 mm

Verso (laid down) Two Draped Figures

Pen and brown ink

Provenance: bequeathed by Richard Payne Knight, 1824

British Museum, Oo.6–27; RD. 12

The view represents the farmhouse with the medieval round tower, known as the Torre Lazzaroni, once situated on the right bank of the Tiber, north of the Ponte Molle which appears in earlier and later drawings by Claude (RD. 136 and 359). The square tower in the distance must be the Torre di Quinto which has given its name to this quarter of modern Rome. The stretch of the Tiber along the left bank from the Porta del Popolo to Acqua Acetosa was one of Claude's favourite walks, giving him a repertory of views which he repeated over a period of thirty years. The farmhouse features in an etching by Swanevelt (H. XXIX, no. 44) in the series of *Diverses veues* in an oblong format which includes more of the building than is visible here (fig. 3). All three of Claude's views which correspond to Swanevelt's etchings relate to sections of the printed image. In common with a number of Claude's early drawings, there are figure studies on the back of the sheet. Two draped figures are visible through the front of the sheet but, like several of the drawings of the Early Sketchbook type which also have pen drawings of figures on the back, it has been stuck firmly on to a sheet of paper, making it difficult to see the drawing clearly.

1

Fig. 2 Herman van Swanevelt, *Ruins on the Palatine*. Etching. H. XXIX, no. 39, British Museum.

2

(*Below*)
Fig. 3
Herman van Swanevelt,
Farmhouse.
Etching. H. XXIX, no. 44,
British Museum.

3

3. The Pyramid of Caius Cestius

Pen and brown ink on fine-textured, off-white paper, stained in three corners and along the upper edge, 90 × 127 mm

Inscribed on *verso* in pen and brown ink: *Claud Lorain*

Provenance: presented by Charles Emanuel, 1950

Ashmolean Museum, 1950.178.25; RD.32

This is associated by Roethlisberger with drawings from the Early Sketchbook to which it corresponds in size, paper type and style of drawing. The view is taken from a point within the present Protestant Cemetery with part of the Aurelian Wall on the right, looking north towards the Aventine. The artist has redrawn the nearest edge of the monument in an attempt to correct his misalignment of the wall and pyramid, a slip which was probably the result of inexperience, but his drawing otherwise accurately represents the pyramid as it appeared before the restoration by Alexander VII in the early 1660s.

The use of neat pen outlines, without wash, is an early instance of a style of drawing which Claude used periodically for the sake of recording buildings.

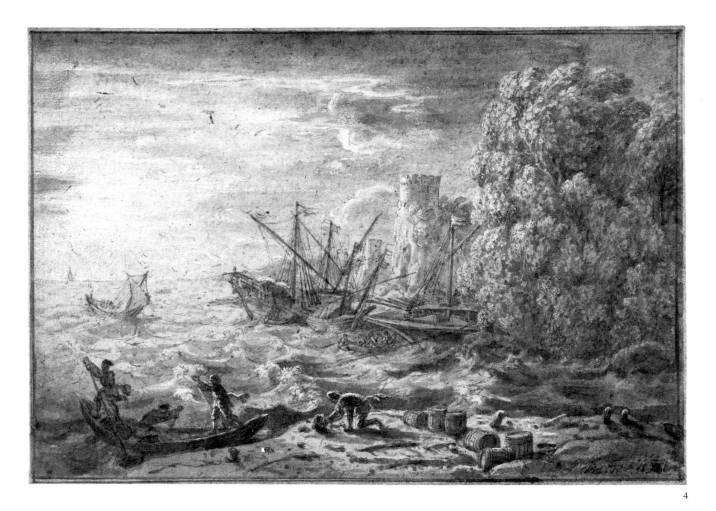

4

4. A Storm at Sea

Red chalk with pen and brown wash, heightened with white body colour on beige paper, 129 × 179 mm

Inscribed by the artist in pen and brown ink, lower right: *CLAUDIO IV 163[.]*, over a similar inscription, dated 1631, in red chalk

Provenance: Henry Wellesley; H. Vaughan, by whom bequeathed, 1900

British Museum, 1900-8-24-555; RD.46

This is Claude's earliest known dated drawing, composed as a model for an etching (cat. 5), to which it corresponds in detail and in reverse. The outlining in sharp red chalk is a common feature of the few drawings by Claude which were drawn for transfer to the etching plate. The attraction of the subject for Claude lay in the effect of moonlight which licks the tops of the waves and illuminates the outlines of the figures. Similar effects are common in Claude's sea paintings of the 1630s, usually associated with the setting sun. Most of Claude's etchings are based on or copied from his paintings but it is unlikely that this drawing, which is minutely finished with the brush in the manner of a small painting, was copied from a lost composition. The night-time subject seems better suited to an etching than to a painting. The drawing has a date in ink of which the last digit is illegible, written over an earlier inscription in red chalk which is plainly dated 1631. This is odd, as the print is dated 1630. The discrepancy is difficult to explain unless the date on the drawing was intended to refer not to the date of the drawing, but to the anticipated date of publication.

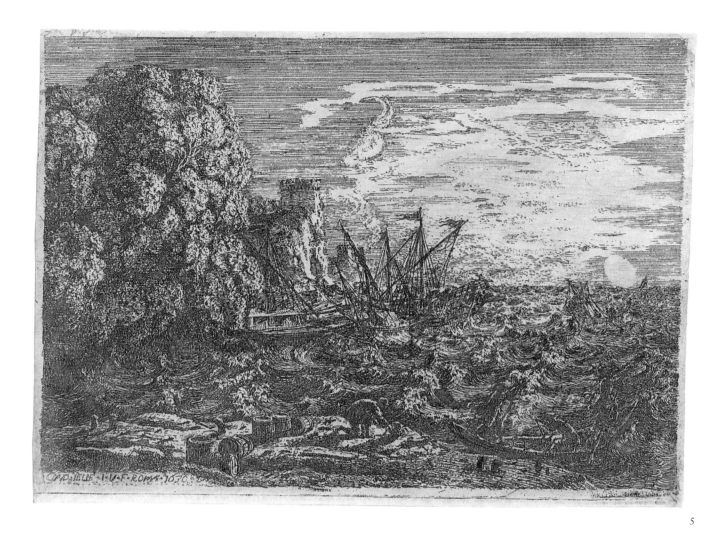

5

5. The Tempest

Etching, 125 × 176 mm (plate)

Inscribed in lower left:
CLAUD.IELLE.I.V.F.ROMAE.1630

Provenance: presented by Chambers Hall, 1855

Ashmolean Museum, M. 6.i

This print indicates the moon in its three-quarter phase close to the horizon but, otherwise, follows the drawing without significant changes in the detail. The general effect, however, is different. The subtle variations of light in the drawing, based on a complex mixture of red chalk, pen, brush and wash and white body colour, are lost in the simpler medium of the etched lines. The scattered lights confuse the image and the figures vanish into the background of the sea. In the second and third states (fig. 4), Claude heavily reworked the image, burnishing out details in the sky, removing the bending figure in the foreground and flattening the figures in the boat to black silhouettes, clearly defined against luminous patches burnished out in the sea behind. Claude's decision to abandon the ambitious contrasts of the drawing in favour of a simplified effect suggests the experimental nature of the print which, in its early state, required a degree of technical sophistication which was then beyond the artist's reach. The form of the signature is unusual but reappears in *The Judgement of Paris* painted in 1633 (RP. 39). Roethlisberger has suggested that the form of the name in the painting may be due to retouching, but it is probably better explained as one of a number of spellings employed by Claude. A variant: *Claude Jelle*, appears in the second state of the etching.

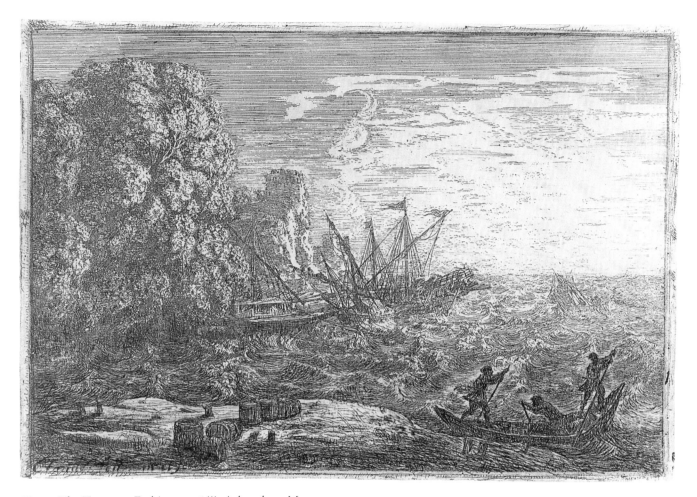

Fig. 4 *The Tempest*. Etching. M. 6.iii, Ashmolean Museum.

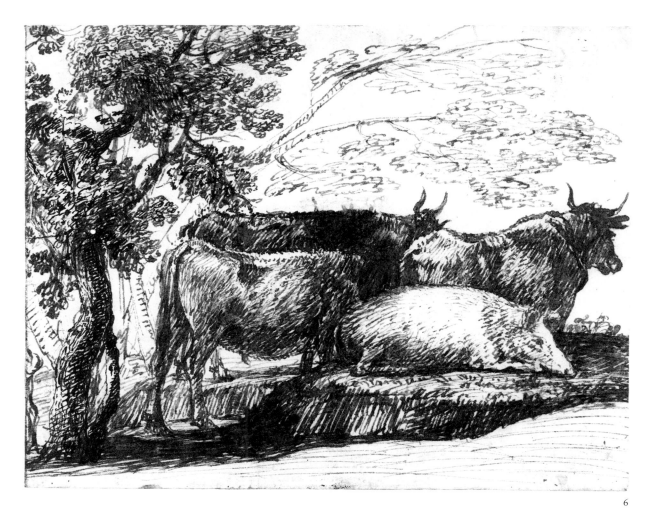

6

6. Cattle and a Hog

Pen and two shades of brown ink on white paper, damaged
near centre, 127 × 162 mm

Provenance: Henry Wellesley; John Malcolm; purchased, 1895

British Museum, 1895–9–15–916; RD. 51

This drawing is the most finished and pictorial of a group
of animal drawings, modelled with dense, slanting
strokes of the pen, several of which were once in the
Animal Album (e.g. RD. 52, 204, 207, 228, 229). There
are marked affinities with the looping pen lines which are
a feature of the Early Sketchbook drawings (e.g. RD. 34
and 35) and, more generally, with a small group of
more elaborate landscapes (RD. 56, 58, 73 and 74) which
must all date from the beginning of the 1630s. The revi-
sion of the cow's head at the centre, heavily worked over
with the pen, and the inclusion of the flanking tree,
balancing the image on the left, suggest that Claude took
unusual care over the presentation of the drawing. The
best analogy can be found among Swanevelt's etchings of
animals, one of which includes a similar hog (H. XXIX,
no. 116). The dense, incisive pen lines, without wash, are
uncommon in Claude's art but appear in a number of

composition drawings, dated by Roethlisberger to the
early 1630s (RD. 56, 58, 73, 74). Claude laid in the out-
lines of the drawing with a sharp pen, strengthening
them later with a thicker point. The flicks and cutting
lines give the drawing the appearance of an etching.

7. Landscape with a Country Dance

Pen and brown ink with brown wash on discoloured, spotted
white paper, 194 × 232 mm

Stamped: Spencer (L. 1530)

Verso A Seated Draughtsman and a Separate Study
of his Head (fig. 5)

Red chalk

Provenance: Earl Spencer; H. Vaughan, by whom bequeathed,
1900

British Museum, 1900–8–24–152; RD. 64

This is evidently a preparatory drawing for *The Land-
scape with a Country Dance* in the Art Museum in
St Louis (RP. 11) which Roethlisberger now attributes to

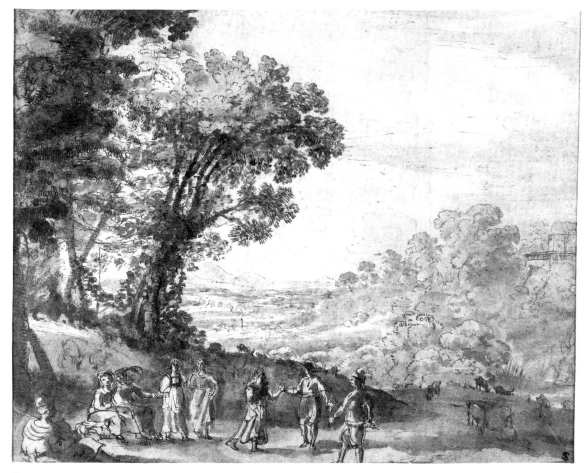

7

Fig. 5 *A Seated Draughtsman and a Separate Study of his Head*. Red chalk. RD. 64, *verso*, British Museum.

49

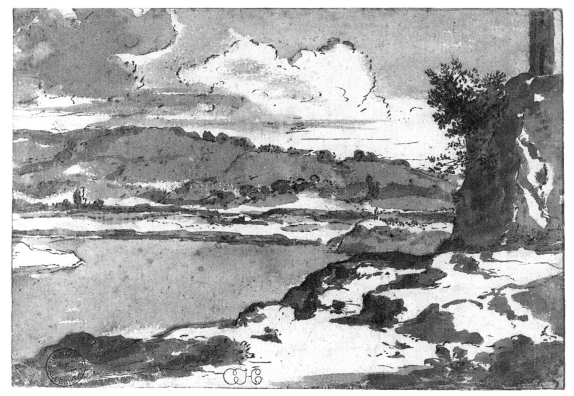

8

8. View on the Tiber

Pen and brown ink with brown wash on white paper with traces of framing lines in brown ink along the edges,
104 × 147 mm

Stamped: Hall (L. 551); University Galleries (L. 2003)

Provenance: presented by Chambers Hall, 1855

Ashmolean Museum, 1855.69; RD. 108

Claude after some initial doubts. The niggling touches of the pen, the curly lines and extensive use of wash are signs of a date in the early 1630s. Similar foliage, resembling florets of cauliflower, and similar peg-like figures are found in drawings by Swanevelt to whom Eckhart Knab has attributed this study,[3] but, as Roethlisberger confirms, there are also many points of contact between this type of drawing and a number of studies in a freer style which are certainly by Claude. Exact points of comparison are difficult to find, perhaps because preparatory compositional drawings for paintings of the early 1630s are also uncommon. There are analogies in a drawing of a coast scene in the Fitzwilliam (RD. 47) which is a study for a painting of 1630 and is touched with the same blend of neat, fine penwork and similarly shaded with extensive wash. The present study cannot be much later. The dancers and the seated spectators, who appear here for the first time in Claude's art, provided him with a motif which he developed in a sequence of paintings, drawings and etchings over many years. The little figure on the *verso* (fig. 5), drawn in red chalk, seems to be a study for the seated artist who appears in the first state of the etching of *The Landscape with an Artist Drawing* (M. 2.i) but was burnished out in the second state. Other figure studies in red chalk are known on the backs of drawings from the early 1630s (RD. 21v, 172v) but this is the only figure study of the 1630s which can be linked to a composition.

An early date is suggested by the combination of luminous blank spaces, dotted penwork and sharp, short curling pen lines which is not found in the studies that can be dated to *c.*1640 onwards. There is a similar view, flanked by a short cliff on the right, in the British Museum (RD. 172r), dated 1635–40 by Roethlisberger. It is not easy to date drawings of this type precisely but this view and the drawing in the British Museum cannot be far apart in time. The motif is common among Claude's river views. A similar bank features in a painting of 1641–2 recorded in the Liber Veritatis (RD. 469) and again in two views taken from the road along the river looking towards Acqua Acetosa (RD. 165r and 172r). The building on the cliff-top on the upper right is probably the small chapel perched on a rock by the side of the road to Acqua Acetosa which is visible in the distance in four later views by Claude (RD. 488, 874, 875 and 876) and on other contemporary views of this popular site. The fortified manor house

which appears on the distant high ground in other views from this stretch of road must have been cut off by the edge of the page on the left.

9. Path along the Tiber

Black chalk with pen and brown ink and brown wash on white paper, water-stained along the top, bottom and right margins, with light framing lines in pen and brown ink along the left and right edges, 178 × 127 mm

Stamped: Spencer (L. 1530); Hall (L. 551); University Galleries (L. 2003)

Provenance: Earl Spencer; Chambers Hall, by whom presented, 1855

Ashmolean Museum, 1855.70; RD. 109

The dimensions of the sheet are similar to those of a number of sheets with drawings of widely differing dates, including the pages of the Stockholm sketchbook which probably dates from the 1650s. This drawing is similar in character to the previous drawing, cat. 8, and must be about twenty years earlier than the Stockholm drawings. Claude doubtless used several sketchbooks of this format across a number of years. The view seems to have been taken from the road to Acqua Acetosa, looking back along the Tiber towards Rome with a view of the wooded terraces which feature in the background of the view from a neighbouring site in Cleveland (RD. 591r). The same view from higher ground appears in a slightly later drawing (RD. 167) and in several drawings of the 1660s (RD. 874, 875 and 876).

10. The Goats

Etching, 194 × 255 mm (plate)

British Museum, 1868–11–14–353; M. 8.i

This unique impression of the first state of Claude's largest etching has been described as a derivation from a drawing in the Liber Veritatis (cat. 29) which Claude altered from an upright to an oblong format by adding a section on the right. According to the inscription on the back of the sheet, the drawing in its original form records a painting for Cardinal Rospigliosi which, from its place in the book, must have been painted in c.1637. This must be the related *Pastoral Landscape* which remains in the Rospigliosi–Pallavicini collection in Rome. Diane Russell has argued that the etching cannot be as late as c.1637, and suggests, with caution, that the drawing in the Liber might, instead, be a record of the etching. Lino Mannocci, confirming the discrepancy in dates, is inclined to dismiss all question of a link. Mannocci's scepticism is understandable, particularly

as far as the original, upright drawing is concerned. If one isolates the left-hand portion of the drawing in the Liber, any similarity between the drawing and the etching largely disappears. There is no great tree on the left side of the etching as there is in the drawing and in the painting, the animals are different and although, by analogy with the drawing, the figure in the etching is usually described as a shepherd, his frogged coat identifies him as a traveller or a huntsman. The dense, tight, dark manner of the etching must date from before 1635, a date confirmed by Mannocci's observation that one of the prancing goats appears on a trial plate (M. 7) next to a preparatory figure for the etching of *The Rape of Europa* of 1634; similar goats, as Hind noticed, also appear in an oblong composition of a seated herdsman in the British Museum (RD. 260) which seems to have been improvised round a number of studies of animals of the type found in the Animal Album and may have been the source of the present composition. The right-hand section of the drawing makes a better comparison with the print. The details of the little travellers, the round tower and the sloping tree, which forms a bridge between the two parts of the drawing, are common to both, although none is identical. It may be that when Claude decided to extend the drawing in the Liber, he had the print in mind as a model for the added section. At some stage, Claude cut the plate in two. All other known prints from this plate have been taken after the plate had been divided. It is not obvious why Claude should have done this. The divided drawing in the Liber may have prompted him to make two more compact images from this large print but there is no proof of this. Mannocci thinks Claude may have simply cut the plate to remove a patch of damage which appears in all later states of the right-hand section.

11. The Flight into Egypt

Black chalk with pen and brown ink and brown wash on off-white paper with a number of holes on the tree on left, camouflaged with black chalk; damaged and restored upper right edge; a large ink blot, upper left of centre; vertical crease through centre, 160 × 215 mm

Stamped: Hall (L. 551); University Galleries (L. 2003)

Provenance: presented by Chambers Hall, 1855

Ashmolean Museum, 1855.71; RD. 347

Karl Parker first pointed out that the figures reappear reversed in an etching (M. 9) but, because of many differences in detail, concluded that it was not a related study.[4] For similar reasons, Roethlisberger suggested a link with a hypothetical lost painting. In 1983, Roethlisberger published a painting from a private

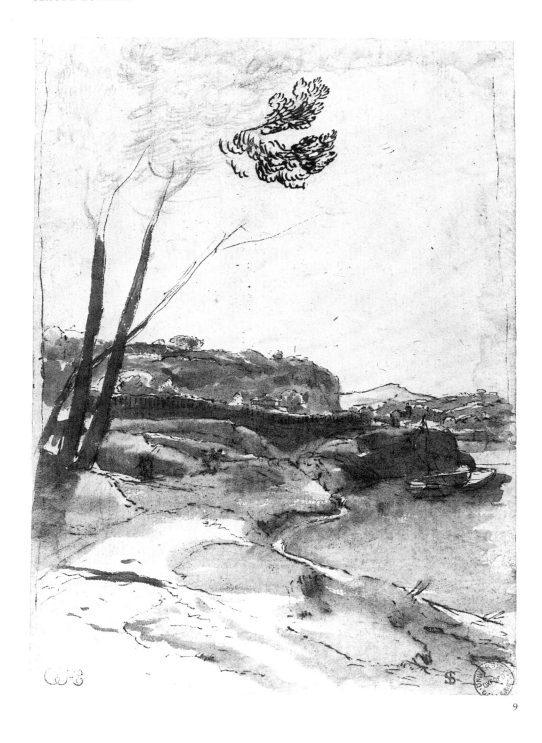

9

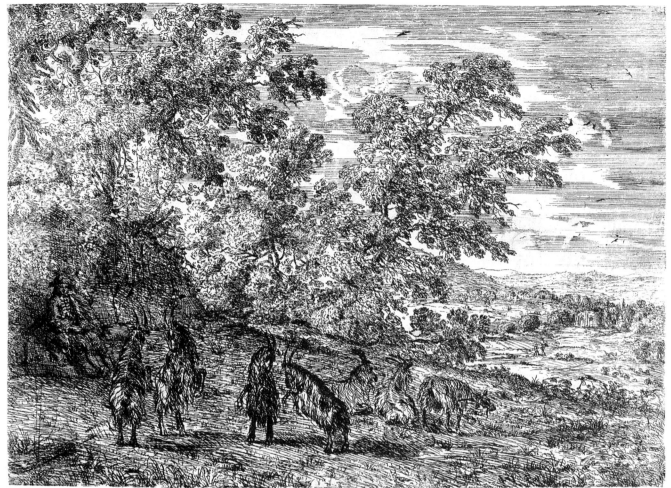

10

collection in Zurich, dated 1647, in which the figures closely correspond although the setting is quite different and the date of the painting rules out a direct connection with the drawing (RP.283). The scribbling pen and heavy wash is found in one or two of the earliest drawings in the Liber but is less common towards the end of the decade, suggesting a date towards the mid-1630s. The etching is generally dated from the early 1630s but there is no reason why it could not have been made nearer the middle of the decade. This date raises the possibility that the drawing is a study for the print. The reversing of the image implies that it is not derived from the print while the position of the Christ Child, which does not correspond to his position in the print or in the painting, is not inconsistent with a version of the composition which is earlier than either. This sequence is also suggested by the pentimenti visible in the drawing. The Virgin, originally drawn in profile, facing in the same direction as the Child, has been turned to face the angel

as she appears in the etching and painting. The Child was no doubt altered subsequently to match this change. St Joseph, who is unconventionally youthful and informally dressed in the drawing, corresponds to the figure in the print but not to the figure in the painting which dates from a time in Claude's art when his taste for genre was giving way to a more classical sense of detail. Joseph was originally drawn in black chalk at some distance from the donkey but this evidently did not satisfy the artist who redrew him immediately behind the second angel. He changed his mind again in the etching, placing Joseph at a greater distance down the road, but eventually reverted in the painting to the intermediate solution, indicated in the pentimento. The idea of the Virgin in profile with the Child holding his arms towards the angel was not retained in the painting of 1647 but was used in a related painting of 1663 in the Thyssen-Bornemisza collection (RP.229). The sequence of drawing, print and painting seems plausible but it would not be a surprise if

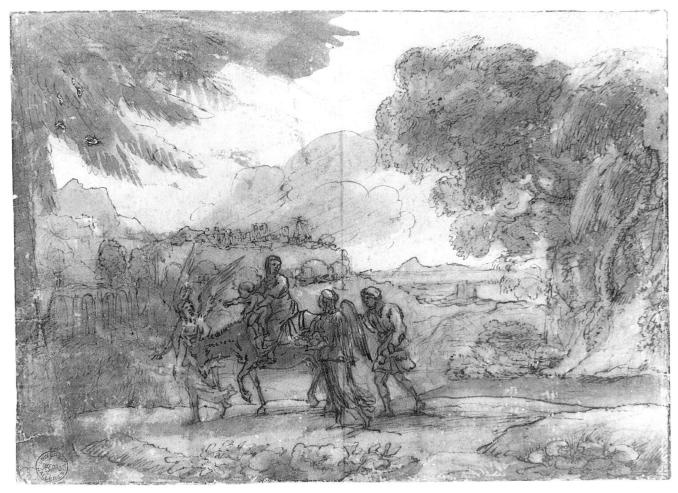

11

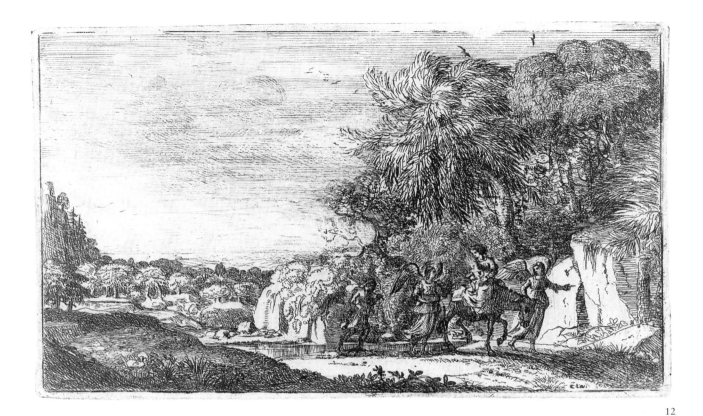

12

a small painting of the kind proposed by Roethlisberger, intervening between the drawing and the print, were to come to light.

12. The Flight into Egypt

Etching, 107 × 170 mm (plate)

Inscribed at lower right: *CLAU*

Provenance: presented by Chambers Hall, 1855

Ashmolean Museum, M.9.i

The *Flight into Egypt* is one of a number of themes which have always appealed to landscape painters. It appears throughout Claude's work in drawings, etchings and paintings with minor changes in the figures, but with greater variation in the setting. The figures in this etching reappear in a painting of 1647. It is possible that the etching and the later painting were both based on a lost painting of the early 1630s although none of the five early etchings of similar size to this seems to have been taken directly from any paintings and, if this print was based on a painting, it was probably adjusted in the manner of *The Landscape with Brigands* (cat. 17) to constitute a new composition. The question has some bearing on the status of the related drawing in Oxford which, if it is not a study for the etching, may have been composed for a small painting on which the etching has been based. The style of the etching suggests that it may be slightly earlier than *The Landscape with Brigands* which shows more technical assurance. The surface has been worked over with small, dense, careful strokes, creating a generally dark effect which Claude has tried to modify by burnishing out areas of the sky, but leaving a number of disfiguring areas of damage, particularly near the centre. This is the first known state but there were presumably earlier states before the burnishing. In common with a number of Claude's prints of this size and date, the unfinished condition of the first state, the only known state which was printed in Claude's lifetime, leads one to suppose that Claude set this etching aside before it was ready for publication.

13. A Watermill among Trees

Pen and black ink with grey wash over black chalk on white
paper with traces of a framing line in pen and black ink on
right side, 142 × 199 mm

Stamped: Lely (L. 2092); Richardson sen. (L. 2184); Chambers
Hall (L. 551); University Galleries (L. 2003)

Provenance: Lely; Richardson sen.; George Hibbert; Christie's,
10 June 1833; Chambers Hall, by whom presented, 1855

Ashmolean Museum, 1855.80; RD. 78

This drawing corresponds, in reverse, to the setting of a
painting in a private collection (RP. 84) and, in the same
direction, of an etching (M. 13), dated 1634 by Russell
and Mannocci. Roethlisberger has suggested various
dates for the painting between c.1635 and 1638, all
of which seem too late for an immediate link with the
drawing. Because it is in the same direction as the print,
Diane Russell thinks the drawing may have been made
after the etching. The broken pen lines and smudged

effects of wash suggest a connection with the Early
Sketchbook, particularly with the sheets of tree studies in
the British Museum (RD. 4, 5 and 7), but as this manner
of drawing may have extended into the mid-1630s, it
may not prove conclusively that the drawing is earlier
than the etching. On balance, the best explanation is that
the drawing in Oxford is an early idea for the setting
of the painting, without the figures and in reverse, of
a kind which is fairly common among Claude's later
preparatory drawings, and that the etching is a record
of the painting. It represents an early appearance of
the watermill with a round tower which became a very
common motif in his art. Kitson has drawn attention
to the mark of Peter Lely (1618–80) on this drawing,
making it the earliest dateable acquisition of a Claude
drawing by a collector in England and one of only a
handful of drawings which are known to have left the
artist's studio in his lifetime.[5] According to the list which
came to the museum with Chambers Hall's gift in 1855,
the drawing once belonged to Earl Spencer, but it cannot

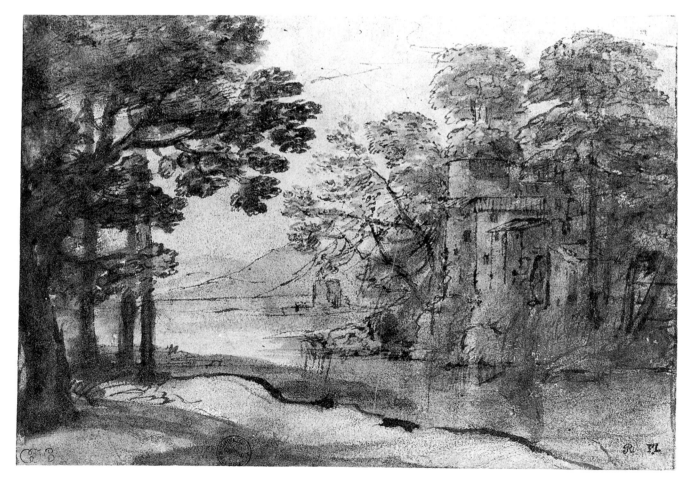

13

be identified in the sale of 1811, nor can it be firmly identified among several lots of Claude's drawings in Hibbert's sale in 1833, most of which were bought by Thane and Woodburn.

14. The Dance on the River Bank

Etching, 131 × 200 mm (plate)

British Museum, 1862–7–12–127; M. 13.i

This print reproduces a painting belonging to Edgar Kaufmann in New York which shares a number of elements with other paintings on the theme of the country dance: the spectators, seated on a log, the dancing couple and the pair of prancing goats which form a humorous parallel with the dancers. Roethlisberger dates this composition to *c*.1637 in the belief that it is taken from the etching (cat. 27) which incorporates details of the *Landscape with a Country Dance* painted for Urban

VIII; but it is difficult to understand why Roethlisberger has linked the Kaufmann picture with the etching of *c*.1637 rather than the earlier, undated picture in the Uffizi on which the etching of *c*.1637 has been substantially based. Diane Russell has pointed out that the technical problems which Claude encountered in preparing the plate for the present etching, visible in the accidental strokes along the margins and the pit-marks in the sky, are not found in the prints of the later 1630s. Lino Mannocci places it among the group of prints of *c*.1634. Roethlisberger partly substantiates his dating of the Kaufmann picture by comparing it to a painting in the Museum of Fine Arts in Boston which is inscribed with a date which he reads as 1637, but this reading has been disputed by Kitson and Russell and by the evidence of a technical analysis in the museum which suggests that the date inscribed on the painting is 1631.

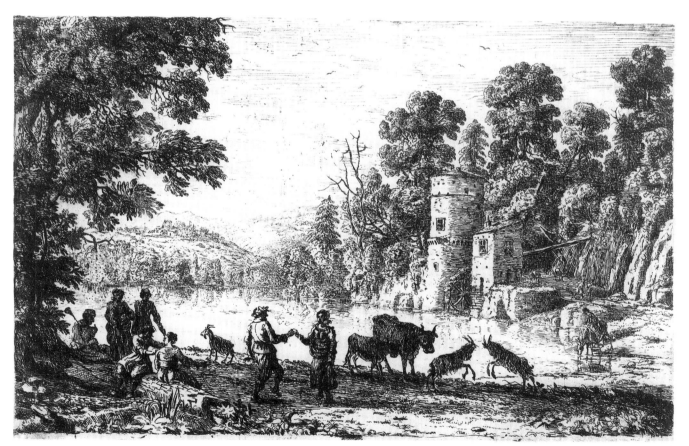

14

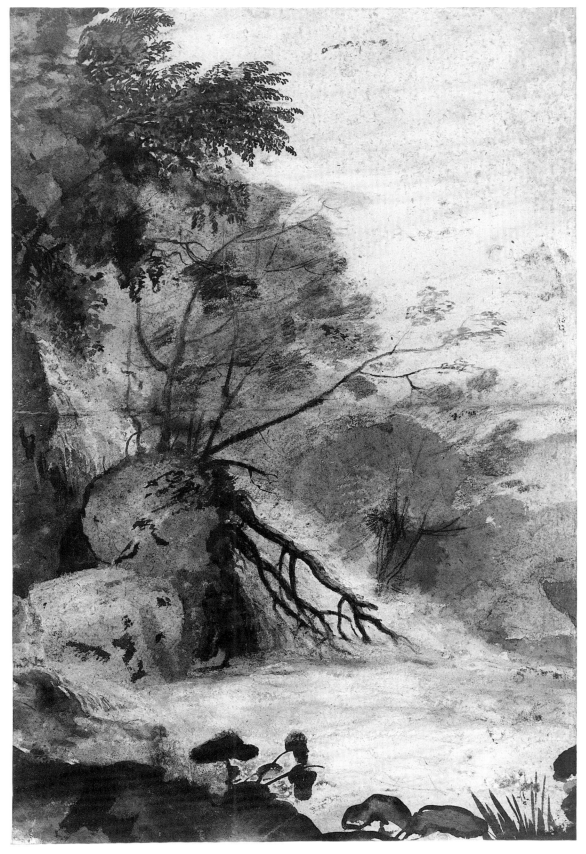

15

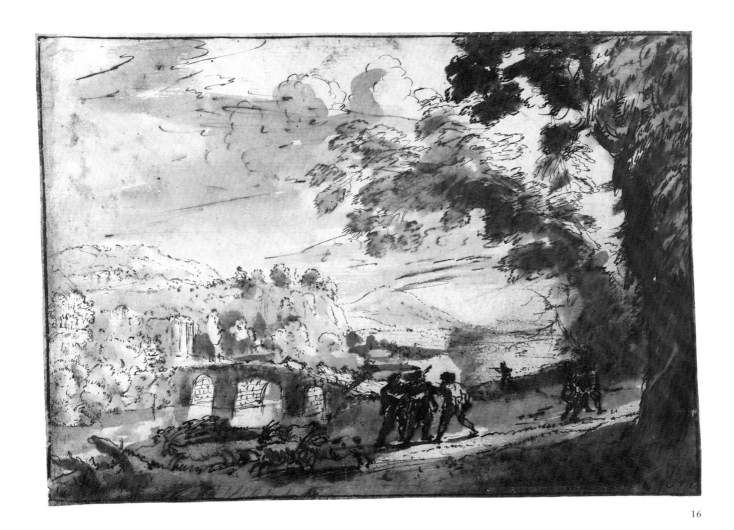

15. A Waterfall and Trees

Black chalk, pen and brown ink and brown wash, heightened with white body colour on medium weight, buff paper, creased horizontally through centre; a green stain, centre left, 388 × 252 mm

Inscribed on the *verso* by the artist: *Claudio/ 1635*

Provenance: bequeathed by Richard Payne Knight, 1824

British Museum, Oo.7–209; RD.92

Roethlisberger's catalogue lists only four dated drawings of the 1630s which seem to have been drawn from nature: a tree study of 1633 (RD.63), the present drawing, dated 1635, cat.23, a view of a stream in Subiaco, dated 1637, and a tree study in the Uffizi (RD.293) with a date in which the last digit is illegible. All four provide firm points, rare at this period in Claude's work, for dating the development of his nature drawings. The breadth and density of the brushwork, the use of a fairly heavy pale oatmeal paper and the emphatic contrasts of dark forms against the white water blur the distinction between drawing and painting and indicate, perhaps, the kind of nature painting in oils which, according to Sandrart, Claude practised in the 1630s. The theme of rushing water, studied at Tivoli and Subiaco, is common in Claude's drawings of the 1630s but features rarely in his paintings. Claude generally used white body colour in his drawings to indicate the lighter side of forms, but in these studies he uses it to give substance to the water, emphasising the effect by the use of dark brown wash and toned paper.

16. Landscape with Brigands

Black chalk with pen and brown wash on white paper, 196 × 265 mm

Verso Sketches of a Seaport, upside down in relation to the *recto*

Black chalk

Inscribed by the artist in pen and brown ink: *faict pour/ paris a Roma*; and above: *Claudio fecit/ in VR*; in lower left: *CL*

Provenance: Agnese Gellée(?); Joseph Gellée; 2nd Duke of Devonshire; 9th Duke of Devonshire, by descent; purchased 1957

British Museum, 1957–12–14–9; RD.77; K.3

This drawing originally formed the third page in the Liber Veritatis, one of five pages on loose sheets of paper which were added to the beginning of the bound volume. The painting which it records has not been traced. Claude's inscription on the *verso* indicates that it was sold to a client in Paris. Kitson and Roethlisberger date the drawing to *c*.1635 on the basis of a dated etching which shows the same figures in a different setting. The last digit of the date on the etching is unclear. Lino Mannocci, Pierrette Jean-Richard[6] and Diane Russell all read the date as 1633. This is certainly a possible reading of the inscription in the right-hand margin of the first state but Claude evidently had difficulty in reversing the numbers on his copper plates and it is hard, here, to see what he intended. 1635 seems, on balance, the better reading. The earlier date would imply that the original painting and this drawing date from 1633 or earlier. Diane Russell's suggestion that the etching may have

preceded the painting makes it possible to retain the later date for the painting and the drawing but does not adequately explain the existence of a small trial etching (M.10) which seems to form a link between the painting (as far as one can judge from the drawing in the Liber) and the larger print. The smaller print incorporates detail which appears in the background of the present drawing but is altered in the final etching. The scale of the figures in both etchings is greatly enlarged by comparison with the drawing in the Liber, in keeping with a tendency in Claude's work to increase the scale of the figures when transferring a composition into a smaller format. The meagre effect which resulted from diminishing the landscape of the drawing must have encouraged Claude to employ in its place the more dramatic setting which features in the print. For this, he used the background of his *Landscape with St Onofrio*, painted for Philip IV of Spain, omitting the tall tree which fills the space to the left of centre in the Spanish composition. The dating of the print provides circumstantial evidence for putting back the date of the Spanish commission to *c*.1634, confirming a suggestion by Michael Kitson that the *Landscape with St Onofrio* and the *Landscape with*

17

St Maria Cervello, which are not recorded in the Liber Veritatis, had been finished before Claude had begun to keep a consistent record of his work.

17. Landscape with Brigands

Etching, 132 × 199 mm (plate)

Inscribed in centre of right margin: *CLAUD I.V.ROMAE 1635*

British Museum, 1973-U-605; M. 11.ii

This is the second state of the print. According to Mannocci, early impressions are often poorly printed, but the details are richly worked and the effect of background light is suggested with great delicacy. The dark mass above the boulder near the centre is generally described as a rock, as it is depicted in the later, reworked states (M. 11.vii and viii), but comparison with the *Landscape with St Onofrio* confirms that Claude intended to represent a clump of trees. Scenes of bandits are a common theme in the work of contemporary Northern genre painters working in Rome, inspired by the notorious bandits who were, for many years, one of the hazards of the Campagna. Apart from a similar scene, painted for Cardinal Rospigliosi in 1638–9, and a variant, brigands do not feature elsewhere in Claude's art. The subject of the painting recorded in page 3 of the Liber is probably contemporary but the inclusion of the palm tree in the etching suggests a more specific theme. The tree may have been no more than a casual consequence of the debt to the Spanish painting but it could, equally, indicate that Claude had the story of the Good Samaritan in mind.

18. A Grove in Shadow

Pen and brown ink with brown wash on white paper, 191 × 260 mm

Stamped: Spencer (L. 1530)

Provenance: Earl Spencer; Richard Payne Knight, by whom bequeathed, 1824

British Museum, Oo.6-101; RD.97

This drawing represents an extreme instance in the development of Claude's 'blottesque' manner, based on his early mastery of wash, but applied with a new vigour and rapidity. The scribbled penwork came before the wash. The odd upright shape in the centre seems to represent the beginning of the bank which Claude redrew further to the right, then washed over this pentimento, rather meaninglessly, with the brush. In general, it seems, Claude used a thicker pen when reinforcing a composition which had been outlined in graphite or black chalk but used a thin, sharp point when drawing the preliminary work in pen. The darker washes were applied before the thinner washes had completely dried, causing an effect of melting tone and leaving a mysterious impression which is difficult to decipher in any detail. There are certain parallels to this manner in two composition studies for known paintings, neither exactly dateable but probably dating from before 1636 (RD.68 and 69) and, in a more general sense, in the early pages of the Liber, but nature drawings of this type are hard to date precisely. In general, Claude's pen drawings seem to have become increasingly disciplined and descriptive from the early 1640s onwards. The use of blotted washes does not appear to have survived this transition and it is not as common, even in his early work, as the fame of this kind of drawing might imply.

19. The Roman Forum

Pen and brown ink with brown wash on blue paper, 188 × 263 mm

Inscribed in pen and brown ink, lower left: *CLA*

Inscribed by the artist on the *verso* in pen and brown ink: *faict pour monsigr/ lambassadeur de france/ monsr de betune/ a Roma*; and below: *Claudio fecit/ in VR*; lower centre: *CL*

Provenance: Agnese Gellée(?); Joseph Gellée; 2nd Duke of Devonshire; 9th Duke of Devonshire, by descent; purchased 1957

British Museum, 1957-12-14-15; RD.123; K.9

19

20

Claude's painting of the Roman Forum (or the Campo Vaccino, as it was known from the cattle which were a feature of the site), recorded here in a page from the Liber Veritatis, was painted for Philippe de Béthune, who served as French ambassador in Rome on and off until 1629. With its pendant, *Port Scene with the Capitoline*, it forms a pair of Roman views (RP. 59 and 60), one more or less accurate, the other composed in the manner of a capriccio. In 1958, Michael Kitson demonstrated that Claude seems to have based his composition on an earlier work by Herman van Swanevelt, now in the Fitzwilliam.[7] The similarity between the two (including the omission of the column of Phocas) leaves little doubt that one of these paintings was based on the other (or that both were based on a common source). The differences in the façade of the church of SS Cosma and Damiano, which was rebuilt by Urban VIII in 1632, confirms that Swanevelt's picture was the earlier of the two. A number of small pen sketches of buildings in the Forum which appear on the back of the fifth sheet of the Liber have been identified by Kitson as notes for the composition. As these little sketches are on the back of a record drawing, Roethlisberger has argued that they were probably not done from nature; but, as they are

drawn upside down by comparison with the *recto*, they must have been done before the sheet was bound into the Liber, probably in *c*.1635. The drawing on the *recto* of these studies records a port scene, etched by Claude in 1634. This seems too early for any preparatory work on Béthune's painting which was probably still on the easel in 1636 when Claude transferred the composition to an etching. The notes on the *verso* must, therefore, be later than the drawing on the *recto*, lessening the possibility that they were made from nature, without ruling it out altogether.

20. The Roman Forum

Red chalk, pen and brown ink with brown wash on discoloured white paper, folded vertically through the centre, 181 × 256 mm

Provenance: bequeathed by Richard Payne Knight, 1824

British Museum, Oo.6–63; RD.122

In a careful comparison between the painting, the record drawing in the Liber, the present, more sketchy drawing in the British Museum and the etching, Michael Kitson

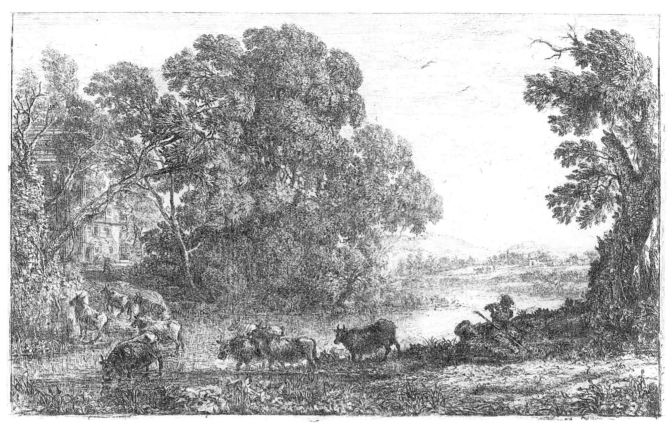

21

has pointed out that this drawing was based on the drawing in the Liber and was in all likelihood made for transfer to the print.[8] Despite Roethlisberger's refusal to rule out the possibility that the present drawing might have been a preliminary drawing for the painting and his reluctance to link it with the etching, Kitson's proposal seems to be consistent with the evidence. While the drawing could not be described as the sole model for the print, it seems, nonetheless, to have played a role in the transfer of the composition in the Liber Veritatis to the copper plate. An experiment with tracing paper suggests that the main outlines of the buildings in the second drawing have been traced from the drawing in the Liber, probably using a fine point of red chalk, traces of which are visible all over the sheet, particularly where they have not been obliterated by the pen lines. The main contours correspond precisely, although the details of the buildings along the east end of the Forum, from

S. Francesca Romana on the left to the entrance of the Farnese Gardens on the right, do not correspond at all, perhaps because this part of the drawing, which could not have been very clear with transmitted light, has been mistraced. The façade of S. Francesca Romana which runs into the side of the Colosseum and floats over a blank space, occupied in the Liber drawing by a substantial building, is particularly confused. Most of the figures seem to have been copied free-hand, not from the Liber drawing, but from the painting which must have been still available to Claude. The tracing must have been made in the process of transferring the main outlines to the copper plate with numerous corrections and with the addition of many details omitted in the Liber. The etching which corresponds in general outline and dimensions to both drawings, and in its smaller details to the painting, was Claude's most minutely detailed and carefully finished etching to date.

21. The Cowherd

Etching, 131 x 200 mm (plate)

Provenance: presented by Chambers Hall, 1855

Ashmolean Museum, M.18.i

The technical sophistication of *The Cowherd*, dated 1636 on the second state, marks a notable stage in the development of Claude's work as a printmaker, dividing the prints which bear signs of inexperience from those in which his mastery of the etching needle has been perfected. Prints which might be dated later than this have to match the assurance of this print; those which do not are probably earlier. The delicate effects of tone, created with a powdering of fine lines, evoke the warm light of a summer evening. The balanced composition and careful rendering of details suggest a painting but no related painting is known. When Claude set aside a number of his early etchings in *c.*1641 to make up a set of twelve sheets, he paired *The Cowherd* with his etching of Orsini's *Shipwreck* (cat. 55).

22. A View of Pine Trees

Pen and brown ink with brown and grey-brown wash on white paper, 289 × 207 mm

Provenance: bequeathed by Richard Payne Knight, 1824

British Museum, Oo.7–226; RD.111

Roethlisberger has pointed out that this view of pine trees is related to a similar view in the Early Sketchbook group (fig. 6) and also to a bank of trees in the background of a painting of 1637, recorded in the Liber Veritatis (RD.155). It is not impossible that one of these two drawings was copied from the other but the slight shift in viewpoint and other differences make it more likely that both were drawn from the same spot, on separate occasions, the small sheet first, as Roethlisberger suggests. The link between the present drawing and the composition of 1637 is particularly close, providing rare evidence of the use to which Claude put his nature studies in preparing painted landscapes. The composition is closed in the foreground by a dark band of ground

Fig. 6 *Pine Grove.* Black chalk and brown wash. RD.6, British Museum.

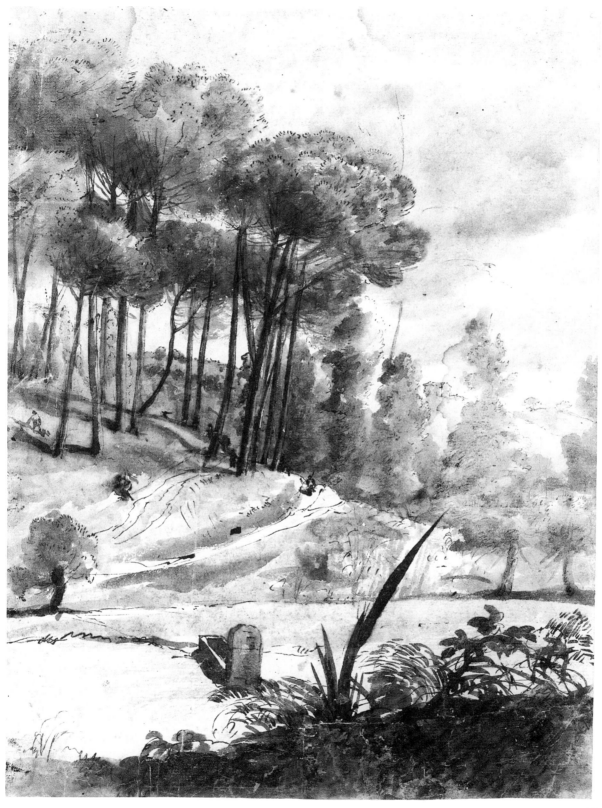

22

23

and plants, a motif which he used elsewhere in the 1630s in his nature drawings (e.g. cat. 15 and RD.354). The figures, wandering among the pines, suggest a Roman park.

23. A Stream in Subiaco

Black chalk with pen and brown ink, brown and pinkish-brown wash, heightened with white body colour on blue paper, creased vertically through the centre, 238 × 395 mm

Verso inscribed by the artist *Claude Gillée/ in fecit in sobiatco/ 1637*

Provenance: bequeathed by Richard Payne Knight, 1824

British Museum, Oo.6–71; RD.178

Although the technique of this drawing is essentially that of the study of the waterfall of 1635 (cat. 15), the handling is more disciplined, in keeping with a general tendency in Claude's drawings in the late 1630s towards greater technical exactitude. Similar effects recur among the studies of running water in the Tivoli Book and in a number of related drawings. The streaking application of white, the density of the brown wash and the layering of the foliage in upper left are characteristic of this group of drawings, which are all probably close in date to the present drawing. Claude has left three outlined spaces in lower left and along the lower edge for the inclusion of the type of framing motifs which are commonplace in his drawings from nature, but has completed only the left space in dark brown wash, leaving the others blank. According to Sandrart, Subiaco was one of Claude's favourite sites. From the evidence of the small number of drawings which can be linked to Subiaco, he continued to visit the locality in later years and drawings of the district must have been more common at one time than they are now.

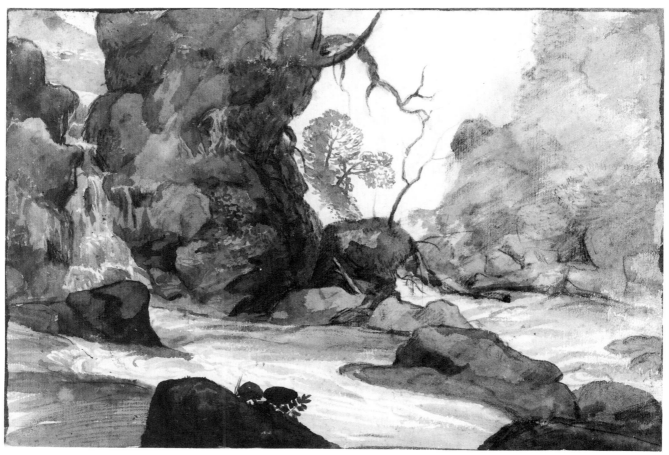

24

24. A Study of a Stream

Black chalk, with pen and brown ink and brown wash on white paper, within a framing line in pen and brown ink, 216 × 312 mm

Provenance: bequeathed by Richard Payne Knight, 1824

British Museum, Oo.6–73; RD.440

The subject recalls the waterfall drawn by Claude in 1635 (cat. 15) but the handling is broader and simpler, closer in effect to the tree studies in the Campagna Book. The lights on the water, picked out against the dark wash, and the movement of the stream, indicated with strokes of thin wash, contrast with the dark mass of rocks and foliage which are boldly washed in and thickly outlined with the tip of the brush. The rock, on lower right, is drawn over another rock and was probably an invention of the artist who could rarely resist adding foreground motifs of this kind in the lower corners of his drawings from nature. As in many of Claude's drawings, the brush has picked up the black chalk, giving a greyness to the thinner wash. From the evidence of the number, inscribed in the lower right corner, Roethlisberger has identified the drawing as a page from the Tivoli Book.

25. Landscape with a Country Dance

Pen and brown ink with brown wash; touched with green wash on the drapery on the tree, in the foreground plants and in the foliage, upper right; heightened with white body colour, on white paper; toned with a yellowish wash, 194 × 259 mm

Inscribed by the artist on the *verso* in pen and brown ink: *faict pour la sate del ppa Vrbana*; and below: *Claudio fecit/ in V.R*; and below again: *faicta ppa urbana*; in lower centre: *CL*

Provenance: Agnese Gellée(?); Joseph Gellée; 2nd Duke of Devonshire; 9th Duke of Devonshire, by descent; purchased 1957

British Museum, 1957–12–14–19; RD. 130; K. 13

The effect of this drawing, one of the most richly worked among the early pages of the Liber, depends on a combination of pen, wash and white body colour, found more commonly in the blue pages. The pale brown wash covering the paper gave the artist an equivalent ground on which to work up the effects of flickering sunlight slanting into the composition from a point not far above the horizon on the right. The picture which it records, painted for Urban VIII, was one of Claude's most important commissions to date, one of a pair with a view of a seaport at sunset, now in the collection of the Duke of Northumberland. The seaport is signed 1637, which must also be the approximate date of the *Landscape with a Country Dance* (now in the collection of the Earl of Yarborough) and also of this drawing. As is usual in Claude's copies in the Liber, the figures are drawn on a slightly larger scale by comparison with the figures in the painting. The details, otherwise, follow the original, apart from the trophy, hanging from the slanting tree, and a round temple in the background to the right, which, as Kitson notes, feature in the painting but are omitted from the drawing.

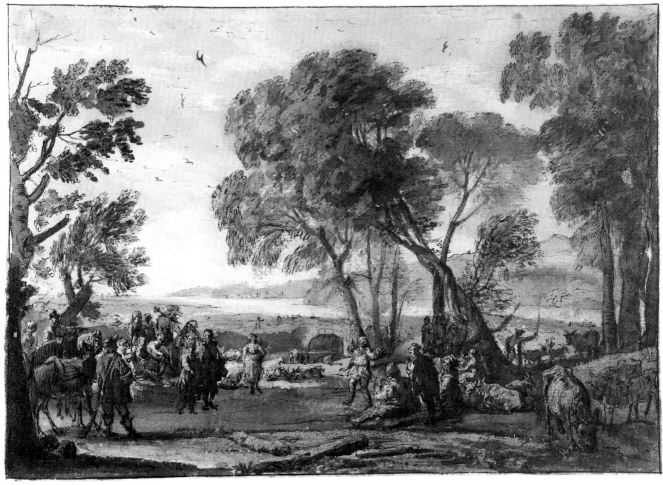

25

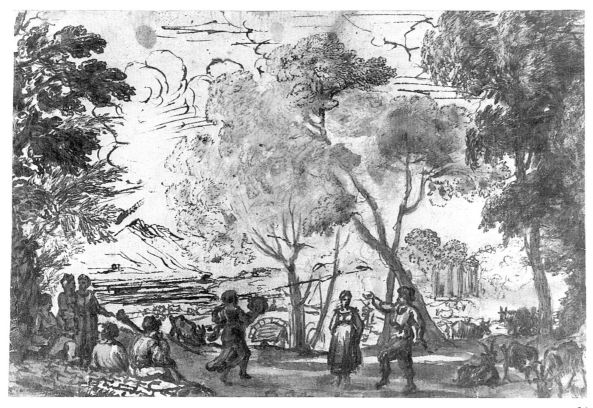

26

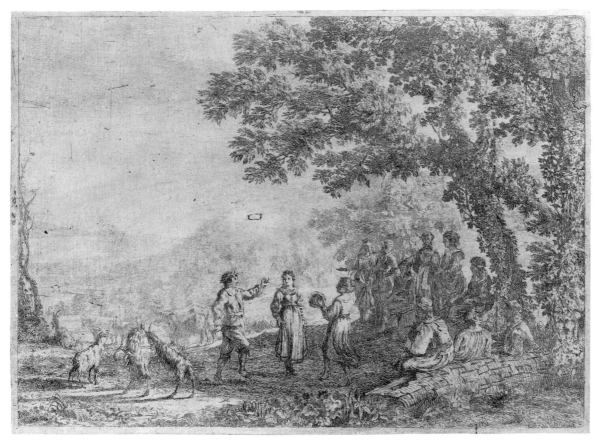

26. Dancers in a Grove

Black chalk with pen and dark brown ink and dark brown wash, partly indented, on off-white paper; green stains, upper left and upper centre, 125 × 180 mm

Provenance: presented by Chambers Hall, 1855

Ashmolean Museum, 1855.81; RD.131

The theme of the country dance appears at stages throughout Claude's art, beginning as a simple rustic motif and changing later into classical and biblical variations as his interest in commonplace subjects gave way to a growing interest in themes from literature and history. This drawing, prepared for transfer to the etching plate, combines two separate compositions on the subject of the dance, one of which is in the Uffizi (RP.63), the other of which, commissioned by Urban VIII, is in the collection of the Earl of Yarborough (RP.65). The painting in Florence, which seems to derive from the early *Dance by the Water's Edge*, must be earlier than the Yarborough picture and is recorded, fairly closely, in another etching (fig.7). The present drawing and the etching based on it are not a record of the papal commission but combine the figures in the Uffizi picture with the background of the Yarborough painting to create a new composition. It is not, strictly speaking, a record of Urban's picture. If anything, it seems to have been made as a record of the composition in Florence into which the background of the Pope's picture has been inserted, perhaps because it provided a livelier setting for the dance than the less interesting valley view with flanking trees which appears in the painting in the Uffizi. As Roethlisberger points out, Claude seems to have used the drawing in the Liber as a model for the background of this drawing. The Uffizi painting does not feature in the Liber but Claude probably had the larger etching of *The Country Dance* (fig.7) to hand to provide a model for the figures. The outlines are incised with a stylus and correspond closely in reverse to the second etching. It is not obvious why Claude should have etched this composition twice. It may be that the experimental nature of the first etching, which led to a rapid deterioration of the image, coupled with a patch of damage on the plate, visible in the second state, persuaded Claude to abandon the first version and make a second etching of this engaging composition, incorporating his latest thoughts about the background.

(*Left*) Fig.7 *The Country Dance*. Etching. M.20.ii, Ashmolean Museum.

27. The Country Dance

Etching, 136 × 196 mm (plate)

British Museum, 1851-5-30-1; M.19.i

The figures correspond to the *Landscape with a Country Dance* in the Uffizi, a painting which is not recorded in the Liber Veritatis, probably because, as Diane Russell suggests, it predates the beginning of the book. This painting was also reproduced in an ambitious etching (fig.7) which Claude seems to have abandoned after attempting to correct a patch of damage near the centre of the plate. Neither print is dated but the damaged print lacks the assurance of the present print and is surely the earlier of the two. The setting of the present etching does not correspond to the painting in the Uffizi but is taken from the later version of this subject, painted for Urban VIII in c.1637. The foliage in the background is denser here than it is in the painting, in keeping with a less spacious and more intimate treatment of the subject. The composition was traced from the preparatory drawing in Oxford (cat.26) which is, more or less, a mirror image of the print. The goats, on the right side of the drawing, were burnished out in the second state. In the set of twelve prints, prepared in c.1641, Claude paired this etching with the *Coast Scene with Artist Drawing* (M.2).

28. An Antique Herdsman

Red chalk with black chalk and brown wash, reworked in the lower half with pen and brown ink, on white paper, edged with a framing line in red chalk, reinforced in pen and brown ink, 269 × 192 mm

Provenance: bequeathed by Richard Payne Knight, 1824

British Museum, Oo.6–66; RD.147

The technique of broad, soft, black chalk underdrawing, shaded with a transparent wash, is reminiscent of the chalk and wash landscapes, usually dated to the 1640s and later, but the fine outline in red chalk and the rapid scribbled hatching with the pen suggest a date in the late 1630s. It has the character of a drawing from nature, taken from a hill overlooking the Tiber valley, which has been expanded later with the pen to include the seated figure. But this possibility is undermined by the outline in sharp red chalk which corresponds, in the main, to the present composition, apart from the landscape on the left which was originally drawn in red chalk with a tree and pointed mountain in the distance but was redrawn with black chalk as it now appears. The fine red chalk outline may have been traced from a nature study, but this is a studio drawing, composed perhaps as an intermediary stage between a study made in the open air and a composition. By contrast with most of Claude's

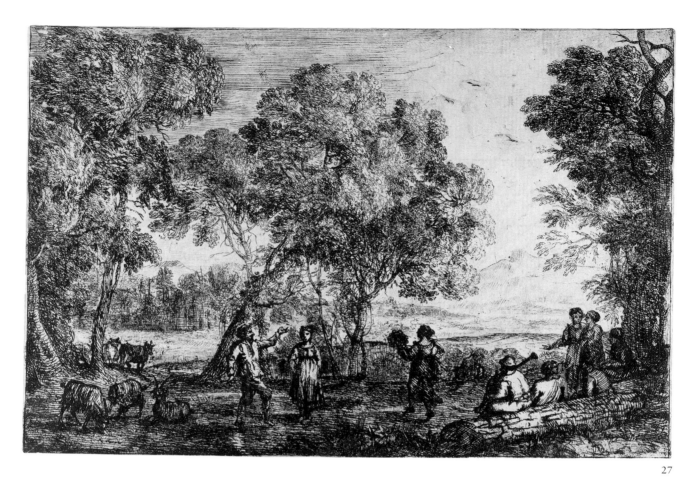

27

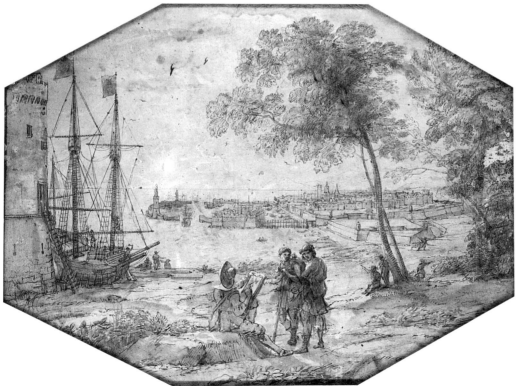

Fig. 8 *View of Civitavecchia*. Black chalk, pen and brown ink, heightened with white body colour on faded blue paper. Private collection, photograph by permission of Sotheby's.

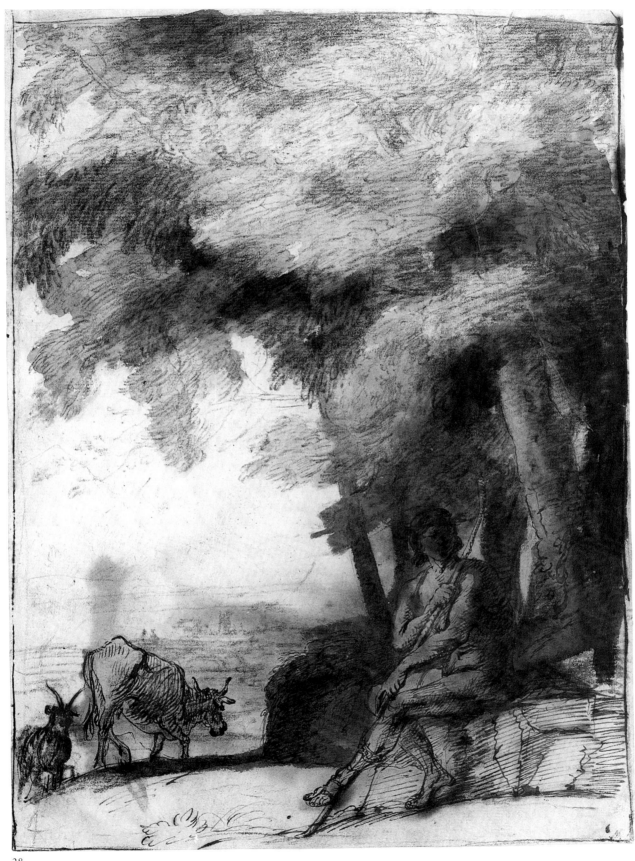

28

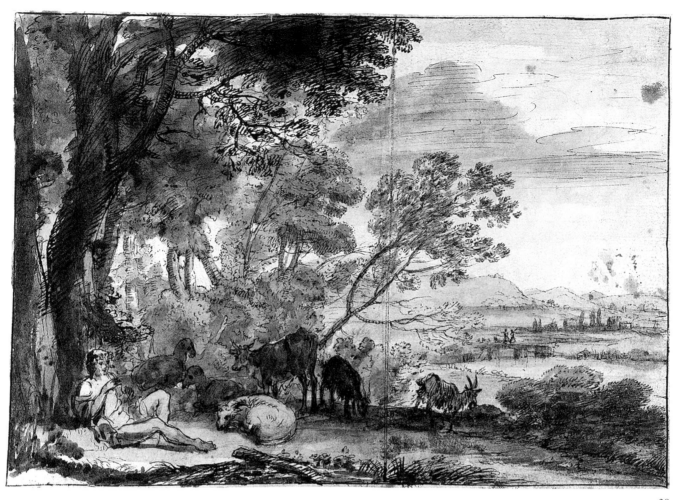

29

herdsmen of the 1630s and 1640s, this figure is identified by his elaborate buskins as a herdsman from antiquity. Although he does not correspond to the similar antique herdsman in the *Pastoral Landscape* of 1637 in the Pallavicini collection in Rome, the monumental composition, the unusual upright format and the antique theme are common features. It is not impossible that the drawing may have been made for the Pallavicini painting but Claude's working methods make it difficult to be certain. Similar subjects, treated in the same upright format, appear sporadically in Claude's drawings over a number of years, with or without the seated figure (e.g. RD.498, 869).

29. Landscape with a Goatherd

Pen and brown ink with grey-brown wash on the left side and grey wash only on the right side; reworked on the left with pen and dark brown ink, on white paper, 195 × 260 mm

Inscribed by the artist on the *verso* in pen and brown ink: *faict pour (moigre* crossed out) *monsre Roispiose/ Roma*; and below: *Claudio fecit/ in VR*

Provenance: Agnese Gellée(?); Joseph Gellée; 2nd Duke of Devonshire; 9th Duke of Devonshire, by descent; purchased 1957

British Museum, 1957–12–14–21; RD.134; K.15

The picture recorded in this page from the Liber Veritatis was painted in 1637 for Cardinal Rospigliosi, later Clement IX, and remains in the possession of the Rospigliosi-Pallavicini family in Rome. Only the left section of the drawing corresponds to the painting which is an upright picture. Michael Kitson attributes Claude's decision to extend the composition on the right to the artist's desire to fit the upright composition into an oblong page. Elsewhere, Claude simply squashed the composition to fit the page or (less willingly) turned the book on end. At this stage in the book, he seems to have drawn the copy in the same format as the painting but later changed his mind, adding a section on the right for the sake of unifying the appearance of his book. The left section was outlined in thin black chalk and worked over with pen and brown wash. The second section is drawn over black chalk with pen and grey ink and grey wash with a central tree added as a bridge between the two

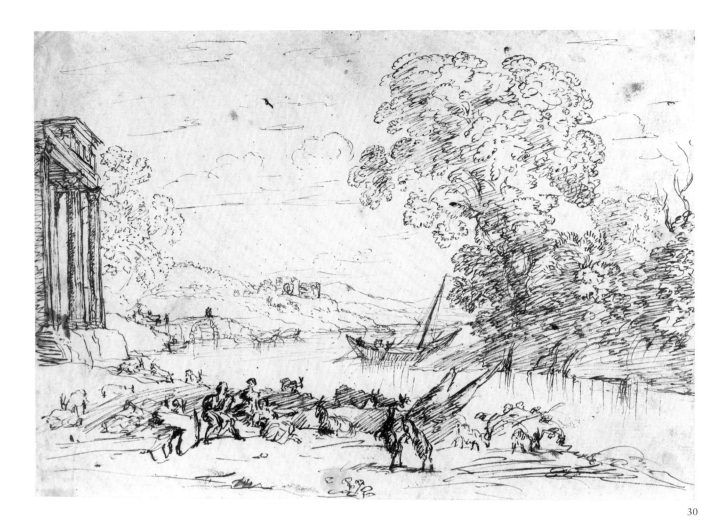

parts. The grey wash in the right section is not used in earlier drawings in the Liber but Claude adopted it briefly in three later pages, LV 20 to 22, which are separated from the present drawing by five pages of drawings in brown ink. The work in grey wash was probably done at the same time as the group of three, later in the same year. This account is consistent with Kitson's explanation of the drawing but less easy to reconcile with Diane Russell's theory, cautiously proposed, that Claude designed the drawing in two sections as a record of an etching (cat. 10) which the artist printed in two parts by cutting the plate in half. It is possible that he expanded the drawing in the Liber by borrowing some aspects from the etching for the added section and it may be that the ambiguous nature of the extended drawing gave him the idea of dividing his print, but even this is doubtful. In its extended form, the drawing seems to have provided him with the theme of a similar, oblong drawing of a herdsman in the Louvre, dated 1660 (RD. 848). It also links, in a general sense and in several details, with a number of later pastoral scenes of seated figures and animals.

30. Pastoral Landscape with Figures and Animals

Pen and brown ink on white paper, 199 × 271 mm

Verso A Study of a Composition with a Flanking Building on the Right

Black chalk

Provenance: bequeathed by Richard Payne Knight, 1824

British Museum, Oo.6–55; RD. 161

This drawing corresponds closely to a painting belonging to the Earl of Halifax (RP. 80). It was assumed, until Kitson discovered a variant in a private collection in Sussex (RP. 81), that the Halifax painting was the original of the drawing in the Liber, despite many differences of detail.[9] Kitson initially supposed that the Sussex painting, recorded in the Liber, was the prime version but now accepts that the Halifax painting must be the earlier of the two, partly because the present drawing, which has an exploratory character, seems to anticipate the Halifax painting more closely than the other and partly because

the temple on the left in the painting in Sussex once followed the form of the temple in this drawing and in the Halifax painting, but was subsequently overpainted in the form in which it appears in the Liber. Pen drawings of this type (but usually neater) seem to have been used by Claude in the 1640s and 1650s to work out details of his compositions after the general outlines had been settled. In this case, the drawing is very close to the painting and, if it is a preparatory drawing, must have been drawn fairly late in the preparatory process. But to what purpose? The rapid, sweeping touch and the close correspondence to the finished painting seems more consistent with a quick copy of the painting which, in the absence of an entry in the Liber, might have been used by Claude as the basis of the Sussex variant. The only other known drawing of this type (cat. 60) is similarly close to the final composition. The pair of prancing goats in this drawing reappears in the etching known as *The Goats* (cat. 10), which is sometimes thought to derive from the drawing on page 15 of the Liber (cat. 29), but is certainly earlier. The drawing in the Liber does not include this detail but a pair of grazing goats which is similar to the pair in the Sussex painting. If the use of grey wash in the added section of LV 15 can be taken as evidence that Claude reworked the drawing in late 1637 or 1638, at the time he entered LV 20–22, it is probable that the original of LV 23, the Sussex painting of 1638, was already on the easel to provide him with the detail of the grazing goats which he inserted into the added section in the drawing.

31. Pastoral Landscape with Castel Gandolfo

Pen and brown ink with brown wash, heightened with white body colour, on blue paper, 195 × 265 mm

Inscribed by the artist on the *verso* in pen and brown ink: *faict per papa/ Vrbano*; and below: *Claudio fecit/ in V.R.*; numbered: 35 (twice); in lower right: *CL*

Provenance: Agnese Gellée(?); Joseph Gellée; 2nd Duke of Devonshire; 9th Duke of Devonshire, by descent; purchased 1957

British Museum, 1957–12–14–41; RD. 326; K. 35

This enchanting composition is an exact record of the little octagonal painting on copper, now in the Fitzwilliam, commissioned by Urban VIII as a record of the castle at Castel Gandolfo, built for the Pope by Carlo Maderno in 1629. Claude preferred to copy the composition in a rectangular format but lightly indicated the original shape in the corners of the sheet. From its placing in the Liber, the drawing must date from 1638–9. It has always been regarded as one of a pair with the octagonal painting of Santa Marinella of

c.1639, now in the Petit Palais in Paris, recorded on page 45 of the Liber. The coppers are of similar size and composition but are separated by ten pages of the Liber and must be about one year apart. It seems likely that the view of Santa Marinella was originally intended as a pendant to a view of Civitavecchia which was not carried further than a model drawing (fig. 8). From an inventory of the Pope's possessions, drawn up shortly before his death in 1644, it appears that the painting in Cambridge and its companion in Paris were originally framed in similar, but not matching, surrounds as one might have expected of a pair.[10] The point is unimportant as all three were clearly designed *en suite* as records of three sites associated with papal building projects. Perhaps because the size of the drawing in the Liber is not far removed from the size of the original in Cambridge, the charm of the painting is conveyed more accurately in this copy than it is in many other drawings in the book where the changes introduced by Claude to take account of the differences in scale tend to diminish or alter the sense of space in the original.

32. Landscape with a Hunting Party

Pen and brown ink with brown wash on white paper, 198 × 268 mm

Inscribed by the artist on the *verso* in pen and brown ink: *Claudio fecit/ in V.R.*

Provenance: Agnese Gellée(?); Joseph Gellée; 2nd Duke of Devonshire; 9th Duke of Devonshire, by descent; purchased 1957

British Museum, 1957–12–14–43; RD. 329; K. 37

This drawing and its pendant (cat. 33) are two of the most puzzling drawings in the Liber. Each corresponds, more or less, to the left- or right-hand side of a version of the *Landscape with a Country Dance*, now in the Louvre, and, less precisely, to the left or right side of the original composition, painted for Urban VIII in c.1637. The date of the related painting and their place in the Liber indicate that they were drawn in 1639. Roethlisberger suggests that they were drawn for the sake of recording details of the painting in Paris which differ from the original. Michael Kitson suspects that the purpose of these drawings is more complicated, partly because one of the pair of drawings, the companion to this, records a section of the painting which does not differ very much from the first version, while the present drawing records a detail which differs in many respects not only from Urban's painting but also from the painting in Paris which is its ostensible source. The riderless horse which appears in the painting in this group of onlookers has been omitted here, perhaps because its

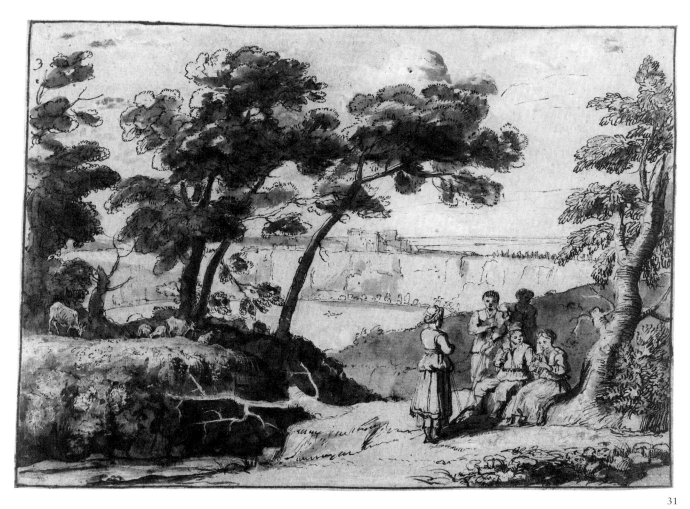

owner, without whom it loses its *raison d'être*, has left the group to join the dancers and, as a result, has also been cut out of the drawing. This points in the direction of a new composition in Claude's mind, derived from but independent of the original. By 1639, Claude must have already been thinking about his picture of Santa Marinella, commissioned by Urban VIII, in which this group of figures appears prominently in the foreground. Claude transferred this composition in the Liber directly into the model drawing for Urban (fig. 9) and again, with some minor adjustments, into the record of the painting of Santa Marinella in the Liber. By this stage, Claude had reproduced this group five times in different compositions, and to judge by the hasty pen and summary detail of the drawing in the Liber after the painting of Santa Marinella, his interest in the theme had begun to flag. A similar group of horsemen, nevertheless, reappears in the background of a drawing on the theme of the dance, dated 1663 (RD.902), a nostalgic reprise of what must have been a golden moment in Claude's rise to fame in the court of the Barberini pope.

33. A Herdsman with Seated Peasants

Pen and brown ink with brown wash on white paper, 199 × 269 mm

Inscribed by the artist on the *verso* in pen and brown ink: *pe*; and below: *Claudio fecit/ in.V.R.*; in lower centre: *CL*

Provenance: Agnese Gellée(?); Joseph Gellée; 2nd Duke of Devonshire; 9th Duke of Devonshire, by descent; purchased 1957

British Museum, 1957–12–14–42; RD. 328; K. 36

This group forms a pair with the previous drawing and raises the same problems. In this case, as Michael Kitson has remarked, the motif does not differ greatly from the corresponding detail on the right side of the painting in the Louvre, but nor does it differ extensively from the original painting in the Yarborough collection. The two groups in this drawing, the musicians and spectators seated on the log on the left and the herdsman driving his cattle on the right, each have a long history in Claude's work as motifs which he used as staffage for compositions. Claude hardly needed a record of such familiar details, particularly as they appear relatively unaltered in

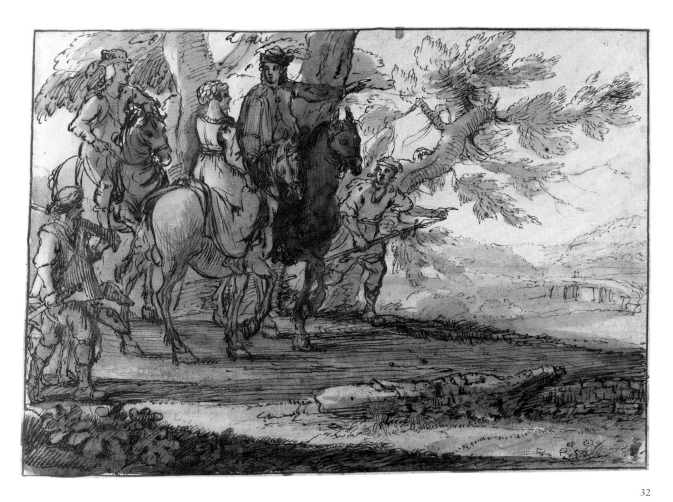

32

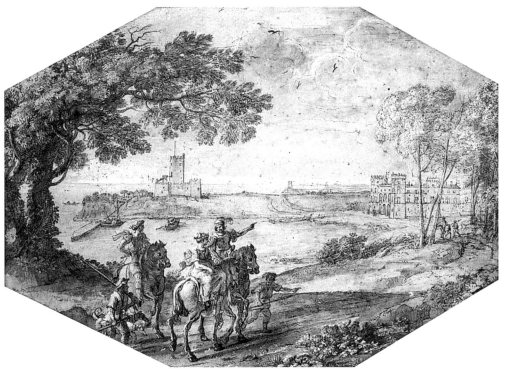

Fig. 9 *View of Santa Marinella*. Black chalk, pen and brown ink, heightened with white body colour on faded blue paper.
Private collection, photograph by permission of Sotheby's.

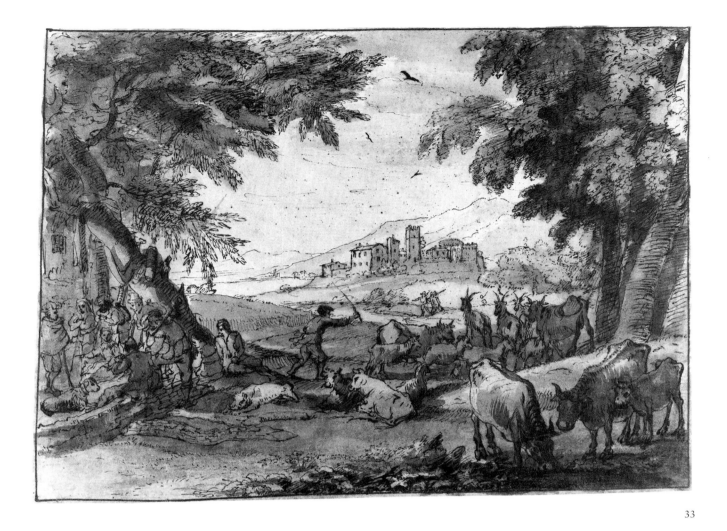

the Pope's picture of which there was already a record in the Liber. The conspicuous novelty in this corner of the variant, carefully recorded here, is not the group of figures, but the fortified *casale* which dominates the right end of the painting in Paris and seems to fill a role which goes beyond the normal requirements of picturesque accessories. It somewhat resembles the fifteenth-century castle at La Crescenza, two miles from the Ponte Molle, which figures elsewhere in his drawings and paintings but is of a type which is common in his work (e.g. RD. 589, 659, 685). The drawing is approximately contemporary with the similar views of Castel Gandolfo, the castle at Palo and the castle at Santa Marinella, each accompanied by figures in the foreground. In this case, the use of the companion drawing (cat. 32) in the painting of Santa Marinella, painted for Urban VIII, may be significant. Roethlisberger, followed by Kitson, has tentatively suggested that the patron of the Louvre variant may have been Urban who already owned the first version of this composition. Claude seems to have begun to write the name of a patron on the back of the drawing ('pe...', i.e. 'per' or 'for...') but changed his mind. The drawing in the Liber which records the Pope's picture is twice inscribed with Urban's name, suggesting by comparison with other inscriptions, where the owner of the variant is listed under the name of the first patron, that both paintings were commissioned by the Pope. This seems surprising, especially in view of the early French provenance of the variant and the presence of fleur-de-lis on the flags in the pendant, but there is nothing implausible in the suggestion that the Barberini pope might have commissioned it as a gift for one of his allies at the French court. The reason why Claude made these drawings was probably simple but is not now obvious. Whatever purpose they served, their existence illustrates Claude's habit of compiling a repertory of motifs which increased with time and passed from one composition to another in different combinations of background and figures.

34. The Tiber from Monte Mario Looking South

Dark brown wash on white paper, 185 × 268 mm

Verso A Faint View of Hills and a Slight Study of Folded Drapery

Pen and dark brown ink

Provenance: bequeathed by Richard Payne Knight, 1824

British Museum, Oo.7–212; RD.356.

The origin of this type of pure brush drawing can be traced to some of the pages in the Early Sketchbook and to Claude's early fondness for a flamboyant use of wash. The elimination of pen and line gives the image a remarkable purity. A similar mastery in contrasting patches of dark wash with the ground colour of the paper can be found in several drawings from the Tivoli Book in which pen and dark liquid wash are combined with memorable bravura. Without dated drawings, it is difficult to follow the progress of this style, but the manipulation of the wash to suggest a range of reflected lights and shadows seems to represent a notable development from similar river views which date from the early 1630s. Roethlisberger has identified Claude's viewpoint as a site on the hill above the Ponte Molle near the Villa Madama, looking back towards Rome with the Castel Sant'Angelo and St Peter's on the right.

34

35. View of Shrubbery with a Wall on the Right

Faint traces of black chalk with brush and brown wash on white paper, built up with a thin strip of paper on each side with framing lines in black ink on the added strips; a patch of repaired damage in centre of left side; a spot of green pigment, once at lower left, was removed by Eric Harding at the British Museum in 1970; spots of graphite mark the centres of the upper and lower edges, 190 × 252 mm

Inscribed in pen and brown ink, lower right: 35

Stamped: VC (L. 2508); Hall (L. 551); University Galleries (L. 2003)

Provenance: V.C.; Chambers Hall, by whom presented, 1855

Ashmolean Museum, 1855.67; RD.357

This view was drawn in the open air, close to the corner of a building, with a path on the left and what may be a flight of steps rising through rocks and bushes. It may have been made in one of the parks in Rome. Chambers Hall (who was not always reliable as a source of topography) described it as a view taken from the garden of the Villa Madama. The luminous wash and angular shapes in the shrubbery, drawn with the brush, recall the view from Monte Mario in the British Museum (RD.356), dated c.1640 by Roethlisberger. Both drawings may be earlier, but it is difficult to be certain.

35

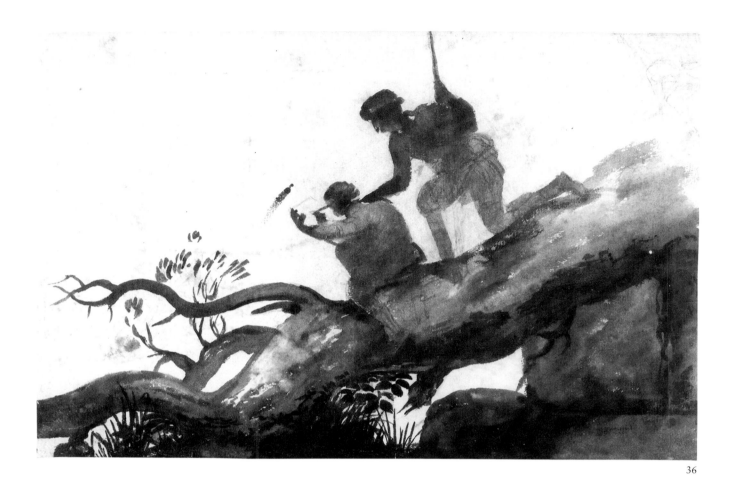

36

36. An Artist Sketching with a Second Figure Looking on

Black chalk with dark brown wash on white paper,
214 x 321 mm

Verso Study of a Tree (fig. 10)

Pen and brown ink with brown wash

Provenance: bequeathed by Richard Payne Knight, 1824

British Museum, Oo.7–181; RD.290

As Hind noticed, this charming, informal study of an artist sitting on a fallen tree with a second figure, probably a huntsman, looking over his shoulder, reappears in a drawing in the Liber Veritatis of *c.*1648 where the artist is seated on a trunk overhanging a river, with the Colosseum and the Arch of Constantine in the background (LV 115). Roethlisberger is surely right in dating the present study at least ten years earlier. The loose, liquid application of the wash with broken touches of darker ink in the shadows cannot be matched in drawings which can be dated after the early 1640s, at the latest, but is often found in drawings of the 1630s. The tree study on the other side of the sheet (fig. 10), drawn in a dotted manner with the brush, recalls a tree study in Florence, inscribed with a date in the 1630s, which is probably contemporary with the figures on the *recto*. Claude's use of a drawing made out of doors in a painting of much later date is consistent with his habit of composing pictures from an existing stock of images based on nature. It also points to the danger in assuming that paintings and related studies are necessarily contemporary.

Fig. 10 *Study of a Tree*. Black chalk and brown wash. RD. 290, *verso*, British Museum.

37. The Tomb of Cecilia Metella

Black chalk with pen and brown ink and brown and grey washes on white paper, edged with remains of a framing line in brown ink, 285 × 221 mm

Inscribed in pen and brown ink by the artist in centre of lower edge: *Claudio fecit/ Capo di Buove/* over an erased number: *8*

Verso Outline of the tomb traced from the *recto*

Red chalk

Provenance: bequeathed by Richard Payne Knight, 1824

British Museum, Oo.7–228; RD.283

The size and character of the paper and the nature of the inscription, followed by a number, all identify this drawing as a sheet from a dismembered sketchbook, reconstructed by Roethlisberger from its scattered pages and named by him the Campagna Book on account of its contents which largely consist of drawings from nature in the neighbourhood of Rome. None of the pages is dated but Roethlisberger has suggested that the sketches of Civitavecchia, which must have been made in *c.*1638–9 while Claude was preparing his painting of Santa Marinella for Urban VIII, provide an approximate date for the remainder of the book. This page was originally the eighth sheet in the book. Like most of the drawings in the sketchbook it was drawn largely, or entirely, on the spot. The view is taken from a site on the bank of the Appian Way, looking back towards Rome with the tomb of Cecilia Metella on the right. The inscription 'Capo di Buove' refers to the popular name given to the monument on account of the ox-heads which appear along the frieze. The drawing combines dense penwork in the trees of a kind associated with pen drawings of the early 1630s (e.g. RD.56, 58, 73) with a use of luminous wash in the rocks below, reflecting the lingering influence of Breenbergh and of the Dutch artists with whom Claude associated at this date. The virtuosity argues against a date in the region of the Early Sketchbook drawings but before the early 1640s when Claude's drawings acquired the greater breadth which is evident in several of the drawings from the Tivoli Book. The outline of the tower has been traced through on the *verso* with a sharp point of red chalk which Claude used in his early years for making tracings. He may have done this for the sake of taking a counterproof from the tracing with the intention of reusing this detail in a composition.

38. A Ship in a Storm

Light black chalk with pen and brown ink with brown wash on white paper, 270 × 228 mm

Inscribed in pen and brown ink by the artist in lower left: *Claudio fecit*

Verso Two views, one above the other, of a shipyard and castle

Inscribed in faded brown ink, lower left: *Cl 9*

Provenance: bequeathed by Richard Payne Knight, 1824

British Museum, Oo.6–99; RD.282

Although drawn on a page from the Campagna Book, this is not a study from nature. Roethlisberger has suggested that it might have been drawn from a ship's model which would account for the general accuracy of the detail and the absence of a crew. There is a similar drawing of two ships in a storm in the Louvre which is not numbered and inscribed but may also have been removed from the Campagna Book and subsequently trimmed. These drawings might have had a connection with a painting of a storm at sea which Claude completed for Paolo Giordano Orsini in *c.*1638. The flags on the ships in both drawings are emblazoned with a barry of four, not identical with the bendy of six which appears in the Orsini arms but not dissimilar. The two sketches on the *verso* show a continuous view of the shipyard and Orsini castle on the shore at Palo. These seem to have been the basis for a finished composition in the Louvre (RD.324), probably a model drawing for a painting which was not taken further. The number on the drawing locates the original between studies made in the vicinity of Rome. If the Campagna Book was completed chronologically and if Claude visited Palo on his way to Santa Marinella, the drawing on the *verso* must have been added later and out of sequence. Claude may have selected a blank *verso* at random when he inserted the view of Palo or he may have wished to associate it with the drawing on the *recto*; it is impossible to know and pointless to speculate further.

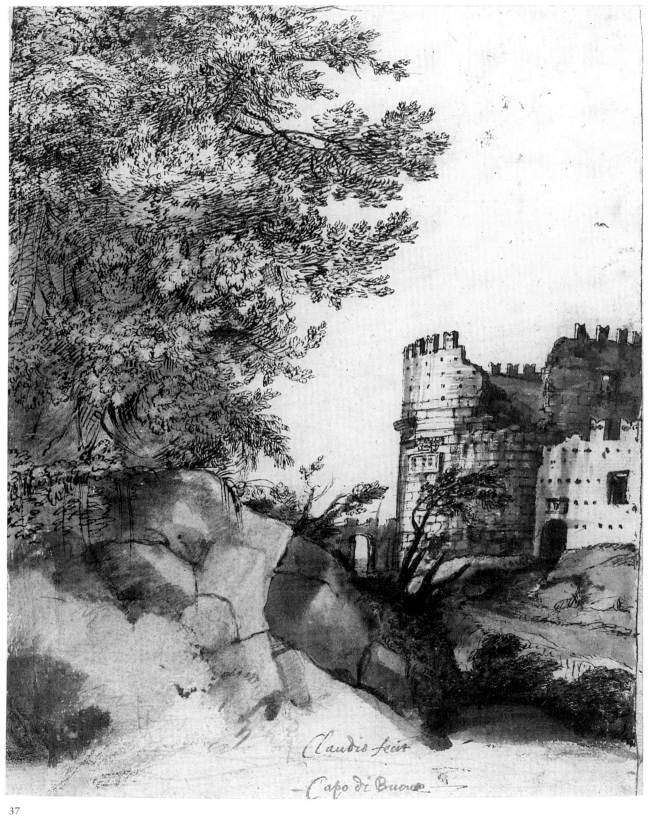

37

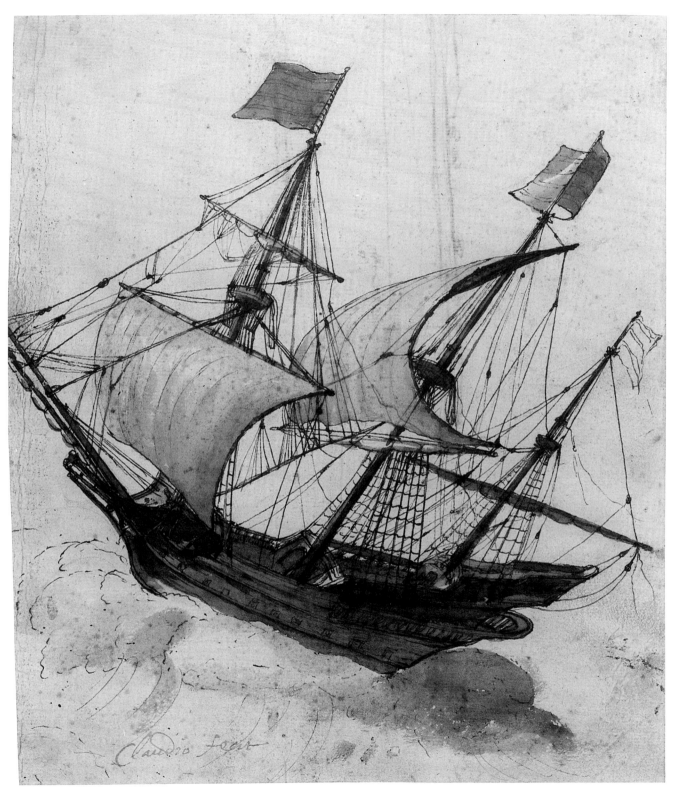

38

39. Study of a Tree

Black chalk with brown wash on white paper, faded and discoloured, with repaired losses in lower left, 316 × 221 mm

Inscribed in pen and brown ink in lower right: *Claudio fecit/ facto a la vigne madama*; the number 20 (erased)

Verso Five slight sketches of landscape, two with a distant view of a fortified building

Black chalk

Inscribed: *Clav 17 and 1836 WE* (L. 2617), in pen and brown ink

Provenance: William Esdaile; George Salting, by whom bequeathed, 1910

British Museum, 1910–2–12–91; RD. 291

Although severe discolouration and fading have almost destroyed the original effect of contrasting light and shade, enough remains to indicate the direction of Claude's drawing in the late 1630s towards a broader, flatter use of wash to evoke the effect of deep shadow and a greater responsiveness to monumental forms in nature. The rapid underdrawing in black chalk and the freedom with which the wash has been applied are consistent with a study drawn on the spot on a wooded hill with a distant view of a fortified *casale*. There exists a second version of this drawing in the Fitzwilliam (RD. 292) which, without knowledge of the present drawing, might have been mistaken for a drawing from nature. Roethlisberger is surely right in identifying the Cambridge drawing as a careful copy by Claude of the drawing in the British Museum, a little lifeless by comparison, perhaps done about the same time for the sake of clarifying the image for reuse in a painting. Massive trees like this are common in Claude's art.

40. Study of an Oak Tree

Black chalk with pen and brown ink and grey-brown wash on white paper within a framing line in dark brown ink, 330 × 225 mm

Inscribed in pen and brown ink by the artist in lower right: *Claudio fecit/ facto a Vigne Madama, 22*

Verso A group of trees, traced from the *recto*

Red chalk

Inscribed: *54*, upper left, and *CL 19*, lower right, in pen and brown ink

Provenance: bequeathed by Richard Payne Knight, 1824

British Museum, Oo.7–224; RD. 295

This drawing belongs to a group of tree studies which appeared between the pages numbered 17 and 25 in the Campagna Book, probably dating from the late 1630s, two of which are identified in Claude's handwriting as views taken in the park of the Villa Madama, less than two miles uphill from the Ponte Molle. It is easy to find general similarities between many of Claude's tree studies and the trees in paintings but the changes which he made habitually in developing the details of his compositions make it difficult to point to exact correspondences in any but a few cases. A tree trunk of this kind reappears in a highly finished drawing of *Diana and Callisto*, in reverse direction (RD. 546). There is also a general likeness between this study and a pastoral painting in the National Gallery in London which is not close enough to be identified as a study for the painting but it suggests the kind of study which Claude may have employed in preparing his composition. The painting in the National Gallery has for long been associated with Baldinucci's account of a painting made from nature by Claude in the park of the Villa Madama for which Cardinal Rospigliosi is said to have offered 'as many doubloons as were necessary to cover it completely'. According to Baldinucci, Claude valued the picture as a model for studying 'the variety of trees and foliage' and refused to sell it to the Cardinal. Because Claude painted a variant of this composition in the same unusual upright format for Rospigliosi (see cat. 29), Roethlisberger is inclined to identify the painting in London as the one seen by Baldinucci.[11] Kitson is less convinced, pointing out that the painting does not differ significantly from Claude's studio work, and suggests it may be no more than a variant of the Rospigliosi painting.[12] It remains possible, however, that this was the picture seen by Baldinucci. Whether or not it was painted in the open air, the affinities between this painting and the present drawing emphasise the extent to which the naturalism of Claude's paintings depended, at least indirectly, on studies done in the open air.

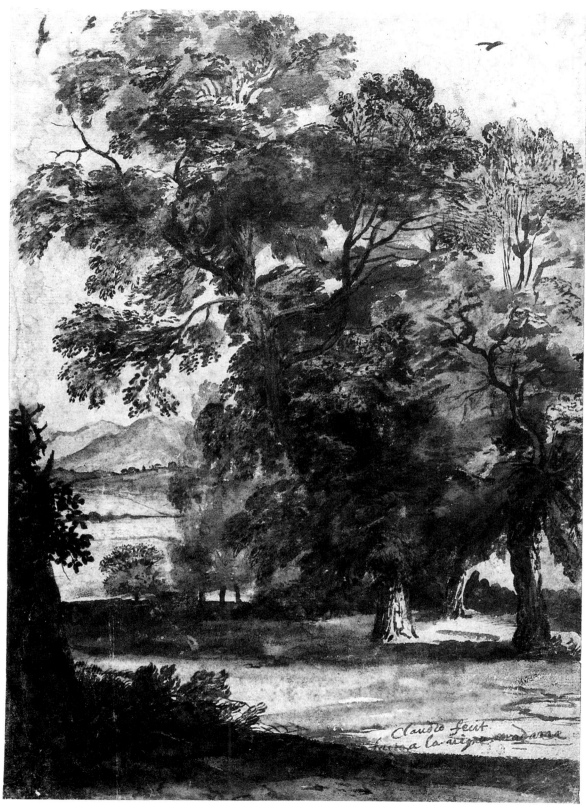

39

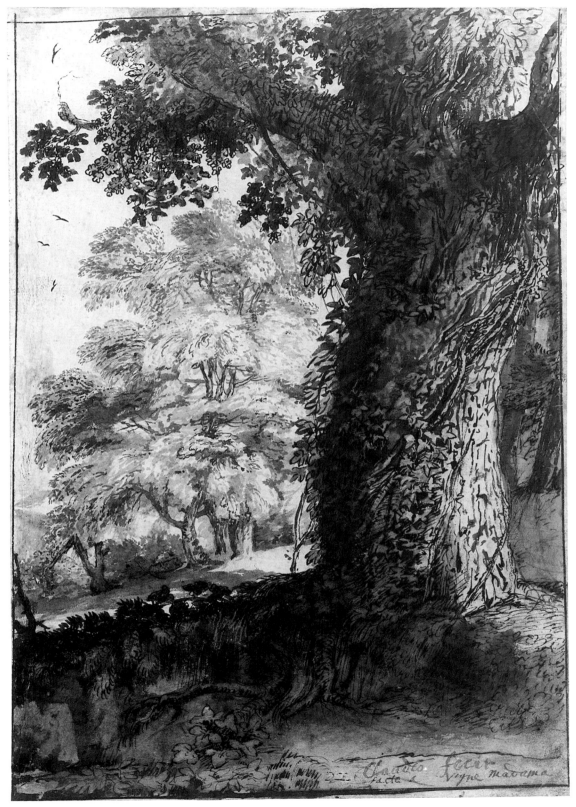

40

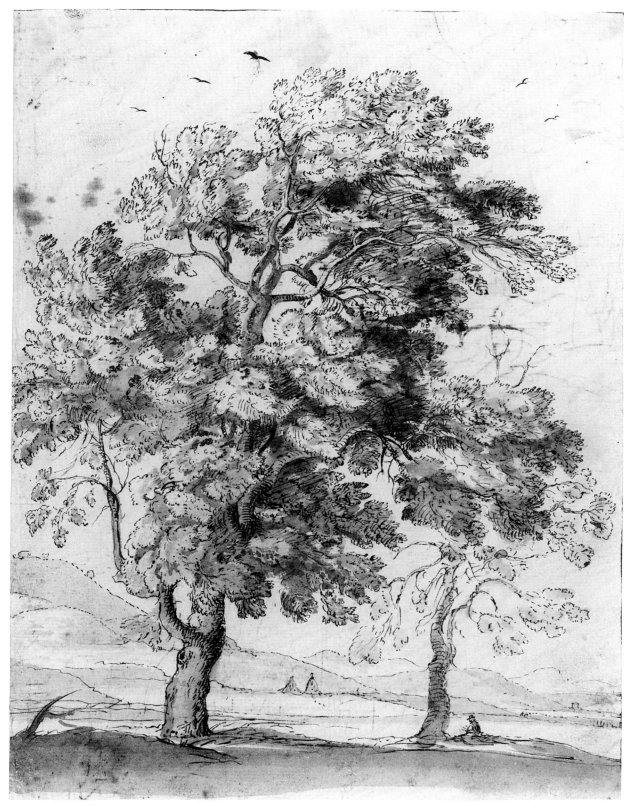

41

Fig. 11 *Four Composition Studies*. Pen and brown ink, touched with wash. RD. 302, *verso*, British Museum.

41. Study of a Tree

Pen and brown ink with brown and grey wash, touched with white heightening (oxidised) on the tree, on white paper, edged with fragments of a framing line in pen and brown ink, 292 × 218 mm

Verso Four Composition Studies (fig. 11)

Pen and dark brown ink, touched with brown wash

Provenance: bequeathed by Richard Payne Knight, 1824

British Museum, Oo.7–173; RD. 302

The mechanical character of this study, drawn in pen and ink without the preparatory work in black chalk found in the tree studies in the Campagna Book, suggests that it is not drawn from nature but is a copy, made in the studio. The pen and wash drawing, on which it seems to have been based, is found on a sheet from the Campagna Book in Haarlem (RD. 305), with a tracing on the back which has, in turn, been copied on to another sheet, also in Haarlem (RD. 306). As a result, there are four known versions of this drawing, two shaded in brown wash, in opposite directions, and two mainly in pen and ink, also in opposite directions. The drawing on the recto of the sheet from the Campagna Book is freer and richer than the others and is probably the original nature drawing from which the others derive. Mirror images would have usefully increased the stock of Claude's motifs as staffage for his paintings. The verso of this drawing has four slight sketches for upright compositions with trees and buildings which probably mark Claude's first thoughts about a composition or series of compositions (fig. 11). Studies of this kind must have been used as the starting point for many of Claude's paintings but only a handful are known, preserved on the backs of more finished drawings. Several of these exploratory drawings show Claude trying out a number of variations of a single composition, but in this instance he seems to have had four separate images in mind. Claude's compositions, painted for the King of Spain in 1639–40, seem the only candidates. The fortified mill, in the background of *The Finding of Moses*, is faintly recognisable in the first of the four drawings; the others are too tentative to be identified. If the *verso* was drawn at about the same date as the *recto*, the tree study must date from *c*.1639. The original study in the Campagna Book must be earlier, but probably by very little, confirming the other evidence which indicates that the Campagna Book was in use in *c*.1638–9.

42. View of Civitavecchia

Pen and brown ink with grey and pink wash on white paper, 105 × 324 mm

Inscribed in pen and brown ink by the artist in lower right: *Claudio fecit per il viage/ di ciuitauecio/ 38*

Verso Two Views of Civitavecchia (fig. 12)

Pen and brown ink with grey wash

Inscribed in pen and brown ink by the artist in lower left: *Claudio fecit/ la pianta de la Citta de Ciuitauecio/ Cla 35 fogli*; numbered 35, changed to 36; on right: *mare*

Provenance: bequeathed by C. M. Cracherode, 1799

British Museum, Ff.2–157; RD. 310

According to Baldinucci, Claude went to Santa Marinella at the request of Urban VIII to draw the site where the Pope had recently completed a castle and where he planned an extensive expansion of the harbour. Only one drawing relating to this commission is known[13] but several drawings in the Campagna Book (RD. 310, 311, 312, 316), as well as others, probably from the same book (RD. 313, 314 and verso of 354), and a separate drawing in Berlin (RD. 315), record his work at the neighbouring port of Civitaveccia where he seems to have gone for the purpose of preparing a companion picture for the Pope. The painting of Civitavecchia was not taken any further than a model drawing (fig. 8) but the painting of Santa Marinella was finished as intended. The painting can be dated to *c*.1639 from the location of the copy in the Liber, making it probable that he went to Civitavecchia in 1638–9. Several of these studies, like this view from the Campagna Book, show horizontal views of the fortifications, seen from different directions; others, including the drawing on the *verso* of this drawing (fig. 12), are bird's-eye views, more closely linked to the background of the proposed composition. The view traced on to the *verso* was added after the inscription and, therefore, after the more substantial drawing of the sea-wall above. The drawing on the *recto*, showing a view of the harbour from the south with the lighthouse on the left, must have been cut, as the drawings of Civitavecchia in the Louvre have been cut, from a sheet with at least one other view of the harbour above. The use of pink wash is a common feature of the drawings from the Campagna Book from approximately folio 15 onwards (RD. 254).

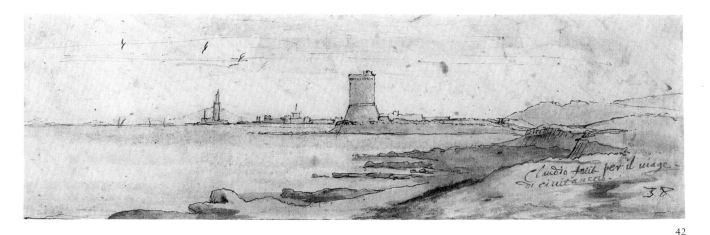

42

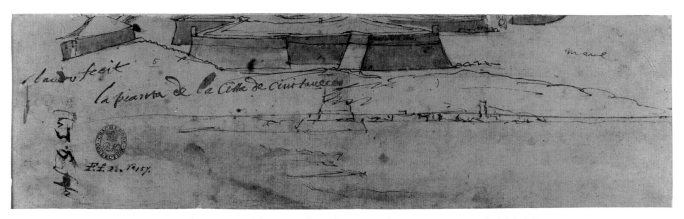

Fig. 12 *Two Views of Civitavecchia*. Pen and brown ink and grey wash. RD. 310, *verso*, British Museum.

43. Farm Buildings under a Tall Tree

Red chalk with pen and brown ink and brown wash, over an unrelated study of a rabbit, in black chalk on off-white paper, repaired on the lower edge and lower right corner, 310 × 217 mm

Inscribed in pen and brown ink, lower left: *Claudio. Gille*; and at lower right: *4*

Stamped: Hall (L.551); University Galleries (L.2003)

Verso View of Civitavecchia (fig. 13)

Pen and brown ink

Inscribed in pen and brown ink by the artist in upper left: [...] *porto*; and lower left of centre: *mare*

Provenance: presented by Chambers Hall, 1855

Ashmolean Museum, 1855.68; RD.354

The use of red chalk suggests a comparison with a number of drawings of the late 1630s which Claude tinted with a pinkish wash (e.g. RD.314 and 320), probably by touching the paper with red chalk and washing it with the brush. There is a landscape drawing in the Louvre (RD.737), touched with a few strokes of red chalk on the tower of a farmhouse, which may have been prepared for this effect. The area of brown wash, lower left, conceals an unrelated study of a rabbit in black chalk. The drawing on the *verso* (fig. 13), uncovered by Richard Hawkes in 1995, shows a view of the harbour wall at Civitavecchia very similar in character to six views of Civitavecchia in the Louvre and the British Museum (RD.310–14 and 316), all connected by Roethlisberger with the Campagna Book. The present drawing is almost certainly from the same series: the drawings on the *recto* and *verso* are similar in character to the drawings in the Campagna Book, the paper is approximately of the same size, and the damage at the lower right of the present sheet no doubt accounts for the absence of the inscriptions which are commonly found on these drawings. The fortified walls round the port of Civitavecchia do not survive, but the site drawn by Claude can be identified in Labat's plan of the town, drawn in the early eighteenth century, as the Porta di Livorno, protected by a gate and giving access to the sea by steps cut into the esplanade.[14] On the left is the entrance to the Darsena, the harbour for the papal galleys. The drawing has been only partially uncovered on account of the fragility of the paper; the upper left part of the *verso* is covered by an old patch strengthening the damaged sheet, through which the drawing and an inscription can be seen indistinctly.

Fig. 13 *View of Civitavecchia*. Pen and brown ink with brown wash. RD.354, *verso*. Ashmolean Museum.

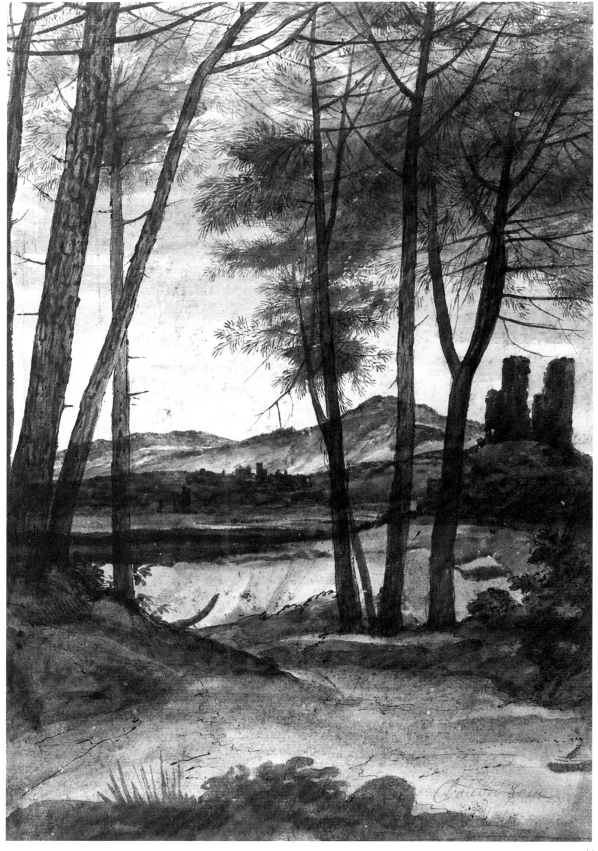

44

44. A Grove of Pine Trees with a Ruined Tower

Pen and brown ink with brown, grey and pink wash, on white paper, 320 × 222 mm

Inscribed in pen and brown ink by the artist in lower right: *Claudio fecit*; over an erased number: *39*

Verso Views of Civitavecchia (fig. 14)

Pen and brown ink

Inscribed in pen and brown ink by the artist, above: *mare*; lower centre: *fose/ pianto bono Vb*; and on the left: *Cla 39* (*59* erased)

Provenance: bequeathed by Richard Payne Knight, 1824

British Museum, Oo.7–230; RD.395

The dark line of wash in the middle distance may represent a roadside or riverbank. The ruined tower on the right and the tower on the distant hill are of a kind which was common throughout the Tiber valley in Claude's lifetime. The sense of twilight must at one time have been more dramatic but the effect is now diminished with the fading of the washes, particularly along the near foreground. The main lines of the view were marked first with a very sharp quill which the artist worked over with the brush in brown ink and pink wash before adding the pine trees with the brush. Finally, he touched in the details and strengthened the contours with a broader pen. Apart from the band of vegetation along the bottom, which is a stock motif in Claude's drawings from nature for closing off his composition, there is nothing in the drawing to contradict the supposition that Claude completed it entirely in the open air, working rapidly in the changing light of the Campagna. Claude used the back of the sheet to draw three rough outline studies of the sea-wall at Civitavecchia (fig. 14) which might have been added at any time after the date of the present drawing but, as an earlier sheet from the Campagna Book, numbered 36 on the *verso* (and 38 on the *recto*), has views of Civitavecchia on both sides, this view of pine trees from the same book, drawn on a page numbered 39 on the *verso*, must have been drawn at the time of his visit to the coast at Civitavecchia, dated by Roethlisberger to 1638–9. The inscription on one of the two views of the same stretch of the sea-wall on the *verso* was probably added by the artist to remind him which of the two was the more accurate.

Fig. 14 *Views of Civitavecchia*. Pen and brown ink. RD.395, *verso*, British Museum.

45. A Road in Wooded Countryside

Pen and brown ink with brown, grey-brown and pink wash on white paper, within fragments of a framing line in pen and brown ink, 215 × 313 mm

Inscribed by the artist on the *verso* in red chalk:
CLAU/ Ro IV

Provenance: bequeathed by Richard Payne Knight, 1824

British Museum, Oo.7–159; RD. 443

This drawing was once on page 2 of the Tivoli Book. It belongs to a group of woodland scenes which are all characterised by the virtuosity with which Claude evokes the play of light and shadow in the trees with rapid, scattered touches of the pen and washes of varying density. It is difficult to ascertain the extent of the period covered by this manner of drawing. It was certainly in use by the late 1630s, judging from the drawings in the Campagna Book, several of which are drawn with a similar darting pen and extensively washed in dark brown and pink. The drawing of a woodland road (RD. 284), formerly on page 15 of the Campagna Book, is particularly close. The Campagna drawing probably dates from the region of 1638 but this does not, in itself, exclude the possibility that the present drawing was done in the 1640s.

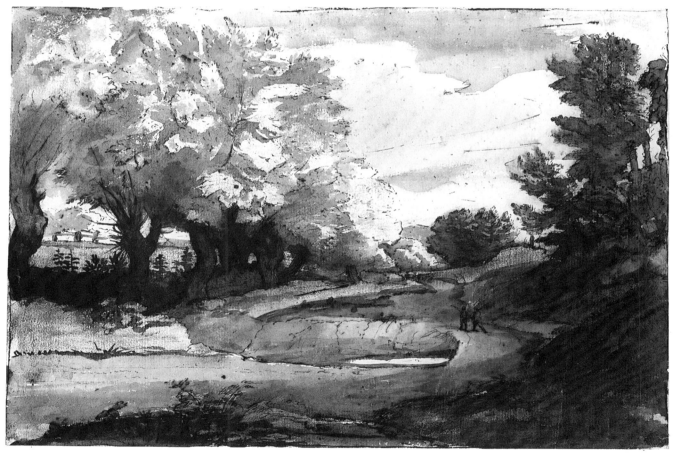

45

46. A Ploughed Field with Artists Sketching under a Tree

Black chalk with pen and brown ink and brown and grey wash on faded blue paper, 219 × 318 mm

Inscribed in pen and brown ink by the artist in lower right: *Claudio/ fecit*

Provenance: Jonathan Richardson (L. 2184); C. M. Cracherode, by whom bequeathed, 1799

British Museum, Ff.2–158; RD.414

This evocative drawing, sadly faded from exposure to light, has much in common with several tree studies in the Campagna Book and is probably contemporary, i.e. from *c*.1639–40. The first outlines are laid in with black chalk, the washes are applied with the brush, the details touched in with pen and the lights added with white body colour (now discoloured). The effect, which depends on a fine balance of transparent washes and opaque ink and Chinese white, must have been more striking once. The view shows two artists seated under a large tree by the edge of a ploughed field, a souvenir of the excursions which Claude made in the company of fellow artists into the Campagna. In keeping with a compositional device which Claude commonly introduced into his views of nature, the lower left corner has been cut off with a dark, indeterminate patch of wash.

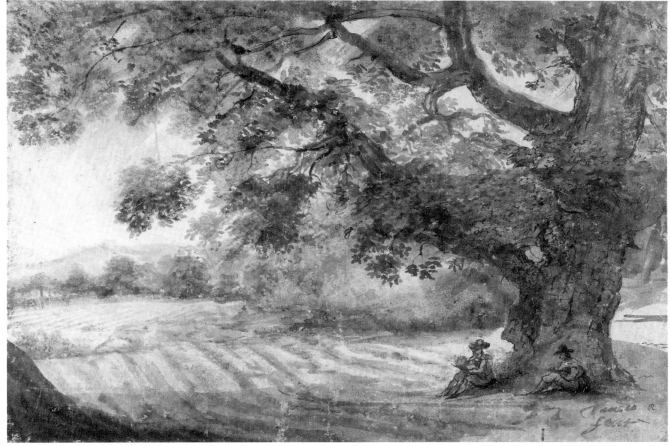

46

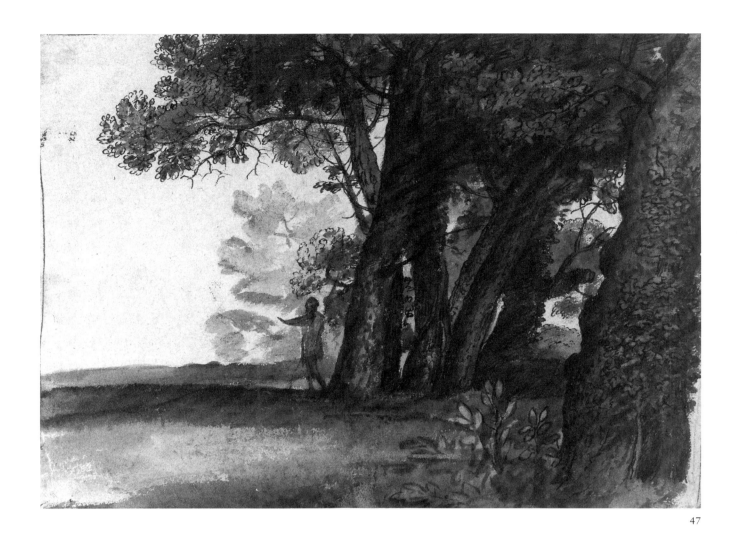

47. The Edge of a Wood

Black chalk, pen and brown ink and brown wash on blue paper, edged with a framing line in pen and brown ink, 191 × 257 mm

Provenance: bequeathed by Richard Payne Knight, 1824

British Museum, Oo.7–223; RD.417

The fresh condition of this drawing conveys the magical effects which must have originally been more evident in several of the wash drawings of the late 1630s or early 1640s which have survived less well than this, in particular cat. 46, which is drawn with the same sequence of black chalk, pale underwash, pen and brown ink and dark retouching with the brush. The absence of the white highlighting that is common in Claude's drawings on blue paper gives an intensity to the shadows and an element of mystery to the composition, reinforced by the figure walking from the wood, who strikes a poetic pose, reminiscent of the shepherd on the left side of the *Departure of Rebecca*, painted in 1640–41, for Angelo Giorio. The tree on the right recalls the study of an oak tree in the Campagna Book, drawn in the grounds of the Villa Madama in *c*.1639–40 (cat. 40). The greater confidence evident in this drawing, and the very tentative link with the painting, suggest that this drawing might be somewhat later than the group of drawings to which the drawing of the oak tree belongs, perhaps dating from the early 1640s.

48. A Group of Trees

Pen and brown ink with brown wash on white paper, 259 × 240 mm

Verso Lower Part of a Male Nude, Seated on a Block (fig. 15)

Red chalk

Inscribed in pen and brown ink with a series of numbers in two columns

Provenance: bequeathed by Richard Payne Knight, 1824

British Museum, Oo.7–227; RD.485

In the perfect manipulation of wash, this drawing of a group of trees compares with the previous drawing (cat. 47), although the effect is different because the preliminary drawing is not laid in with chalk but with a very fine quill pen which has been finished with smoky layers of very wet brown wash, neatly brushed into the contours and rapidly finished with touches of a thicker pen. The drawing has been made on the back of a sheet which has been cut down from a larger sheet on which Claude, at an uncertain date, drew an academic nude figure study in red chalk (fig. 15). Like all Claude's surviving academic studies, it is of indifferent quality. As all known drawings of this type by Claude are found on the back of other drawings on sheets which have been cut down for reuse, Claude evidently did not value them very highly. Sandrart, who tells us that Claude 'drew for many years in Rome in the academies from life and from statues', had a very low opinion of Claude's figure drawings, and it is possible that the artist himself destroyed them.

49. A View of Distant Hills from the Edge of a Wood

Black chalk with pen and brown ink and brown wash, touched with white (oxidised) on white paper, creased and abraded, especially in the lower corners, 214 × 235 mm

Verso A tracing of the trees from the *recto* over a vista, upside down, of distant hills

Pen and brown ink (below); black chalk (centre)

Inscribed in pen and brown ink by the artist: *Claudio Gellee/ 1640*

Provenance: bequeathed by Richard Payne Knight, 1824

British Museum, Oo.7–221; RD. 422

If the date 1640 marked on the back of this drawing applies to the date of the drawing on the *recto*, it provides useful evidence for dating similar drawings in black chalk, wash and pen, occasionally touched, as here, with white body colour. The damage on the left side and the darkening of the added whites diminish the effect by comparison with the best preserved of these nature studies but there is still an evident kinship with drawings from the Campagna Book, such as the view of pine trees (cat. 44) where the distant hills are similarly touched with delicate strokes of thin wash and reinforced along the edge with darker ink. The preliminary drawing, which includes the outline of the artist seated on the left, was done with fairly summary indications in black chalk, washed over and finished with the pen. The view looks towards the spur of hills known from the colour of the stone as Grotta Rossa, a hill of ancient quarries, not far

from La Crescenza. Like all Claude's dated drawings from nature before the mid-1640s, this drawing was probably dated to record a visit to a site which was somewhat further than the bounds of his habitual walks. There are two faint landscapes on the *verso*, one upside-down, probably drawn on the same excursion. Claude later traced the left part of the drawing on the *verso* with a pen, omitting the view of Grotta Rossa which would have been of little use to Claude in the wrong direction, but retaining the trees which could have been adapted, in either direction, for the purpose of a composition.

50. Study of Four Sheep in Movement

Black chalk on white paper, stained with six spots of glue, three along the top edge and three along the bottom, laid down on blue backing paper, within a band of gold paint and an outer line in pen and black ink, 123 × 179 mm

Provenance: Livio Odescalchi; his family by descent; sold by a member of the Odescalchi family, Sotheby's, 20 November 1957, part of lot 67; H M. Calmann, by whom presented, 1958

Ashmolean Museum, 1958.11; RD. 261

From an album containing fifty-eight sheets with studies of animals and eight with studies of trees and plants, mentioned in an inventory of 1713 listing the possessions of Livio Odescalchi. The album was purchased by Hans Calmann at Sotheby's in 1957 and dismembered by him. The album seems to have been assembled in a fairly arbitrary order from the contents of a number of small sketchbooks, dated by Roethlisberger to 1635–50 and by Kitson from the early 1630s to the mid-1640s.[15] Approximately half the drawings in the album were of a similar size to this drawing, with a variation of about 10 mm in the length of the sheets where the pages would have been cut from the binding. Each drawing was stuck down by spots of glue at the four corners and in the centre of the longer sides. One of these studies (RD. 552), corresponding in height to the sheet in Oxford, can be linked to a composition of 1644 recorded in the Liber Veritatis (LV 79), providing a possible approximate date for the group.

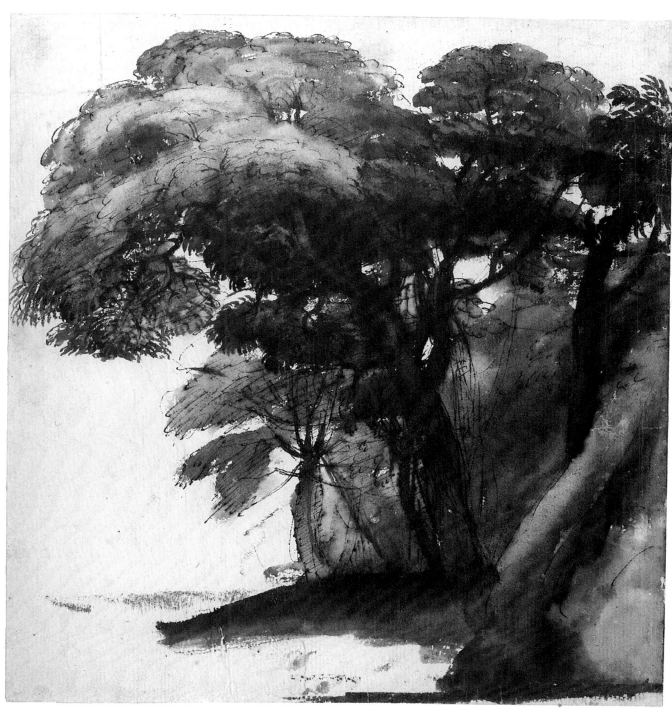

48

Fig. 15 *Lower Part of a Male Nude, Seated on a Block*. Red chalk. RD. 485, *verso*, British Museum.

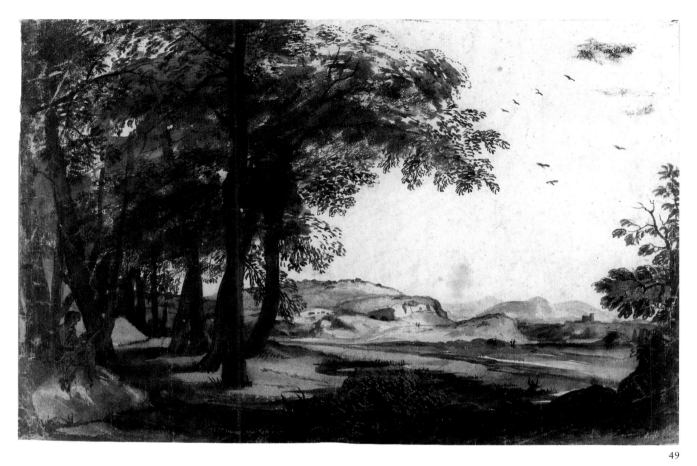

49

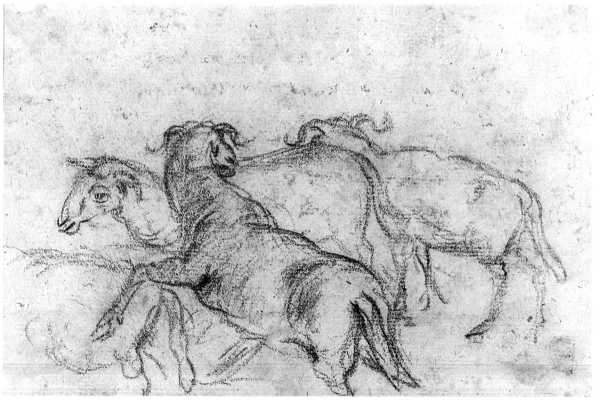

50

51. The Liberation of St Peter

Pen and brown ink with brown wash, heightened with white, on blue paper, 197 × 265 mm

Provenance: Agnese Gellée(?); Joseph Gellée; 2nd Duke of Devonshire; 9th Duke of Devonshire, by descent; purchased 1957

Inscribed by the artist on the *verso* in pen and brown ink: *quadro per illmo sig/ Cardinale Giore*; and below: *Claudio fecit/ in. V.R.*; in lower right: *CL*

British Museum, 1957–12–14–57; RD.377; K.51

This drawing from the Liber for an untraced painting on the theme of *The Liberation of St Peter* is only one of two known compositions that Claude set indoors. The other, an insignificant drawing of the *Birth of John the Baptist* (RD.777), is one of a series of six drawings illustrating the life of the Baptist, all of which, otherwise, are set in the open air. The inscription on the verso identifies the first owner as Angelo Giorio (1585–1662), chamberlain to Urban VIII and one of Claude's most important patrons. The position of the drawing in the Liber is consistent with a date of 1640–41. The inscription must, as Roethlisberger notes, have been added after 1643 when he was elevated to a cardinalate. The theme is taken from the Book of Acts which Claude has followed closely. The use of white body colour and dark wash on blue paper allowed Claude to represent the light which 'shined in' with the appearance of the angel, somewhat supporting Diane Russell's suggestion that Claude used the blue sheets of his record book, at least in the early years, to record pictures with strong light effects. Michael Kitson has pointed out that Giorio's first name, Angelo, and his position as papal chamberlain must have given the theme of the angel ministering to St Peter a special significance for its owner. Presumably, Giorio dictated the subject of the picture, which is unusual in Claude's work although the theme is commonplace in art. It is also unusual in having no connection with his previous work and no influence on his later compositions. Roethlisberger supposes it was a small copper. The peculiar shape of the archway in the upper right suggests it might have been an octagon converted in the Liber to a rectangular format.

52. A Study for a Composition

Black chalk, pen and brown ink with brown and grey wash, touched with red chalk in centre, on white paper, with a lower margin below a line in pen and brown ink, 224 × 327 mm

Inscribed in pen and brown ink by the artist in lower centre: *41*

Verso View of a Seaport (fig. 16)

Black chalk or graphite with pen and brown ink with fragments of a framing line in pen and brown ink

Inscribed in pen and brown ink by the artist: *38* (erased)

Provenance: bequeathed by Richard Payne Knight, 1824

British Museum, Oo.6–97; RD.401

This is one of the few drawings from the Campagna Book which was certainly not drawn from nature and one of only two which were made as the basis of a composition. The proof of this lies not in the general effect, which is imbued with Claude's familiarity with natural forms, but in the underdrawing in black chalk, reinforced with the pen, which is more generalised than his preliminary work usually is. To judge from the numbering of the pages, it may have been drawn during the visit to the region of Civitavecchia when the Campagna Book would have been conveniently to hand for large drafts of this kind. The distant sea-view represents a motif which entered Claude's art at this time, linked probably to his work on the coast at Palo, Santa Marinella and Civitavecchia. As was Claude's habit, he prepared the setting in a separate study without figures (RD.400) which was formerly in the Wildenstein album. Roethlisberger describes the present drawing as a preliminary study for the *Landscape with a Country Dance* of 1640–1 (RP.117), with three unrelated figures, perhaps referring to no particular subject or possibly representing the disciples on the road to Emmaus, as Mrs Pattison first suggested.[16] This would have been a peculiar manner of approaching the theme of the country dance and can be explained better by relating the correspondence to Claude's habit, particularly in successive compositions, of adapting his settings to different purposes, even when the subjects have not much in common. Claude seems to have had the theme of St John with two angels in mind, the saint on the left, the two angels, identifiable by the faint indication of wings, on the right. The subject is more visibly worked out in a related study in the British Museum (cat. 53) where the Baptist stands between the angels and the landscape is reversed. In the event, Claude seems to have set the subject aside, retaining the three figures for the romantic little picture at Corsham Court, dated 1647, which has an entirely different setting, and re-employed the

Wildenstein landscape for the *Country Dance*. There is an elaborate port scene in pen and ink on the *verso* of this drawing (fig. 16) for which there is a corresponding drawing, also in the Wildenstein album, both related by Roethlisberger to *The Embarkation of St Ursula* of 1641 (RP.118) with which they are only linked in a generic sense. There is a better correspondence with *The Landing of Cleopatra* of 1642 (RP.127), particularly in the light of the preparatory drawing in Chatsworth (RD.505) which features a similar large portico.

53. Landscape with John the Baptist and Two Angels

Pen and brown ink with brown wash on stained white paper, 199 × 288 mm

Provenance: bequeathed by Richard Payne Knight, 1824

British Museum, Oo.6–129: RD.647.

This drawing represents a development of the theme of the previous composition; the landscape has been reversed and the sea has been transformed into a river. This setting, in the event, was not employed by Claude for a painting on this theme but was used, instead, for the *Landscape with a Country Dance* of 1640–1 (cat. 54) and, again, for the *Marriage of Isaac and Rebecca* of 1648. A further landscape drawing in the British Museum (fig. 17) seems to represent a stage between this drawing and the later painting.

54. Landscape with a Country Dance

Pen and brown ink with brown and greyish-brown wash on white paper, 196 × 267 mm

Inscribed by the artist on the *verso* in pen and brown ink: *quadro per pietro pescatore*; and below: *Claudio fecit/ in.V.R.*; in lower right: *CL*

Provenance: Agnese Gellée(?); Joseph Gellée; 2nd Duke of Devonshire; 9th Duke of Devonshire, by descent; purchased 1957

British Museum, 1957-12-14-58; RD.402; K.53

This is a neat, detailed, accurate record of Claude's painting of a country dance, commissioned by Pieter Visscher and completed in 1640–41 (RP.117). The wild landscape, adopted from the projected composition of St John the Baptist in the desert (cat. 52), seems a precarious site for a rustic dance, even for the goats, two of which have lost their footing on the rocks. The subject derives from a series of pictures on the theme of the rustic dance (e.g. cat. 7, 14, 25, 26), but the difference in the costumes is evidence that Claude was thinking of an antique subject. The gesture of the woman raising her

52

Fig. 16 *View of
a Seaport*.
Black chalk
with pen and
brown ink and
brown wash.
RD. 401, *verso*,
British Museum.

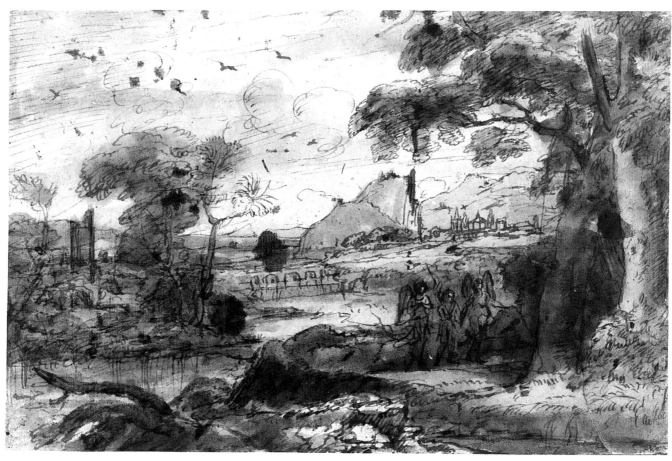

53

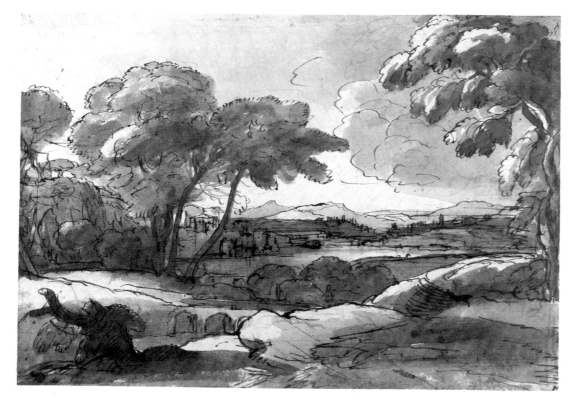

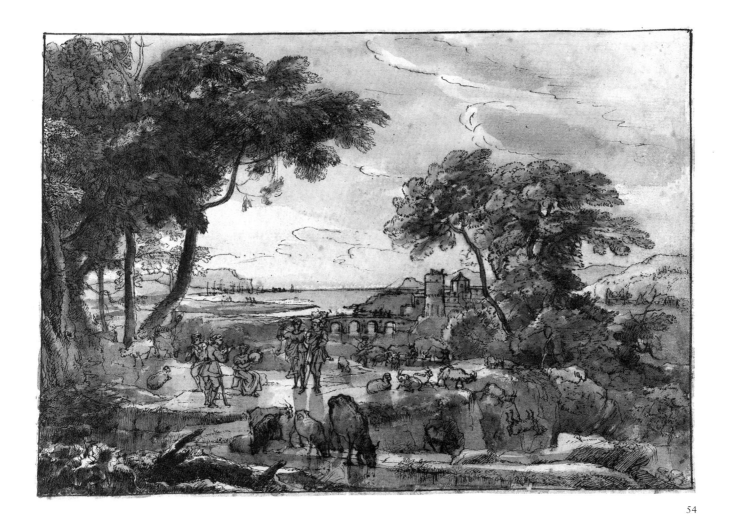

veil is a commonplace in ancient Roman art, used elsewhere by Claude to indicate a subject from antiquity. Claude may have already been thinking of the marriage of Isaac and Rebecca which is apparently the subject of the painting in the National Gallery, painted for Prince Pamphili in 1648. Apart from the veil, which is mentioned in the biblical text, there is nothing in the composition to identify the subject except its kinship with the London picture, where only Claude's title, helpfully inscribed on the painting, makes it possible to identify the theme. The figures in the London picture and in the present version are not close. For the later painting, Claude produced a variation of the dancers from his early pictures of country revellers, but the landscape is much the same as here, reversed and transformed into a more appropriate setting for a rustic dance than the rocky landscape of St John's desert. The fortified tower in the present drawing becomes a tall

mill-tower in the painting, the sea is eliminated and the chasm becomes a river. Claude prepared these changes in an empty landscape composition (fig. 17), also in the British Museum, which forms a clear bridge between this drawing and the later work. He also re-employed the setting, in passing, for a finished composition drawing of a hunting scene (RD.649), dated 1647. On the basis of Claude's inscription on the back ('le present disine et pancé du taublau du prince panfille'), this is usually described as a study or 'pensée' for the picture of Isaac and Rebecca, confirming the supposition that Claude sometimes worked out his compositions by using unrelated subjects, but, apart from the inherent oddity of this manner of preparing a composition, it is more likely that Claude, whose grasp of spelling was not strong, meant to indicate simply that the drawing of the hunt had been transferred ('est poncé') from the composition of the picture for Prince Pamphili.

(*Left*) Fig. 17 *Landscape*. Black chalk with pen and brown ink and brown wash. RD.648, British Museum.

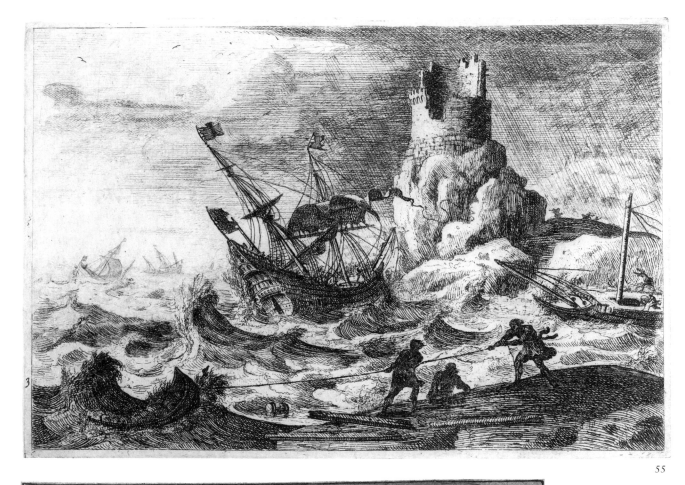

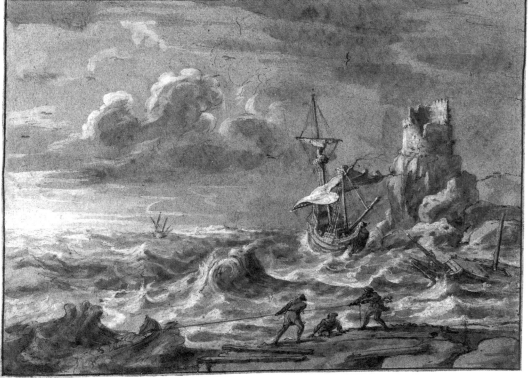

Fig. 18
Storm at Sea.
Pen and brown ink
and brown wash
with white body
colour on blue paper.
RD. 196; LV 33,
British Museum.

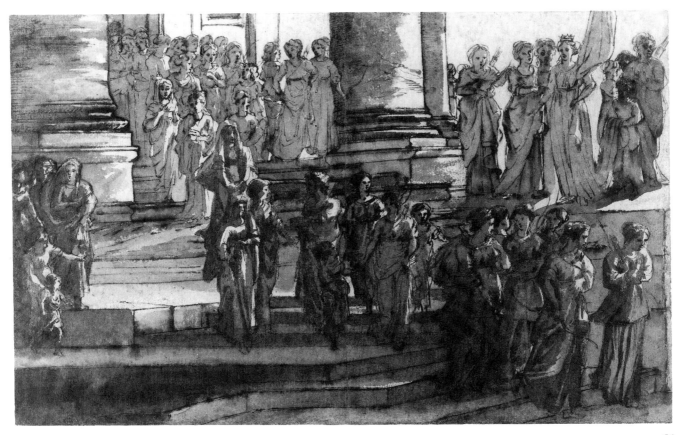

55. The Shipwreck

Etching, 130 × 183 mm (plate)

Inscribed in left margin: 3

British Museum, 1973–U–598; M.35.iii

Images of shipwrecks with exaggerated waves and tall rock formations belong to a tradition of Northern imagery which would have been familiar to Claude from his training in the studio of Agostino Tassi. Similar motifs, featuring a ruined tower on a rocky coast, appear in the etchings of Claude's collaborator, Dominique Barrière, and are commonplace among marine artists of the period. Claude's etching is based on a painting which is recorded, in the same direction, in the Liber Veritatis (fig. 18), but is now otherwise unknown. From its place in the Liber and from the inscription on the back, it seems to have been painted in c.1638 for Paolo Giordano Orsini whose motto 'contra ventos et undas' (against wind and waves), as Roethlisberger points out, probably inspired the choice of subject. Russell suggests that the etching may have preceded the drawing in the Liber since it is in the same direction, but the right-handed figure, taking the strain at the end of the rope in the etching, suggests that Claude probably reversed the image when transferring it to the copper plate. It belongs to a set of six prints, all reproducing paintings by Claude which

Lino Mannocci believes were etched between 1639 and 1641 to add to six existing prints in order to make up a set of twelve. The added prints are technically accomplished but lack the vitality of the earlier prints which are less sophisticated in their handling but sometimes more ambitious in their effects.

56. St Ursula with her Companions

Black chalk or graphite with pen and brown ink and brown wash on white paper, 267 × 419 mm

A label on the *verso* of the mount is inscribed by John Barnard and numbered 1772

Stamped: Benjamin West (L.419)

Provenance: John Barnard; Benjamin West (L.419); Henry Wellesley; purchased, 1866

British Museum, 1866–7–14–60; RD.459

This richly worked composition relates to the figure group in the left side of the painting of *The Embarkation of St Ursula* (1641) in the National Gallery in London, much as the groups of figures from Urban VIII's *Landscape with a Country Dance* (cat. 32 and 33) in the Liber Veritatis relate to the finished painting. Like the drawings in the Liber, the present drawing may have been copied from the painting, but this is not certain.

The individual figures in the drawing differ only in trifling respects from the figures in the painting but the general arrangement has been changed. The steps have been truncated and the group is more compact. The saint and her immediate companions have been moved from the quayside to a place above the figures descending the steps in the lower right of the drawing. As a result, the third column of the portico in the painting has been squeezed almost out of sight behind the centre column. These differences do not represent an alternative idea for the painting but are the result of compressing the final composition into the smaller format of the drawing. The most significant difference between the drawing and the painting is not in the composition but in the way the light of the sun in the drawing picks out the figures with flickering touches, leaving others in the shadow. The effect in the painting is not dissimilar, but is achieved by a more even balance of figures in the light and those in the shadow. The more extensive and complex shadows in the drawing, washed in with a rich brown ink, create a particularly poetic effect. This is a type of illumination that had long attracted Claude, from the etching of *The Tempest* of ten years earlier through many paintings of figures in the sunset, which continued to interest him into later years. The effect of light explains the use of wash which he used less extensively in his later figure studies. Roethlisberger leaves open a faint possibility that this might, after all, have been a preparatory study for the painting. Claude sometimes made studies for the figures in his paintings which he completed simultaneously and adjusted as independent works of art. Drawings of this type are fairly common from *c*.1644 onwards but they have, in general, a more exploratory character and are never so complex as this.

57. St Peter's Basilica, Seen from the Janiculum

Black chalk with thin grey wash, touched with brown wash, on white paper, within the remains of a framing line in pen and brown ink, 211 × 307 mm

Watermark: fleur-de-lis within an oval

Inscribed in pen and brown ink, lower right: 21 (erased)

Verso Ruins on the Palatine (fig. 19)

Black chalk

Inscribed in red chalk: *CLAV/ R.IV*

Provenance: bequeathed by Richard Payne Knight, 1824

British Museum, Oo.7-150; RD.452

The development of black chalk as the main element of the drawing can be followed through a number of pages from the Tivoli Book from which this drawing has been removed. In these drawings, pen and wash are used more sparingly than before or not at all, marking the beginning of a technique which became increasingly common in Claude's work. The basilica and the surrounding area are drawn entirely in black chalk except for a flanking element of wash in the lower left and a spot of brown in a lower window in the nearest tower. The pale grey, covering the main area of the drawing, has been added by working over the chalk with a wet brush. The drawing can be dated from the unfinished state of Bernini's bell tower on the south-east corner which had been completed as far as the second storey, visible here, by December 1640. In June 1641, a third wooden storey was added to try out the effect but severe structural problems halted progress and the tower was demolished in 1646. The scaffolding, visible on the tower in Claude's drawing, was probably erected in preparation for the wooden storey, suggesting a date in the spring of 1641.

58. The Fountain of Egeria

Black chalk with grey and reddish-brown wash on cream paper, 214 × 313 mm

Inscribed on the *verso* by the artist in red chalk: *CLAV/ Ro IV*

Provenance: bequeathed by Richard Payne Knight, 1824

British Museum, Oo.6-90; RD.480

The number 42 at the bottom right marks the former place of this drawing approximately two-thirds of the way through the Tivoli Book. The drawing begins with a fine outline in black chalk, like many of the earlier ink drawings, but is then heavily shaded with a thicker, blunter chalk in place of the dark wash which Claude used commonly in the 1630s. Reworking with the pen is confined to a single line along the edge of the brick arch on the left and the wash is applied lightly, with some added pink to indicate the brick in the background wall. Pink wash is common in the pen and wash drawings in the Campagna Book and in a number from the Tivoli Book which may be contemporary. The combination of pink wash and black chalk in this case may represent a transitional stage in the development of Claude's drawings. The space in lower left was left blank for the addition of a flanking motif in wash which Claude omitted to complete. The view shows the ruin of an ancient Roman garden building, not far from the church of Sant'Urbana at Caffarella, known in Claude's lifetime as the Fountain of Egeria in the belief that it marked the spot where Numa's nymph had died of grief. Her death and transformation into a spring, related by Ovid, gave Claude the subject of a painting for Prince Colonna in

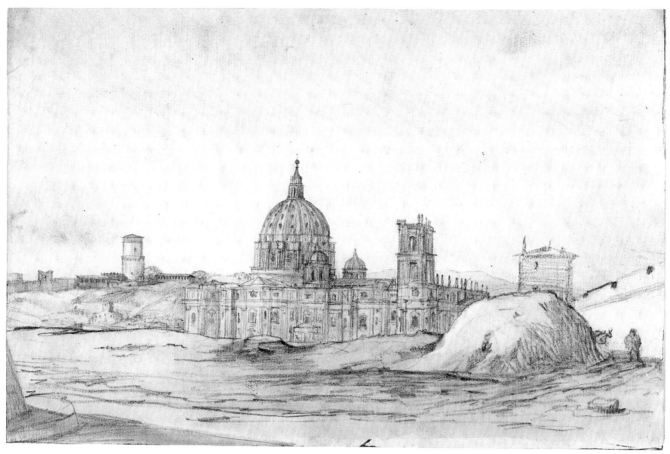

57

Fig. 19
*Ruins on the
Palatine.*
Black chalk.
RD. 452, *verso*,
British
Museum.

58

59

1669. The spot was popular with visitors from Rome, including many artists, from Swanevelt to Piranesi, who made prints and drawings of the site. Swanevelt's print shows much the same view as Claude's. There is also a nearly identical view in the Ashby collection in the Vatican,[17] a little more extended on the right to include the continuation of the wall and the tree growing from the brickwork which is visible in the upper right of Claude's drawing.

59. The Road to Subiaco

Pen and brown ink and brown wash on white paper, slightly foxed, marked with a finger-print in lower left of centre, 214 × 313 mm

Inscribed in pen and ink by the artist along left side of lower edge: *Claudio V fecit/ strada di tivoli a/ sobiacha. l'anno/. 1642/ (il voag* erased)

Verso A group of trees, traced from the *recto*

Pen and brown ink

Provenance: bequeathed by Richard Payne Knight, 1824

British Museum, Oo.6–72; RD.483

The inscription on this drawing which identifies the site as a spot between Rome and Subiaco, drawn by Claude in 1642, provides a useful point of comparison for dating similar outdoor studies. The drawing seems to have been outlined with a sharp pen and lightly and rapidly washed in brown ink. The trees and a few other details have been shaded with patches of a darker wash and the main contours have been retouched with heavier pen lines, more broken in the distant hills and zigzagging along the near bank. Apart from the figures and donkey approaching along the road and the artist and a companion, there is little detail. The general effect is unusually linear. As Roethlisberger points out, the best analogy is found among the wash drawings in the Tivoli Book, particularly a sunlit view of trees in Haarlem (RD.474) which, despite the extensive, atmospheric wash, has a similar basis of fine, somewhat abstracted pen lines.

60. Study for the Flight into Egypt

Black chalk with pen and brown ink on pale brown paper, heavily spotted, 141 × 195 mm

Stamped: Hudson (L.2432); Hall (L.551); University Galleries (L.2003)

Provenance: Hudson; Chambers Hall, by whom presented, 1855

Ashmolean Museum, 1855.61; RD.491

Knab first connected this drawing with a painting of 1642, now lost, but recorded in the Liber Veritatis (RD.492).[18] The Virgin and Child crossing the bridge, followed by Joseph, are barely visible but the elements of the two drawings correspond closely. The structure on the left, inspired by the Colosseum, reappears in his composition of *Apollo and the Cumaean Sibyl* in the Hermitage (RP.180) and again in an elaborate architectural drawing of 1666 (RD.952). Claude appears to have used this technique of free pen drawing for preliminary compositional work (cf. RD.507) and for copies (cf. RD.161 and 610). It cannot be said with certainty to which category this drawing belongs but it is so similar in character to RD.161 (cat.30) that it is probably a copy made as a quick record of the composition.

61. Figures Disembarking at a Port

Pen and brown ink with dark brown wash, divided with a ruler in pen and brown ink over red chalk on white paper, laid down on a page from an album, 147 × 219 mm

Provenance: Lord James Cavendish; Duke of Devonshire; purchased with a contribution from the National Art-Collections Fund, 1952

British Museum, 1952–1–21–47; RD.504

This composition belongs to a class of port scenes with figures landing or departing, lit by the rising or the setting sun, but does not resemble any known painting sufficiently to identify it with certainty. It might represent an early idea for the *Embarkation of Ulysses* (RP.177), a painting of 1646 which, as Roethlisberger has pointed out, includes a similar group of figures in the foreground. The fortified sea-wall in the left background is also common to both, although the triumphal arch and palace, which appear prominently in the drawing, do not appear in the painting. The effect of light which is strikingly rendered in this drawing with luminous patches of blank paper contrasted with warm brown washes seems to anticipate the effect of masked sunlight in the final composition. In the painting, the sunlight radiates from behind the sea-wall; here, it slants into the composition from a point outside the picture on the right, touching the buildings but leaving the figures in the shadow. The effect is more arresting in the drawing than it is in the painting. In this respect, and in the use of golden wash to create this effect, it recalls the relationship between the drawing of the figures for the *Embarkation of St Ursula* (cat.56) and the finished picture. The sheet has been divided horizontally, vertically and diagonally with red chalk and ink, probably to assist Claude in copying the composition. Similar divisions appear in a number of Claude's composition drawings.

60

61

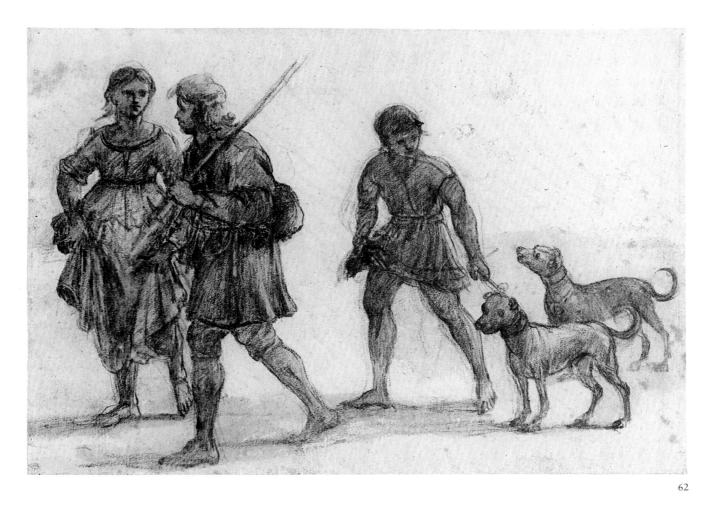

62

62. A Group of Three Figures with Two Dogs

Black chalk and grey wash on white paper with pin holes in the four corners, 181 × 260 mm

Provenance: bequeathed by Richard Payne Knight, 1824

British Museum, Oo.7-153; RD. 555

Few figure studies exist for paintings by Claude before the mid-1640s, but from about 1644 they become increasingly common, drawn mainly in black chalk with the addition of grey or brown wash in keeping with Claude's more extensive use of black chalk after the 1640s. These figure drawings do not resemble in type the familiar academic studies employed by his contemporaries but take the form of pairs or groups of figures, arranged on the page in a manner that suggests, at first glance, that they have been drawn for their own sake. The pentimenti in this drawing, particularly evident in the legs of the boy on the right, support the view that it is a study for, rather than a record of, a painting. The composition of the corresponding painting is known in two variants, one in New Orleans (RP. 143), dated by its place in the Liber Veritatis to c.1644, the other in the De Young Memorial Museum in San Francisco (RP. 144).

The group here is more compact than the figures in the painting in New Orleans and in the drawing in the Liber. There is a better correspondence with the figures in the variant in San Francisco where the figures are placed on the river bank, preparing to wade into the river behind the cattle, followed by an attendant with a dog whose pose was evidently a source of trouble to the artist and was worked out differently here. The second dog does not feature now in the painting but a recent analysis with reflectography has revealed its existence under an area of over-painting as well as a number of other details, now invisible, which correspond to the present drawing.[19] This seems to rule out the possibility that the drawing of the figures was derived from the painting in San Francisco. It could have been made as an intermediary study between the two paintings for the sake of revising the figures but this possibility is contradicted by a comparison of the background of *Tobias and the Angel*, a painting of 1642 (LV 65), with the background of the two pastorals, which suggests that the painting in San Francisco is derived directly from the painting of *Tobias and the Angel* while the picture in New Orleans is a later variant.

63. Landscape with Figures and Cattle Fording a River

Pen and brown ink and brown wash, heightened with white body colour on blue paper; a spot of red, lower right, 198 × 265 mm

Inscribed by the artist on the *verso* in pen and brown ink: *taublaux pour paris*; and below: *Claudio fecit/ in V. R.*; in lower right: *CL*

Provenance: Agnese Gellée(?); Joseph Gellée; 2nd Duke of Devonshire; 9th Duke of Devonshire, by descent; purchased 1957

British Museum, 1957–12–14–87; RD. 556; K. 81

At one time, with some reluctance, Roethlisberger linked this drawing with a painting in the De Young Memorial Museum in San Francisco to which it corresponds in a general sense but with many differences in the detail of a kind which do not normally appear between the copies in the Liber and the originals. The appearance of a painting which was clearly the model for the present drawing, published by Roethlisberger in 1971, has eliminated this difficulty but has also called into question the relationship between the two versions. As Roethlisberger has pointed out, the setting of these paintings has been taken directly from an earlier painting of *Tobias and the Angel*. Claude had already used the drawing of *Tobias and the Angel* when he copied the slim tree in the left of the drawing into a landscape of 1642–3 (LV 66) and probably used it again for the present composition. The drawing in the Liber normally records the prime version and later versions are listed on the back, but there is no mention of a variant on the back of this drawing and the existence of a preparatory drawing for the painting in San Francisco raises the question, posed by Kitson, whether the San Francisco painting might have been directly based on the Liber drawing of *Tobias and the*

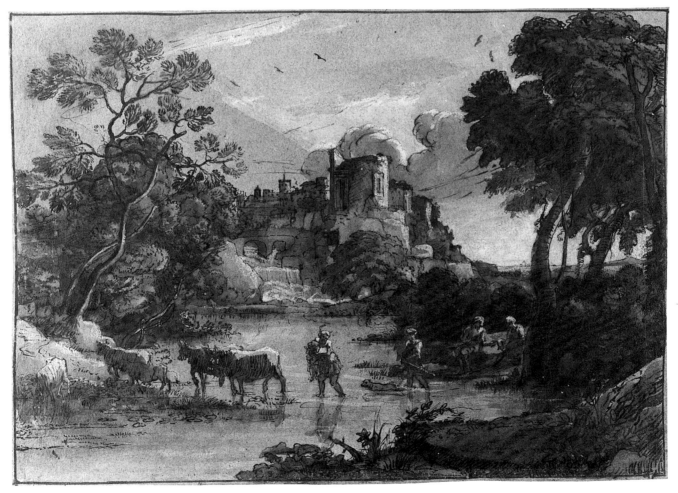

63

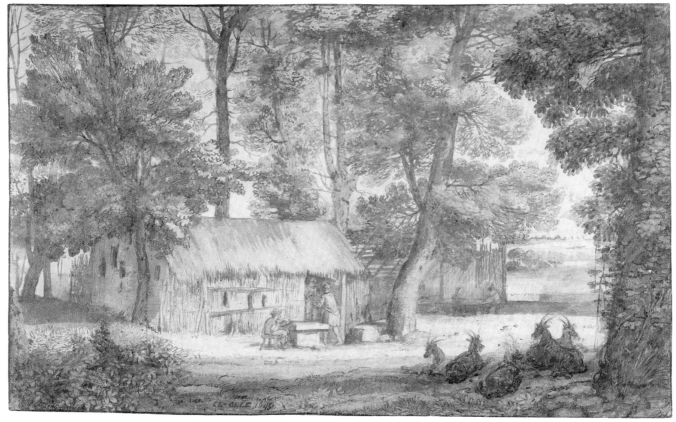

64

Angel and before the variant in New Orleans. The differences which are evident in the buildings in the background of the three pictures support the idea that the painting in the De Young Museum was composed before the variant. It is odd that in this instance and also, it seems, in the case of the record drawing of *The Pastoral Landscape* of 1638 (LV 23), Claude did not make a copy of the original but of the variant, and in both cases failed to note the existence of a second owner on the *verso*.

64. A Hut by the Edge of a Wood

Black chalk, pen and brown ink, heightened with white body colour, on white paper, toned with a yellowish-grey wash, 257 × 403 mm

Inscribed in pen and brown ink by the artist, lower centre: *CL – GELE 1645*

Verso inscribed in pen and brown ink: *W.E. no. 160/ 1837 315; W Esdaile/ J C Robinson/ May 1 1857*; and in pencil *444* (Robinson's number) and *84* (Hind's number)

Stamped: W. B. White (L. 2592); Robinson (L. 1433)

Provenance: William Esdaile; W. B. White; Robinson; John Malcolm; purchased, 1895

British Museum, 1895-9-15--897; RD. 599

This appears to represent a view of a rural tavern with figures eating or drinking in the open air. The theme and composition recalls cat. 58 which bears more obvious signs of having been drawn on the spot. The tree on the right and the goats and bush on lower left are characteristic studio additions. To what extent the drawing had been begun before the motifs is difficult to estimate. There is no clear difference between the main area of the drawing and the flanking motifs as there usually is in drawings which have been finished later, and the uniform treatment of the foliage differs from the manner of drawing foliage usually found in the nature studies, which indicates that it was probably a studio drawing, carefully inscribed and dated as a work of art in its own right.

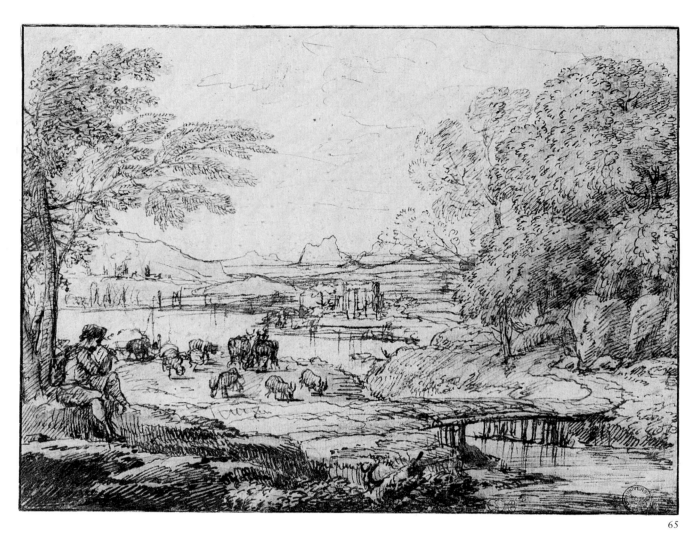

65

65. A Youth Playing a Pipe in a Pastoral Landscape

Black chalk with pen and brown ink and pale brown wash on pale beige paper, edged with black ink, 182 × 238 mm

Stamped: Hall (L. 551); University Galleries (L. 2003)

Provenance: Vivant Denon; his sale, Paris, 1 May 1826, lot 744; Chambers Hall, by whom presented, 1855

Ashmolean Museum, 1855.65; RD. 577

The style of this engaging drawing, worked up in pen with pale wash, belongs to a class of Claude's drawings which are mainly shaded with pen lines with little use of wash or none at all (e.g. RD. 668, 785 and 847). Pure pen drawings appear early in Claude's work (RD. 56) but, in keeping with a general tendency in Claude's art through the 1640s and 1650s, the effect becomes less dramatic and more controlled with less use of long slanting strokes

and a greater reliance on modelling with neat, short parallel lines. Claude seems to have used this technique rarely for working out of doors but he employed it commonly for preparing compositions. The beginnings of a more structured pen line is evident in a study for the *Pastoral Landscape* of *c.*1642 (RD. 507). Others can be linked to work of 1655 (RD. 739) and 1663 (RD. 894) but, without a related painting, most are difficult to date precisely. Roethlisberger links the motif of this composition to a series of paintings of the 1640s which feature a seated herdsman and are generally similar in composition. It was etched in reverse by Vivant Denon when it was in his collection. It must have been acquired by him before 1803 when the etching was listed in his catalogue of prints.

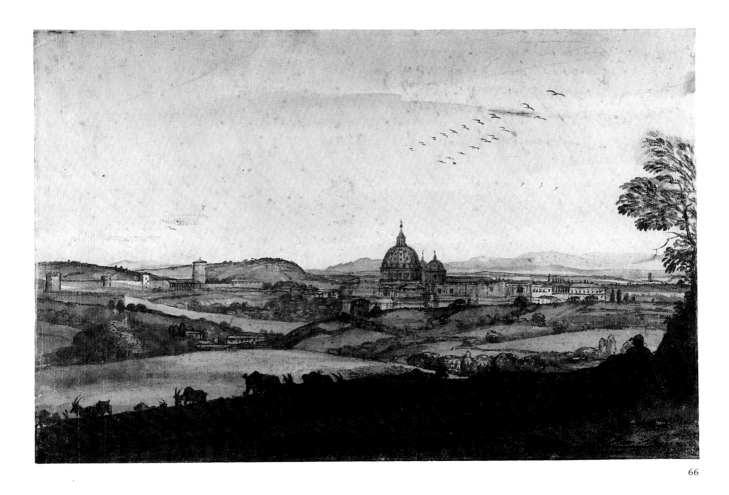

66

66. St Peter's Basilica Seen from the Doria-Pamphili Gardens

Black chalk with dark brown and light brown wash, touched with the pen and brown ink and a little white body colour in the foreground, on white paper, 212 × 314 mm

Verso A banner inscribed: *Se Pour./ Qui Ro*

Black chalk

Inscribed by the artist in pen and brown ink: *A Monsieur [Collier erased] De Bertaine faict par moi/ Claude Gelle dit il lorains a Roma/ ce 22 maigio 1646, la vuie de la/ vigne du papa innocent et st. piere de Roma*

Watermark: fleur-de-lis in an oval

Provenance: bequeathed by Richard Payne Knight, 1824

British Museum, Oo.7–151; RD.619

The view is taken from a site on the Janiculum, now occupied by a terrace in the Doria-Pamphili Gardens, designed by Algardi in 1644 for Prince Camillo Pamphili, nephew of Pope Innocent X and Claude's patron. The view extends across the Vatican to the distant hills stretching from Monte Mario on the left to the summit of Soratte. The foreground detail, with a fallen tree, seated figure and goats, washed in dark brown ink, is a characteristic studio addition. On the *verso* is a study of a banner, with a text which Claude has mistranscribed, and an inscription, seemingly indicating that the drawing was originally intended for a certain M. Collier but given to a M. de Bertaine. The latter cannot be identified. His name may have been misspelt: Bretagne seems more likely. The other may have been Claude Collier, an engraver whose work is not now known but who died in 1657 and is mentioned in contemporary sources as 'maître graveur et graveur ordinaire de Monsieur, frère du roi.[20] There is a general resemblance with the right-hand section of a large panoramic print of Rome, engraved by Barrière and published in 1649. The date of the dedication must be close to the date of the drawing. The absence of Bernini's tower on the south-east corner, which was demolished in 1646, confirms the date beyond much doubt.

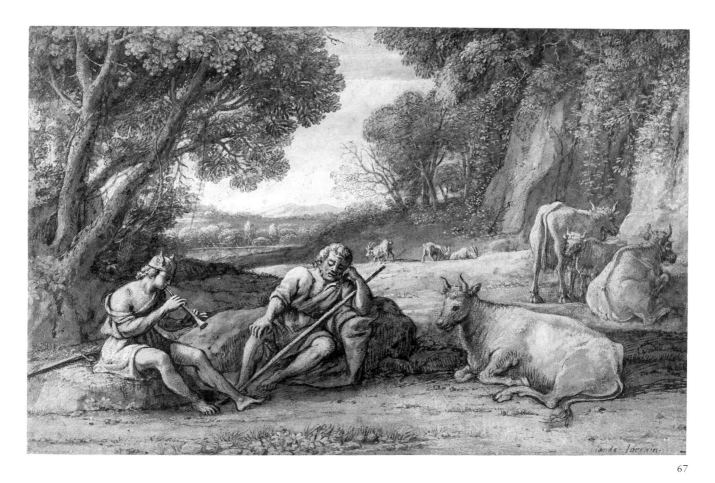

67. Mercury and Argus

Black chalk, pen and brown ink with grey-brown wash, extensively heightened with white body colour on pale blue paper, 241 × 359 mm

Inscribed in lower right: *Claude lorrain*; and on the *verso* by the artist in pen and brown ink: *Claude Gillee/ dit le loraine/ Roma 1647*; and by another hand in graphite: *Signe del ...main*

Stamped: J. Malcolm (L. 1489)

Provenance: Samuel Woodburn; Henry Wellesley; John Malcolm; purchased, 1895

British Museum, 1895-9-15-898; RD.593

As the centre of Claude's interests shifted from modern times to ancient sources in the 1640s, the exploits of Mercury (or, more properly, of Hermes his Greek counterpart) provided him with a convenient excuse to continue to paint pictures of herdsmen and cattle. Mercury, who appears first in a painting of 1643, became one of Claude's favourite characters, particularly in association with other legendary herdsmen, Argus, Battus and Apollo. The seated Mercury in this drawing repeats the pose of the herdsman playing his pipe who is a stock figure in Claude's early pastorals. The drawing otherwise does not relate directly to any composition of the 1640s, confirming the evidence of the tightly finished style which suggests that this drawing was made as an independent work of art on a theme which Claude did not take up again until 1659 (LV 150). The last digit of the date is difficult to read but it was probably drawn after the *Pastoral Landscape* of 1645 which includes a similar group of cattle. The best analogy is with two octagonal drawings in the Pallavicini collection in Rome (RD.546 and 547), inspired, as this is, by Ovid's *Metamorphoses* and of approximately the same size. Too finished for working studies, the Pallavicini drawings must have either been independent works of art or drawings submitted to Cardinal Rospigliosi as models for proposed paintings. The octagonal shape might indicate that Claude was thinking of a pair of coppers but the absence of any paintings relating to these drawings and to the majority of drawings of this type tends to contradict this possibility. The most likely explanation is that Claude had begun to supply finished drawings to his patrons by the mid-1640s which might, on occasion, have been framed up like little paintings.

68. A Youth Helping a Girl to Mount a Donkey

Black chalk and brown wash on white paper tinted with pinkish wash, 206 × 267 mm

Provenance: bequeathed by Richard Payne Knight, 1824

British Museum, Oo.7–137; RD.656

This drawing began life as a study for the group of three figures on the left side of a painting formerly at Houghton Hall.[21] The location of the related drawing in the Liber (LV 115) suggests a date of 1647–8. Claude first drew the three figures with a faint, tentative black chalk, then added the donkey on which the girl is seated and the landscape background and strengthened the whole composition with black chalk in the contours and wash in the shadows. Since the youth in the painting is lifting the girl on to the back of the donkey, on which the

second youth is seated, to allow her to cross a ford behind the cattle, Claude probably had only one donkey in mind originally but drew the same donkey twice here as a convenient method of altering the motif without making disfiguring changes on the sheet. The faint preliminary outlines of the figures suggest that Claude intended to show the youth holding the girl in the air well clear of the donkey but revised this idea, adding the second donkey for the sake of providing her with a mount. Once the relationship of the figures had been settled, he completed the drawing with a landscape which bears no link to the setting of the painting but gives the drawing the appearance of an independent composition. This added work seems to be continuous with the chalk and wash on the figures and must have been done at the same time as the rest. The idea of the cattle wading across the stream and turning down a track away from the spectator, which forms an important element in the

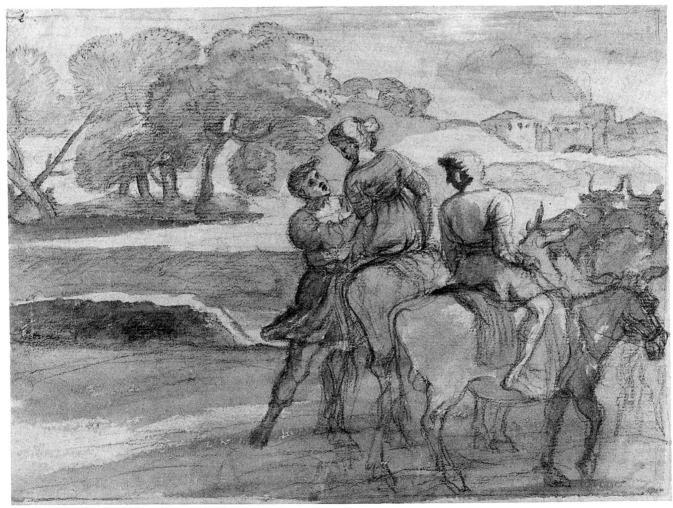

68

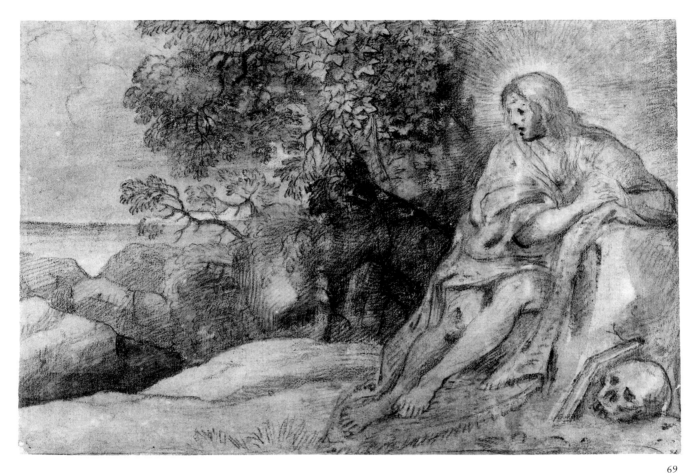

69

painting, was in Claude's mind when he added the cattle on the right side of the drawing, meaninglessly, because the water in between has been omitted. The cattle have been added to compensate for the lopsided effect which resulted from the haphazard manner in which the composition developed from a study of three figures. The pink ground, which is strongest in the sky on the right, suggests a sunset or an effect of light which anticipates the warmth of the painting.

69. The Penitent Magdalen

Black chalk with grey wash, touched with white body colour, on beige paper, 205 × 300 mm

Verso Architectural Studies (fig. 20)

Pen and brown ink (the tower); black chalk (the town wall)
Provenance: bequeathed by Richard Payne Knight, 1824
British Museum, Oo.6–86; RD.664

This drawing is one of the most substantial of Claude's copies, corresponding, as Knab has pointed out, to a drawing by Annibale Carracci in the Louvre, on which Annibale based an etching, and to a painting in the Mahon collection in London.[22] Since Annibale's print and the related painting are in reverse direction to Claude's drawing, Roethlisberger concludes that Claude probably had access to the reversed drawing in the Louvre or to a lost copy. The upright format of Annibale's drawing, which does not include the landscape on the left, and the oblong format of the painting, which suggests that there was an original of similar shape, seem to rule out the drawing in the Louvre as the source; but the Mahon painting is also ruled out because it is in the wrong direction. The evidence of the Madgalen's clasped hands in the Louvre drawing, where she is right-handed, and of the print, where she is left-handed, seems to confirm the probability that Claude had access to a lost oblong original, composed in the same direction as Claude's drawing. Originally, Claude included a cross at the centre of the composition as

Fig. 20 *Architectural Studies*. Black chalk with pen and brown wash. RD. *664, verso*, British Museum.

the object of the Magdalen's gaze, but subsequently deleted it heavily with black chalk, suggesting a degree of improvisation in the left half of the drawing where it differs most from the Mahon painting. Roethlisberger has proposed a date in the second half of the 1640s, comparing the treatment of the Magdalen with Claude's figure paintings of the period. The density of the chalk, particularly in the landscape, recalls several of the black chalk landscapes in the Tivoli Book. The sketch of an ancient wall on the *verso* of the present drawing (fig. 20) looks earlier than the late 1640s, but the sheet has been cut down and the sketch on the *verso* may be earlier than the drawing on the *recto*. The double arch, surmounted by a tower, reappears in a drawing, published by Roethlisberger in 1974, identified by Claude on the *verso* as the ruins of an acqueduct near Tivoli on the road to Subiaco.

70. The Palazzo del Sasso

Fine black chalk (or graphite), pen and brown ink with brown and reddish-brown wash on white paper, 219 × 319 mm

Stamped: Sandby (L. 2112)

Provenance: Paul Sandby (L. 2112); Henry Wellesley; Sir John Charles Robinson; George Salting, by whom bequeathed, 1910

British Museum 1910–2–12–90; RD. 622

Hind identified the buildings as the Palazzo del Sasso, drawn from the lower slopes of the Rupi del Sassone near Furbara on the Via Aurelia.[23] There is a corresponding view in the Ashmolean (fig. 21), showing the same buildings seen from the opposite direction, from a spot in the hills above the buildings in this view. The unfinished state of the Ashmolean drawing gives a hint of the basis on which elaborate drawings of the present type were completed in pen and wash over a precise

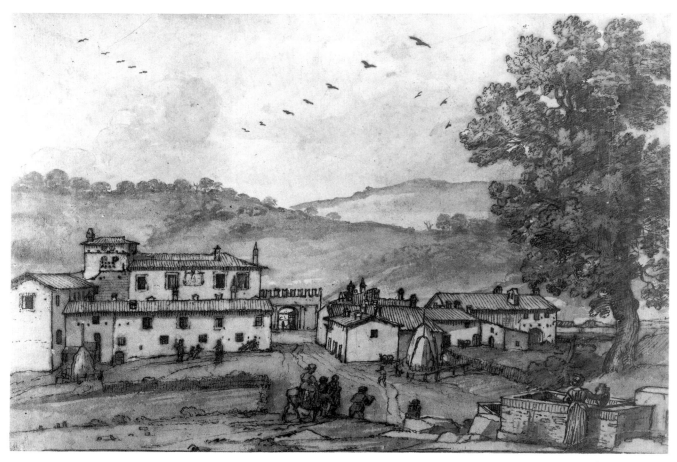

70

preliminary outline of the main features. The oxen and two figures on the Ashmolean sheet, hastily added in black chalk, indicate detail which the artist would have completed in pen and ink in the studio. In this drawing, the girl standing by the fountain and the smaller figures standing near the centre provide a charming variation on the same type of compositional device. The handling of the present drawing which combines three distinct styles – soft wash in the distance, sharp washed outlines in the middle distance and neat, etched penwork in the tree and foreground – tends to bear out the probability that the drawing was done in stages. Roethlisberger originally dated both drawings to the mid-1640s, partly by comparison with a similarly finished view of Tivoli in Madrid (RD.489) which he dates to the early 1640s by comparison with the other views of Tivoli which were formerly in the Tivoli Book; but this ceases to be a factor if the contents of the book are more spread out in time than is usually supposed. The subsequent

discovery of a view of the buildings at Sasso, dated 1649, exhibited in 1983 and published more fully by Roethlisberger in 1984,[24] provides evidence for supposing that the drawings in Oxford and London date from a single visit to the Sasso in 1649. This date also appears on another view, drawn in the neighbourhood of the rock, which is not carried out in a later style, as Roethlisberger once suggested, but in a different, slacker style, used by Claude for less consequential compositions. The drawing in Oxford was taken from a spot only a few feet to the right of where he was seated when drawing the recently discovered view, and represents, essentially, an abandoned variant of the same scene.

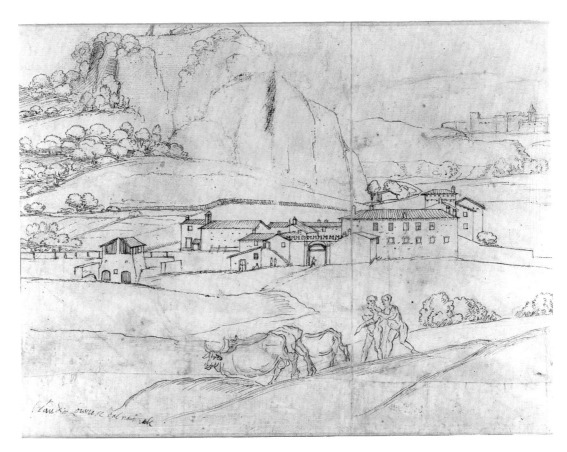

Fig. 21 *View of the Palazzo del Sasso*. Black chalk with pen and brown ink and brown wash. RD.623, *verso*, Ashmolean Museum.

71. View of the Palatine

Black chalk with pen and brown ink with brown wash on white paper, edged with lines in brown ink, 181 × 259 mm

Stamped: Hall (L. 551); University Galleries (L. 2003)

Provenance: presented by Chambers Hall, 1855

Ashmolean Museum, 1855.60; RD.487

The site represented in this drawing has variously been identified as the Baths of Caracalla, Tivoli, Viterbo, Monterano, the Palatine from across the Circus Maximus, perhaps Soracte and possibly a valley north of Rome.[25] It clearly represents the ruins on the Palatine, seen from the Caelian Hill with the arches of the Claudian aqueduct on the left. There is a view in the British Museum taken by Claude from the same site, but turned towards the right, with the Arch of Constantine in the foreground, on the *verso* of a view of St Peter's (RD.452). The abbreviated manner of drawing, with flowing, incisive pen lines defining the edge of the fore-ground, is found in a number of views from nature dating between 1642 (RD.483) and 1662 (RD.667). There is a particular affinity with a river view (RD.667) which Roethlisberger dates tentatively to *c*.1650, a date which is confirmed by comparison with a view of the Sasso drawn in 1649 (RD.670).

72. Two Trees with Two Seated Figures

Black chalk and grey wash on white paper, 194 × 259 mm

Verso View of a Fortified Gate (fig. 22)

Black chalk

Provenance: bequeathed by Richard Payne Knight, 1824

British Museum, Oo.7–166; RD.516

In several of the earlier drawings in which black chalk predominates, Claude used chalk, sharpened to a point in the manner of a pen, or broadly applied like wash, but it eventually became freed from its origins in the ink

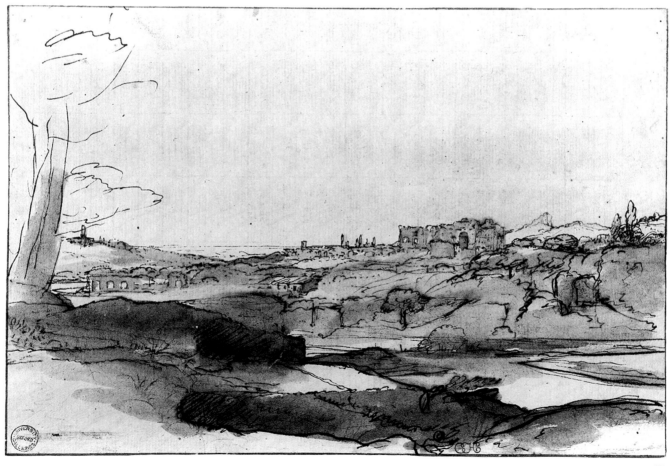

71

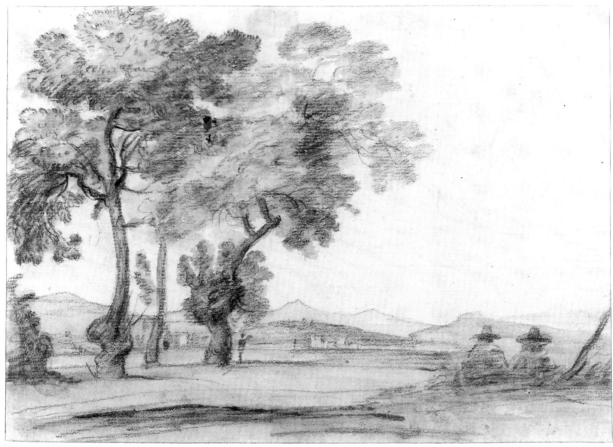

72

Fig. 22 *View of
a Fortified Gate.*
Black chalk.
RD. 516, *verso*,
British Museum.

drawings. The touch becomes soft and painterly, sometimes lightly washed, as here, with brush and water to give a pale tone to the forms. There is a witty balance between the two seated figures who may be artists, sketching in the open air, and the pair of trees. A third figure is visible below the tree on the right and what appears to be a fortified manor house can be seen in the distance. On the verso is a slight, unfinished sketch of an archway (fig. 22), flanked by towers, partly hidden by a mound, possibly representing the Porta San Lorenzo, seen from inside the walls, which was buried up to the imposts in Claude's lifetime.

73. A Bank of Trees

Black chalk with brown, pink and grey wash, touched with a pen and brown ink and heightened with white body colour on blue paper, 224 × 327 mm

Inscribed on the verso by the artist in pen and brown ink: *Claudio fecit Roma*

Provenance: bequeathed by Richard Payne Knight, 1824

British Museum, Oo.7–190; RD.587

The elaborate handling of this drawing combines the range of techniques used by Claude from the late 1630s and the 1640s in his nature drawings: black chalk, brown ink, washed red chalk and white heightening. The emphasis with which he has applied the chalk, like thick paint, and the painstakingly elaborate application of white body colour give it the appearance of a small painting. Otherwise, it belongs to a series of images which recur commonly in Claude's drawings from nature, in which a compact bank of trees and shrubbery form the main element of the composition. There are no good analogies in the Campagna and Tivoli books and, apart from a rather unusual drawing of the type in the British Museum (RD.309), Claude's interest in the motif seems to have developed in the mid-1640s. The neat, spotted application of body colour in the foliage might also be taken as proof of a date not far removed from the drawing of *Mercury and Argus* (cat. 67), inscribed with a date which Roethlisberger reads as 1647. The similar handling of the brush in a recently discovered view of trees, dated 1648, tends to confirm the late 1640s as the approximate date of the present drawing (Sotheby's, New York, 22 January 1998, lot 22). Once the elaborate manner has been discounted, there are many similarities with Claude's drawings from the mid-1640s to the 1660s, most of which explore variations of dappled sunlight on foliage, occasionally with small bushes, or single trees, standing out against a mottled background. Three or four neatly washed drawings of the type are known (e.g. RD.309, 387, 543), one of which (RD.592) is dated

1645. As the type developed, Claude abandoned his use of dense wash and relied increasingly on soft black chalk to define the range of tones between sunlight and shadow (e.g. RD.699, 885 and cat.85). Many of these drawings are closed along the lower side by a wedge of foreground, drawn with pen and wash, probably in the studio, sometimes with the addition of a figure whose absence here gives a sense of emptiness to this composition by comparison with the others.

74. A View of Tivoli from the Temple of the Sibyl

Pen and brown ink with brown wash on white paper, 214 × 314 mm

Inscribed in pen and brown ink by the artist in lower right: 4; and, on the verso, in red chalk: *CLAVdO/ R*

Provenance: bequeathed by Richard Payne Knight, 1824

British Museum, Oo.6–80; RD.429

This is one of the first drawings from the so-called Tivoli Book, identified by the artist's monogram on the verso and by the erased number 4, indicating the page number in the volume. The pages which were at one time before and after this can be dated to the period of the Campagna Book by comparison with the pen drawings washed in pink, but the style of this sheet seems to differ sharply from the others. As Roethlisberger has pointed out, Claude adopted a particularly careful style of penwork for topographical purposes when drawing identifiable buildings, mostly at Tivoli but also at Villa del Sasso, S. Agnese fuori le Mura and Nemi. The character of the penwork, however, is not just more careful than Claude's usual manner of drawing in the early 1640s, but is essentially different. The deliberate handling in small touches and straight, stitched strokes in the foreground parapet seems more typical of the work of the early 1660s. As the Tivoli Book may have been a compilation of drawings of different date, the location of this drawing between two early drawings can be discounted as evidence of a date in the early 1640s. It is probably considerably later than the others, perhaps dating from the 1650s, but this is difficult to establish with certainty.

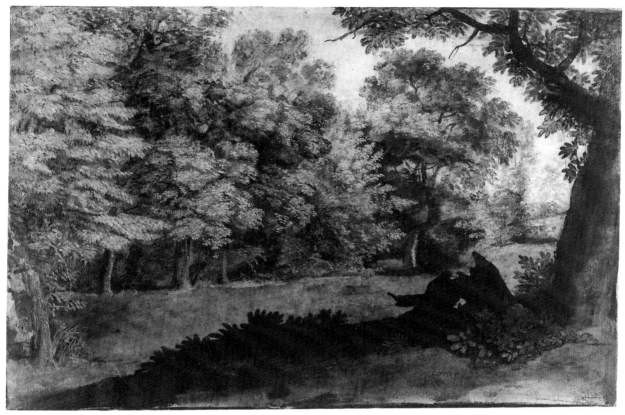

73

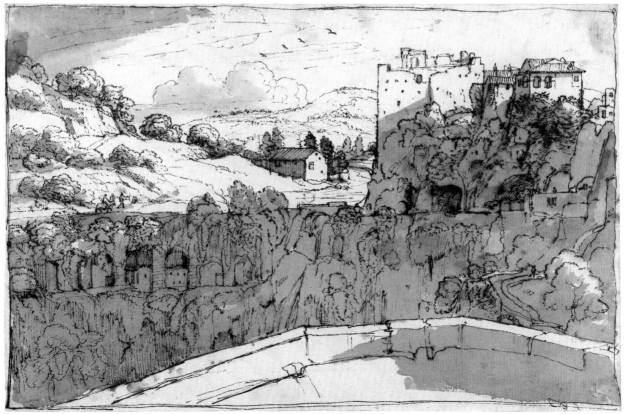

74

75. Figures Disembarking on a Shore

Black chalk, pen and brown ink with brown wash, divided
into sections with the ruler and graphite, on white paper,
tinted with a reddish wash, 192 × 267 mm

Provenance: bequeathed by Richard Payne Knight, 1824

British Museum, Oo.7–160; RD.689

The composition is a preliminary study for the painting
in the collection of the Earl of Radnor, traditionally
known as *The Landing of Aeneas*, although the precise
subject is not clear. On account of the strong, slanting
sunlight, the composition was engraved in 1772 with the
subtitle *The Allegorical Morning of the Roman Empire.*
It is more likely that Claude intended a sunset and quite
certain that he had no such allegorical intention in mind.
The drawing seems to come between a similarly finished

composition of the same subject in the Ecole des Beaux-
Arts in Paris (RD.690), which has similar figures, and
the finished painting, which has a similar background.
For the figures in the painting, Claude reverted to a
drawing of an embarkation scene, dated 1643, which
Roethlisberger suggests may link with the theme of the
Earl of Radnor's picture. The drawing of 1643 has,
otherwise, no connection with the present drawing from
which it differs in both figures and background. The
painting is dated 1650 which must also be the approxi-
mate date of the preparatory studies. Both are carefully
completed in brown wash to suggest the effect of sunset
which is an essential feature of the painting. The pinkish
ground, which Claude used here, adds warmth to the
lights which are carefully picked out against the wash.

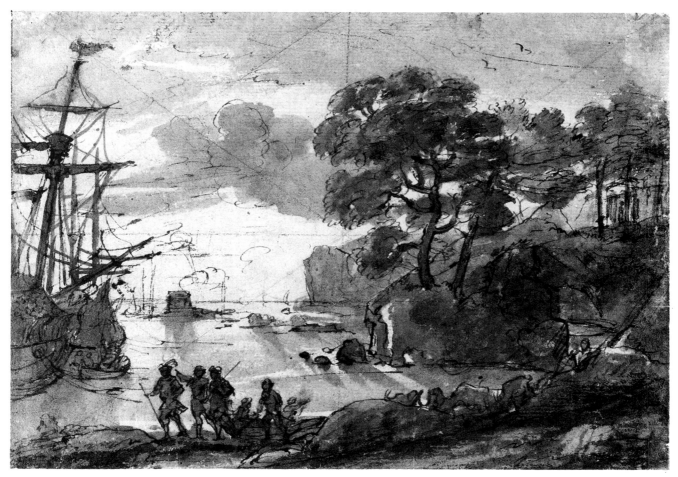

75

76

76. The Castle at Tivoli

Pen and brown ink on blue paper within a framing line in pen and brown ink, 218 × 318 mm

Inscribed in pen and brown ink by the artist in lower left of centre: *fortezza di/ tivoli*; and on the *verso* in red chalk: *CLAV/ Ro IV*

Provenance: bequeathed by Richard Payne Knight, 1824

British Museum, Oo.6–78; RD.535

The view shows the entrance and one of the four crenellated towers of Rocca Pia, the castle built by Pius II at Tivoli, neatly outlined with the pen in the same linear manner as cat. 74, a view of Tivoli from a different site. The composition has been lightly indicated with a finely sharpened quill and strengthened with a darker point in touches of different intensity. The minimal shading, visible only in the tree and in the clouds, gives a spare, unfinished appearance to the drawing, as if prepared for wash, although it is certain that Claude did not intend to add wash. It was once the sixty-first sheet in the Tivoli Book and was probably drawn at the same date as the tree studies on blue paper which appeared with this sheet at the end of the book. The evidence for identifying the Tivoli Book as a compilation removes much of the argument for dating these drawings to the period 1640–45, leaving open the possibility of a later date which would be more in keeping with the dry, controlled penwork. It is difficult to find dated analogies but one might guess that it falls somewhere between the Sasso views of 1649 and the more rudimentary views of La Crescenza of 1662.

77. A Group of Trees by a Roadside

Black chalk with pale greyish-brown wash on white paper tinted with pale brown wash, 222 × 311 mm

Inscribed lower centre by the artist in black chalk: *faict a foro di Roma*; and on the *verso* in red chalk: *ClAV/ Ro IV*

Provenance: bequeathed by Richard Payne Knight, 1824

British Museum, Oo.6–44; RD. 515

The technique of this drawing derives from the drawings of the late 1630s with black chalk in place of wash. Several drawings of the type, including the present drawing, were once in the Tivoli Book. Dating them is difficult. There is no reason why wash drawings and black chalk drawings should not have co-existed into the early 1640s. The type of view, looking down a winding road with little figures of travellers in the middle distance, is found also in the wash drawings but the chalk drawings of this type may be later than the wash drawings perhaps by a margin of many years. The inscription identifies the view as taken from a site outside Rome, possibly near La Crescenza, if the *casale* on the hill on the right can be identified as the manor house of the Crescenzi. The area round La Crescenza was one of Claude's favourite sketching grounds. The castle is more clearly identifiable in another drawing from the Tivoli Book in Haarlem, probably of the same date, drawn in the same blend of thin wash and dense, black chalk (RD. 514). It was also the subject of a painting by Claude in the late 1640s (RP. 186) and it appears in one of a number of drawings made in the area in 1662 (RD. 870, 870a, 871, cat. 86).

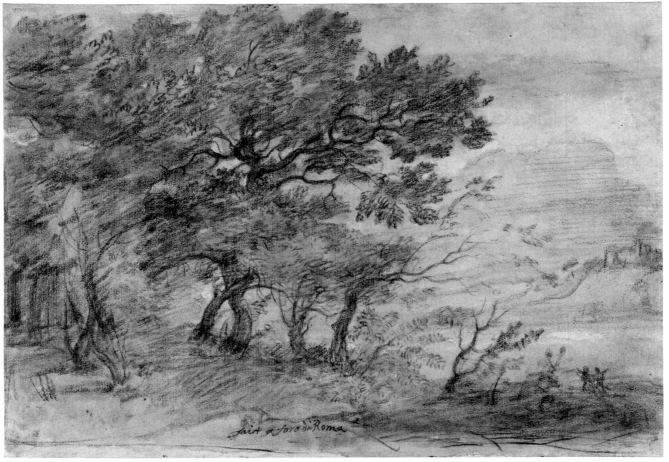

77

78. Figure Studies

Black chalk, pen and dark brown ink, heightened with white body colour, on white paper tinted with a reddish wash, 155 × 257 mm

Provenance: bequeathed by Richard Payne Knight, 1824

British Musuem, Oo.7–140; RD.687

Similar pink washed paper is used in cat. 68 which, like this study for LV 121, a pastoral landscape of 1650 (RP.189), was drawn in preparation for a painting. In the final composition the young girl, on the right side of the drawing, is placed in front of the seated shepherd on the left. Claude probably began with the unfinished study of the youth at the centre of the sheet which he abandoned before completing any more than the left leg, redrawing him on the left side and leaving space for the girl whom he then drew separately on the right. The reversal of the figures hardly mattered to Claude for the purpose of the painting since he was chiefly concerned with the appearance of the figures, not with their relationship which is fairly simple. Claude subsequently completed this study, as he completed cat. 68, by adding a tree on the left behind the shepherd and a figure on the right listening to the girl who would, otherwise, have appeared to be addressing thin air. Since space on the edges was limited, Claude drew the tree and figure smaller than the other details but completely out of scale. At this stage, the disembodied leg at the centre of the sheet was incorporated into one end of a rock on which the shepherd is seated. The figures are charming, but the result of the additions is thoroughly peculiar.

78

79. Shepherd and Shepherdess Conversing in a Landscape

Etching, retouched in pen and brown ink, 200 × 258 mm (plate)

British Museum, 1973–U–621; M. 41.i

Following completion of the set of twelve etchings in c.1641, Claude does not seem to have shown more than a desultory interest in printmaking. Only four of Claude's prints can be dated within the following forty years of his life: one in 1650 or 1651 (the date is unclear), two in 1662 and this spacious pastoral composition which is undated. The figures and animals reappear in reverse in a painting of c.1645–6 but in a setting in which the elements have been substantially rearranged. The print is generally thought to date from the early 1650s. This is a unique impression of the first state, extensively reworked by the artist in pen and brown ink to indicate the places where the print required a darker emphasis. As Diane Russell points out, these changes were not introduced immediately. Many of the changes were not followed in later states (e.g. the shadow on the cow silhouetted against the water and the shadows in lower left) while others (e.g. the darkening of the bushes behind the figures and the goat on lower right) were not carried out until the third or fourth states. In the final state, Claude eliminated the town, made the foliage of the trees less diffuse and pulled the whole image into a tighter and more contrasted composition in which the drier manner of Claude's later drawings and etchings becomes more evident than it is here.

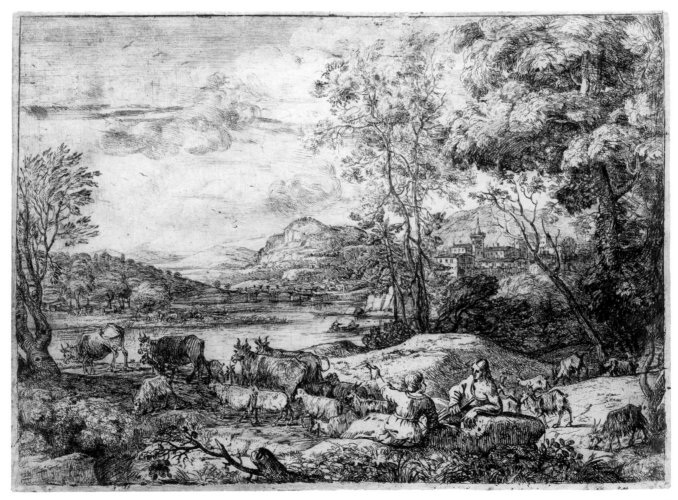

79

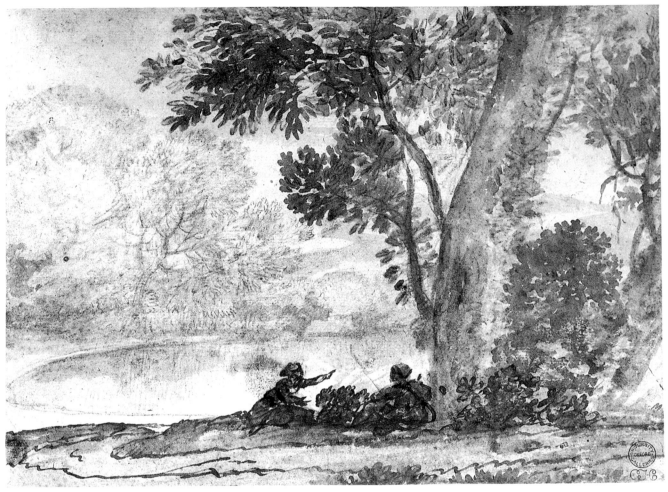

80

80. Two Figures, One with a Fishing Rod, Seated by a Tree

Black chalk with pen and brown ink with brown wash on pale beige paper, 192 × 254 mm

Stamped: Hall (L. 551); University Galleries (L. 2003)

Provenance: presented by Chambers Hall, 1855

Ashmolean Museum, 1855.62; RD. 700

Starting in the late 1630s or early 1640s, Claude developed a style for drawing complex landscapes in light black chalk, drawing over the foreground with the pen and brush in dark brown ink but leaving the background largely untouched or lightly toned with thin, pale wash. The treatment of the tree, drawn mostly with the brush, is particularly close to a number of tree studies in the British Museum (e.g. RD. 678 and 679) which were probably drawn in the 1650s. There are a number of similar drawings of figures seated by the water's edge in Claude's drawings (RD. 464, 571, 682, 696); but firmly dated analogies are difficult to find.

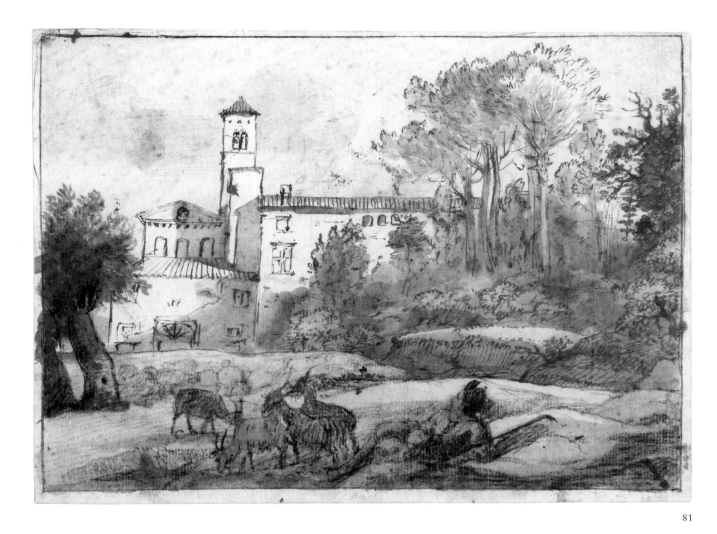

81

81. The Church of Sant'Agnese with a Herdsman in the Foreground

Black chalk with pen and brown ink and brown wash on white paper edged with a framing line in brown ink; a small green stain towards lower left, 187 × 249 mm

Inscribed on the *verso* by the artist with many numbers in pen and brown ink

Provenance: Henry Wellesley; Sir John Robinson; John Malcolm; purchased, 1895

British Museum, 1895-9-15-905; RD.723

The buildings and trees in this spirited view have been drawn with a fine pen and touched with a thicker pen in the shadows, while the clouds, goats and goatherd are drawn in black chalk within a clear foreground band which the artist probably left unfinished when the main view was drawn in the open air, with the intention of finishing it later. Krautheimer identified the buildings in 1937 as the ancient church of Sant'Agnese fuori le Mura in the form in which it was rebuilt by Cardinal Varallo after the sack of 1527.[26] The penwork in the trees is a type which is found in the Sasso drawings of the late 1640s but is not necessarily contemporary. The rougher, broader penwork in the foreground has analogies in drawings which can be dated from the early 1650s (e.g. RD.717) to the early 1660s (e.g. cat. 88). Similar reclining herdsmen are also common in drawings of the same period.

82. A Study of Trees

Black chalk, brown wash on white paper tinted with a pinkish wash, 262 × 200 mm

Verso A Branch of Foliage and a Study of Steps
(fig. 23)

Pen and brown ink (in the foliage); black chalk (in the steps)

Provenance: bequeathed by Richard Payne Knight, 1824

British Museum, Oo.7–171; RD.679

In Claude's drawings, trees drawn along one side of the sheet normally flank a view, however slight, but Claude has omitted the background in this drawing and finished the tree in crisp, brown wash over a drawing in black chalk. How much, if any, was drawn from nature is difficult to say. If not a nature study, it has probably been traced or copied from a nature study for the purpose of reusing it in a composition. Claude tended to use pink washed papers for studies made in the studio, sometimes as a foil to body colour (e.g. RD.711), but more often as a ground for chalk and wash, anticipating the warm light in the background of a painting. The only firmly dated drawing in which the leaves and trees have been so carefully defined with the brush, cat.49, is dated 1640, but flanking trees, drawn in the same simplified manner, recur in a number of oblong landscapes (e.g. RD.587, 699, 701) which were probably drawn between the mid-1640s and the mid-1650s. The slight study of architecture on the *verso* (fig.23) seems to relate to the terrace in the background of *Queen Esther at the Palace of Ahasuerus*, a painting of 1659, which features a group of flanking trees on the left akin to the present study. Kitson's suggestion that it relates to the similar configuration of trees and terrace in the *View of Delphi with a Procession* of 1650 (LV 119) is equally telling and fits better with the range of dates usually associated with this type of drawing; but the form of the steps on the *verso* corresponds more closely to the terrace as it appears in an elaborate preparatory drawing for the painting of Queen Esther (Metropolitan Museum of Art, New York).[27] At a late stage Claude introduced a curving wall into an area of this drawing which had been previously cancelled with white body colour. He probably drew the slight detail on the *verso* of the present study for the sake of trying out the effect before retouching the finished drawing, which he completed with unusual care, perhaps for submission to his patron, François Bosquet, in Montpellier.

83. Queen Esther at the Palace of Ahasuerus

Black chalk, pen and dark brown ink with brown wash, edged with a pen line in brown ink divided into sections along the lower and right edges, 219 × 324 mm

Provenance: bequeathed by Richard Payne Knight, 1824

British Museum, Oo.7–229; RD.817

As the production of Claude's paintings declined after 1650 and as the importance of his compositions increased, the preparatory work for his major paintings became more extensive, as far as one can estimate from the number of surviving drawings. There are three known preparatory compositions and one figure study which were drawn for *Queen Esther at the Palace of Ahasuerus*, completed for François Bosquet, Bishop of Montpellier, in 1659. According to Baldinucci, Claude valued this painting as one of the most beautiful of all his works: 'such was also the opinion which true conoisseurs of art held of that particular work, not so much for the amenity of the landscape as for the various marvellous buildings adorning it'. In the earliest of the three studies (RD.816), Claude appears to have combined the landscape of a recent painting, *Jacob and Laban* (LV 134) of 1655, with the type of flanking architecture which is common in his port scenes, but then altered this idea drastically in the present study, introducing a range of more spectacular buildings, dominated by the Tower of Babel and the vast palace, placed on a steep hill above the river on a terrace which seems to have been inspired by the Terrace of the Belvedere in the Vatican. The awkward junction between the palace and the portico was ironed out in a further elaborate study, perhaps prepared as a *modello* for the patron, dated 1658, in which the palace has become more extensive, rising above complex terraces.[28] Finally, in the painting, he moved the Queen and her retinue to the left side, removing the group of seated spectators, simplified the palace, eliminated the Tower of Babel and created a perfect harmony of figures and architecture. A fragment of the painting, which was severely damaged by a fire at Fonthill, survives at Holkham but the effect can be judged better from the drawing in the Liber (LV 146). The present study has been marked off at regular intervals along the lower margin in eleven and a half sections, corresponding, perhaps, to the length of the painting, measured in hands (i.e. approximately 270 cm).

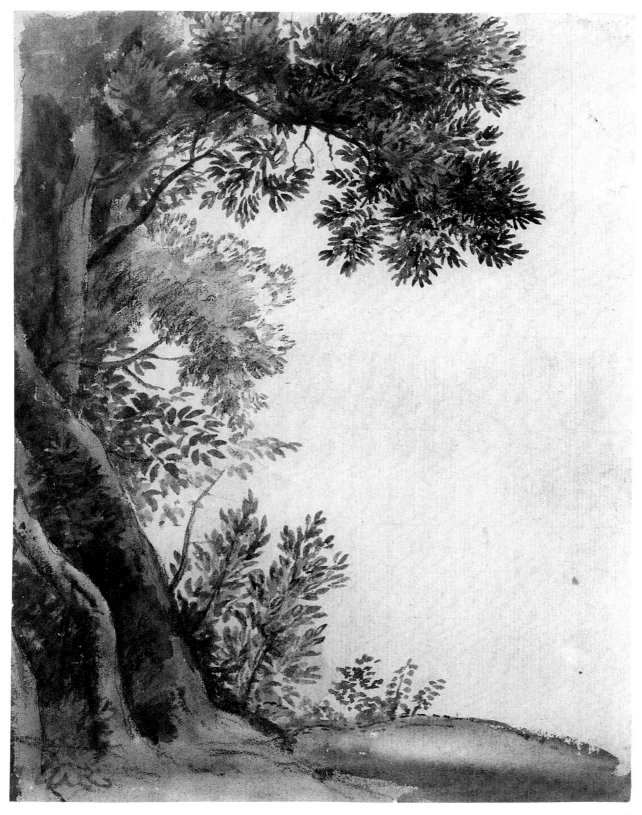

Fig. 23 *A Branch of Foliage and a Study of Steps*. Black chalk and pen with brown ink. RD. 679, *verso*, British Museum.

84. Travellers on a Road below a Large Tree

Black chalk with grey wash, touched with white body colour in the sky and figures, on paper coloured yellow, 257 × 403 mm

Provenance: bequeathed by Richard Payne Knight, 1824

British Museum, Oo.7–207; RD.704

Claude never used a yellow ground to such startling effect as in this large atmospheric image, charged with a thundery light which picks out two travellers passing along a path under a huge tree. A single goat, perhaps a relic of a discarded composition, has been cut off by the lower edge. All Claude's known drawings on yellow-washed paper, apart from this dramatic landscape, are figure studies or figure compositions, mostly drawn in chalk and wash, all but one of which are linked to compositions painted between c.1652 and c.1660. Claude seems to have used the yellow ground in place of the pink wash which was more common between the late 1640s and early 1650s. These grounds allowed him to assess in advance the warmth of the finished painting but, in this case, the effect of light, which has sunk somewhat through discolouration, has become an end in itself. It may have been drawn at the beginning of the 1660s when similar huge trees first appear in Claude's work.

85. A Bank of Trees

Black chalk, hatched and rubbed, with pale grey wash on white paper, 260 × 391 mm

Verso Study of a Tree (fig. 24)

Pen and brown ink

Provenance: bequeathed by Richard Payne Knight, 1824

British Museum, Oo.7–186; RD.824

The motif of a block of trees in sunlight interested Claude over a number of years. The abrupt contrasts of light and shade which were defined by layers of brown wash in the earlier studies have given way to softer effects of black wash, lightly washed with a wet brush. A similar group of trees appears in a drawing done in the same manner in the British Museum (RD.886) of approximately the same size, which may represent the same site and must be contemporary. Claude drew the study in the open air, leaving blank spaces in the foreground for additions in brown ink. Neither drawing was completed as Claude intended with the framing motifs which appear habitually in his nature drawings.

86. Three Figures on the Banks of a River

Pen and dark brown wash on white paper within framing lines in pen and brown ink, 183 × 251 mm

Inscribed in pen and brown ink by the artist in lower right: *Claudio/ Cresencia/ Roma 1662*

Provenance: bequeathed by Richard Payne Knight, 1824

British Museum, Oo.8–242; RD.868

Claude made several excursions in 1662 along the Tiber to Acqua Acetosa, the Ponte Nomentano and La Crescenza, all within a short walking distance of the Ponte Molle. The drawings in which he recorded the sites that he visited at this time are mostly dated, a practice which is uncommon in his earlier drawings from nature. This warm, luminous drawing of figures shaded by the trees on the bank of a small river near La Crescenza is constructed with short, brisk penstrokes of varying density which define the shadows and the contours. The composition inverts Claude's common motif of two figures seated on the nearside of a pond or river, by moving them to the opposite bank. The foreground, in contrast to the dark foregrounds which usually enclose his nature drawings, is drawn with a delicate pen and lighter wash than are the bank and tree across the stream which are shaded with a rich, dark wash over emphatic touches of the pen. There is nothing in Claude's earlier work to compare with the charming motif of the young girl in the foreground leaning against the tree, although a similar figure standing by a tree appears in an undated but probably contemporary drawing of Acqua Acetosa (RD.875). She may be the same young girl who reappears in another view of Acqua Acetosa (RD.874), dated 31 December 1662, and in another pen drawing of La Crescenza, also dated 1662. She is, perhaps, Claude's ward, Agnese, whom he adopted in 1653 and who would have been nine or ten years old in 1662.

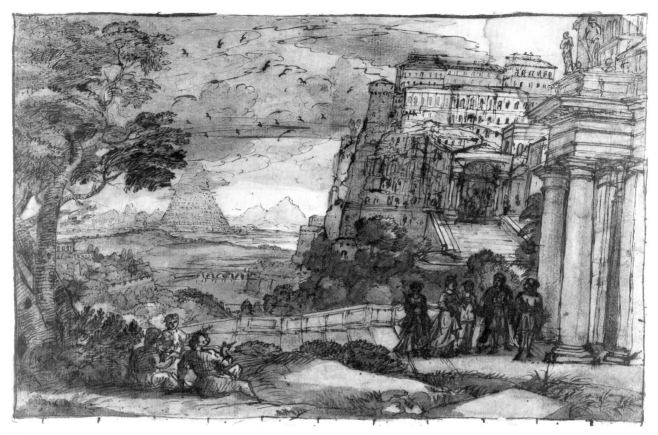

83

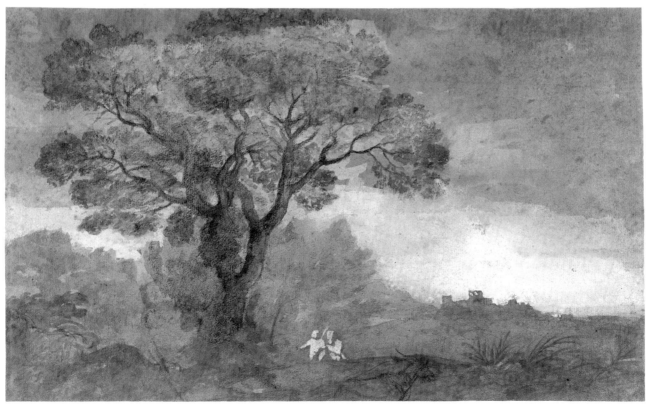

84

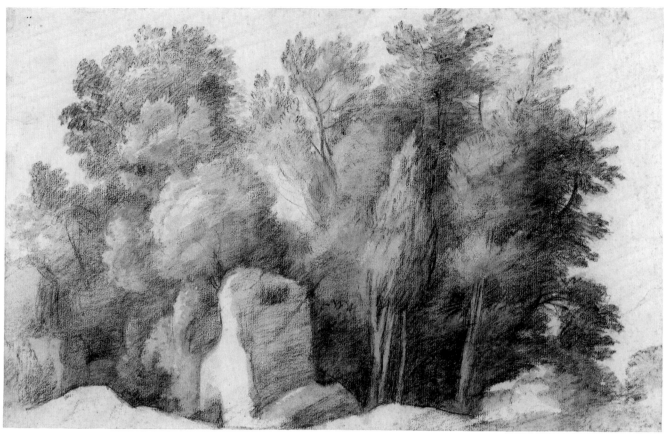

85

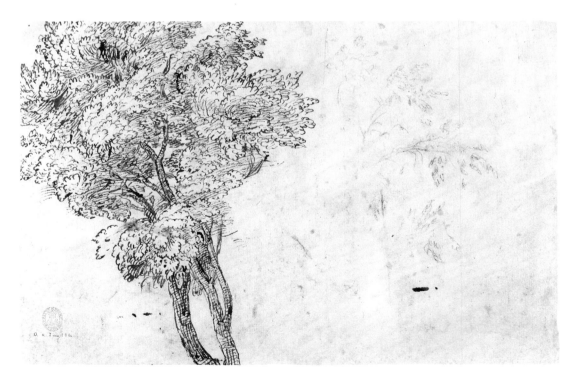

Fig. 24
Study of a Tree.
Pen and brown ink
with brown wash.
RD. 824, *verso*,
British Museum.

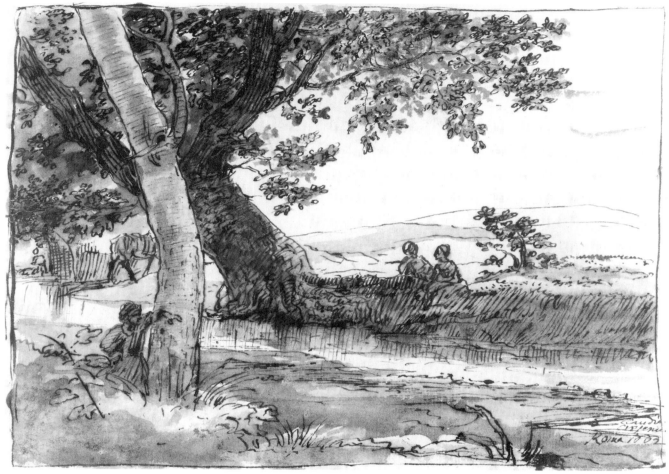

86

87. A Scene of Sacrifice in Antiquity

Black chalk with pen and brown ink and brown wash on off-white paper, edged with framing lines in brown ink, evenly foxed, 185 × 256 mm

Provenance: Sir Alfred Mond, Lord Melchett; Mrs Arthur Acland Allen, by whom presented, 1940

Ashmolean Museum, 1940.90; RD.882

These figures reappear in one of the two Altieri Claudes, *Landscape with the Father of Psyche Sacrificing at the Milesian Oracle of Apollo*, painted in 1662 and now in Anglesey Abbey. The composition, which represents Psyche's father invoking Apollo to find a husband for his daughter, illustrates an episode in Book IV of Apuleius's *Golden Ass*. In 1961, Roethlisberger described this drawing as a 'finished independent drawing', dating from 1663-70,[29] but in 1968, suggested that it is 'an advanced preliminary study' completed as an independent drawing

by the addition of the background and dating from the early 1660s.[30] The penwork of the figures and the background, which appears to be continuous, tend to support Roethlisberger's earlier suggestion that it is not a study for the painting but an independent composition derived from it. The figures have been adjusted to take account of the change in scale. The attendants, approaching from a distance in the painting, have been brought to the edge of the altar in the drawing and the figure of the soldier on the right in the painting has been suppressed to allow the youth with the sacrificial bull to be brought within the smaller format. A similar process of compression of the figures is found in other figure drawings and etchings in which Claude adjusted the scale of the figures in his paintings to take account of the size of the paper. The tentative, ungainly penwork of this composition differs from the more common chalk and wash used for a number of similar figure drawings by Claude during the development of a composition and

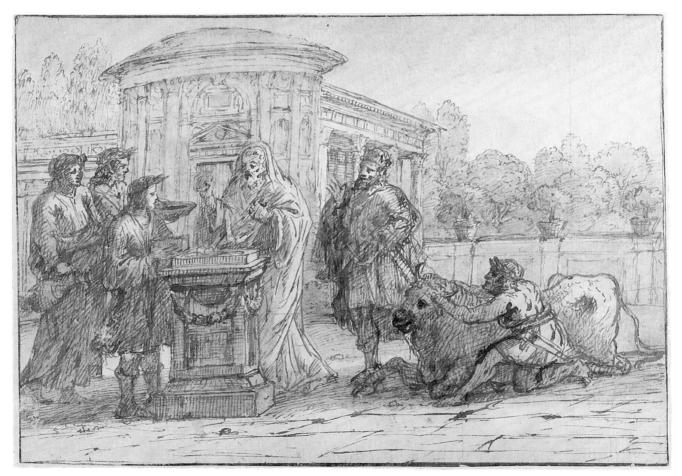

87

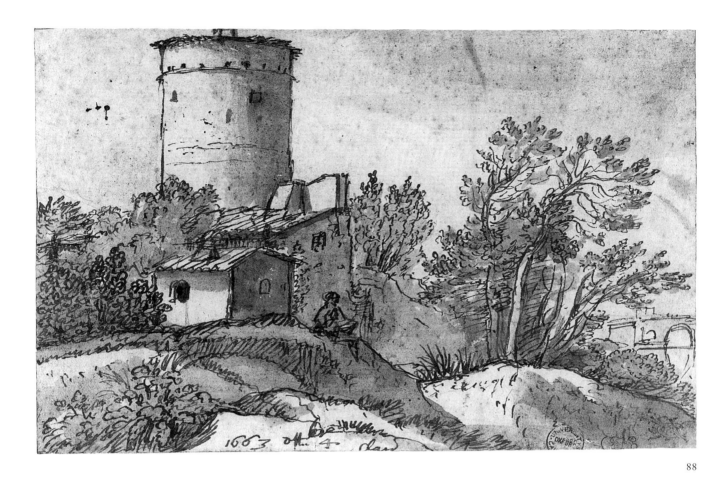

sometimes completed with their own backgrounds. The manner of drawing used here is more normally found in preparatory studies of landscape, several of which can be linked to more extensive compositions. By analogy with these, this drawing can best be explained as a preliminary stage in the development of the painting, as Roethlisberger suggested in 1968, adjusted to fit the size of the paper and completed with its own background to create an independent composition.

88. Farm Buildings by the Tiber

Black chalk with pen and brown ink and brown wash on off-white paper, 122 × 184 mm

Inscribed in pen and brown ink, lower edge: *1663 ottbre. 4 Claud*

Stamped: Richardson sen. (L. 2183); Hall (L. 551); University Galleries (L. 2003)

Provenance: Jonathan Richardson, sen.; Chambers Hall, by whom presented, 1855

Ashmolean Museum, 1855.64; RD. 908

As Arthur Hind first pointed out, the traditional identification of this building as the Torre di Quinto is impossible.[31] The Torre de Quinto was a square structure built well back from the Tiber on the opposite bank. This appears to be a farmhouse, incorporating a round tower which was probably built originally to defend the approach from upstream to the Ponte Molle. The east end of the bridge is visible on the left side of the drawing. The same farmhouse, adjusted in the details, reappears in the *Pastoral Landscape* of 1645 in Birmingham and in the preparatory drawing in the Louvre (RD. 578). The Ponte Molle itself, seen from the left bank, appears frequently in drawings and paintings by Claude dating from the 1630s to the 1660s. Nearly all Claude's identifiable sites along the edge of the Tiber are taken from sites along the road on or near the same side of the river. This study is one of the latest in a series of dated drawings made by Claude in the Tiber valley in 1662–3. He dated few of his nature studies before 1662 and few, if any, during the last decade of his life, when ill-health must have prevented him from walking in the Campagna. The seated figure facing the river may be sketching, but it is difficult to be sure.

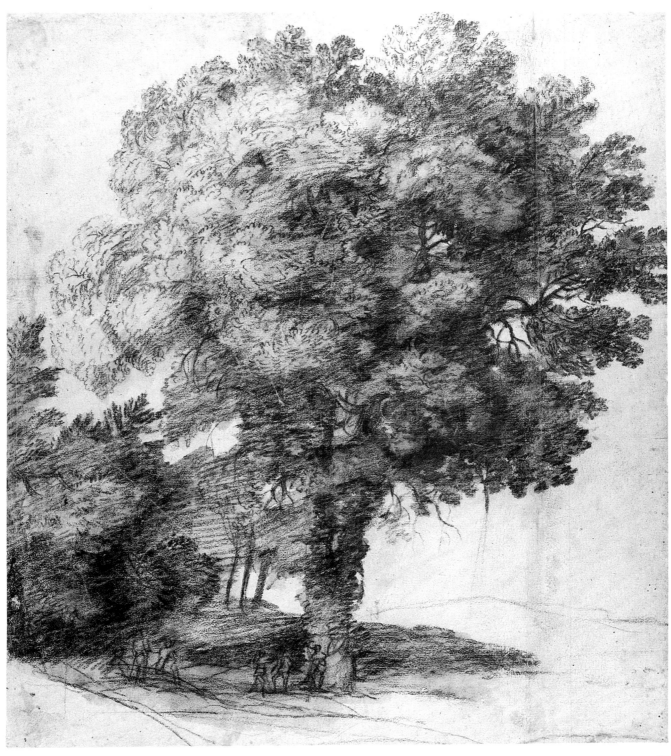

89

89. Study of a Large Tree

Black chalk with grey wash on white paper, 384 × 331 mm

Provenance: bequeathed by Richard Payne Knight, 1824

British Museum, Oo.–7–184; RD.901.

Roethlisberger has noticed a general but convincing similarity between this study of a tree and a similar grandiose tree which appears, in reverse, in a drawing of a country dance in Windsor, dated 1663 (RD.902). The figures in the drawing in Windsor are taken from Claude's *Landscape with a Country Dance*, painted for Urban VIII twenty-five years earlier, but the heroic tree is an invention of the 1660s. Similar vast trees appear at regular intervals in Claude's paintings of the 1660s and 1670s. Tiny dancers were already present in this study in the British Museum, confirming that, whether or not this tree was drawn in the open air, the theme of the finished composition was already in his mind. The figures also provide an indication of scale which contributes to the heroic stature of the tree and was probably exaggerated. The broad, painterly application of black chalk is difficult to match among Claude's drawings that are commonly dated to the 1660s but is found in drawings that have been dated to the 1640s (e.g. RD.515, 567). The evidence for dating this drawing to *c.*1663 cannot be set aside easily and one must conclude that the drawings of this kind may have been dated too narrowly to the supposed period covered by the Tivoli Book from which several of the drawings from nature in black chalk derive. In particular, there is a study in black chalk for a similarly heroic tree in the British Museum (RD.567) which Roethlisberger places in the 1640s although it has, on the *verso*, a little study of a horseman, linked (as far as one can make out) to the horseman on the right side of the drawing in Windsor. The figure is indistinct but it confirms the evidence of the style of the drawing on the *recto* which also suggests a connection between the two studies.

90. Landscape with a Herd of Deer

Black chalk, rubbed, with pen and brown ink on stained off-white paper, 192 × 254 mm

Stamped: Richardson, sen. (L. 2183); West (L. 419); Hall (L. 551); University Galleries (L. 2003); Dimsdale (L. 2426)

Verso inscribed in pen and brown ink: *Claude Gellée fecit Roma [le 2 crossed out] deux juin/ A Roma 1666/ A monsier/ Guquin* (two *ll*s have been added by the artist above the letter *u*); and in black chalk: *26*

Provenance: Jonathan Richardson, sen.; Benjamin West; Thomas Dimsdale; Chambers Hall, by whom presented, 1855

Ashmolean Museum, 1855.77; RD.933 (*recto*) and 1130c (*verso*)

The suggestion that this drawing is linked to Claude's *Enchanted Castle* of 1664 (London, National Gallery) appeared first in the catalogue of an exhibition in Bologna in 1962.[32] The composition corresponds to a section of landscape added to an early study (RD.931), now in the Staatliche Kunsthalle, Karlsruhe, in an attempt to elongate the composition to its present shape. This was subsequently modified, although the deer and rocky mountain on the left of the present drawing were retained in the final composition. It may have been an independent by-product of the other drawing, possibly intended as a gift for the otherwise unknown 'M. Gullquin' mentioned on the *verso* as Roethlisberger suggests. But it is difficult to be sure that it is not a preparatory study linked to a drawing in the same technique, relating to the architecture in the centre which, as Roethlisberger points out, seems to come between the first surviving idea for the extended composition (RD.931) and the final painting. Taken together, the two drawings appear to represent a stage of revision, relating to specific areas of the composition, drawn in the neat etched manner which Claude seems to have used with increasing precision from the 1640s to the 1660s while working on his compositions. An inscription similarly addressed to 'M. Gulquin' (or 'Gillquin'), dated 1666, appears on the *verso* of a study of 1663 (RD.929) for the same painting, which also belonged to Jonathan Richardson. By analogy with the inscription, dated 1666 on the *verso* of RD.929, the inscription on the *verso* may not refer to the date of the drawing. This is also confirmed by the style of the extensive use of pen hatching which was employed more sparingly by Claude from *c.*1665 onwards.

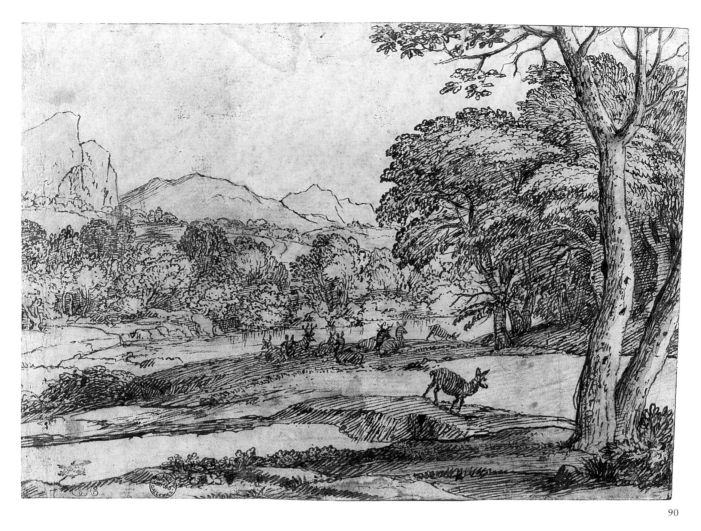

91. A View of a Coast

Black chalk, pen and brown ink with pale grey-brown and grey wash, corrected with touches of white body colour on white paper, 507 × 403 mm

Inscribed in pen and brown ink by the artist in lower right: *CLAVDIO IV f Roma*

Provenance: Anne Damer; Richard Payne Knight, by whom bequeathed, 1824

British Museum, Oo.7-233; RD.970

This large, minutely detailed drawing which corresponds to the left half of the painting of *Ezekiel Walking by the Shore* of 1667 (RP.244), with minor differences, belongs to a small, puzzling group of drawings, dated between 1667 and 1672, each of which is based on one half of a painting. Four of these drawings combine to form two compositions (RD.1030, 1035) but do not match perfectly and each has been adjusted in small respects to make independent compositions. The date 1670, inscribed on the drawing which corresponds to the left side of the *Pastoral Landscape* of 1671 (RD.1030), suggests that it may have had a preparatory role but this is not certain. These drawings are similar to a series of large copies or variants of the 1660s and 1670s which were drawn shortly before or after the completion of the related painting, some of which were certainly drawn solely for the purpose of replicating a composition. There may be a link with a tendency in Claude's late drawings towards an upright format (e.g. RD.91, 982, 1019, 1020, 1037) which does not appear in his contemporary paintings. The interest in an upright format in this period might have encouraged him to supply images to fit by slicing his compositions in half, as he had done, many years earlier, when he divided his print of a huntsman with goats by cutting through the plate. All that can be said with certainty about the present drawing and about other similar large copies of this period is that whatever purpose they may have served originally, they were completed by the artist to stand on their own as independent works of art.

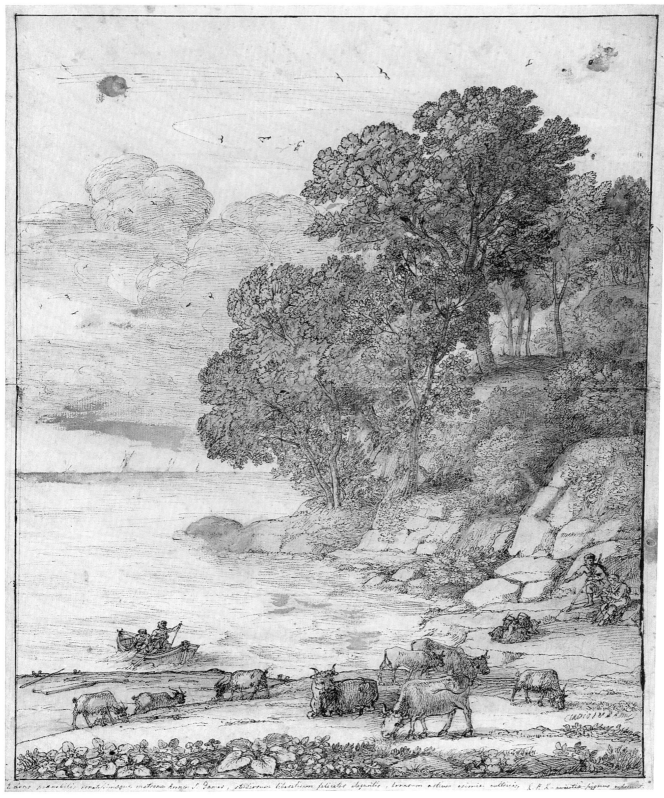

Edidit pernobilis venetissimaeque matronae domina S. Pani, stilicerum libertatem felicitas elegantia, bonorum artium eximia cultoris, L.P.L. amicitiae pignus inscripsit.

CLAUDIUS IV INV

91

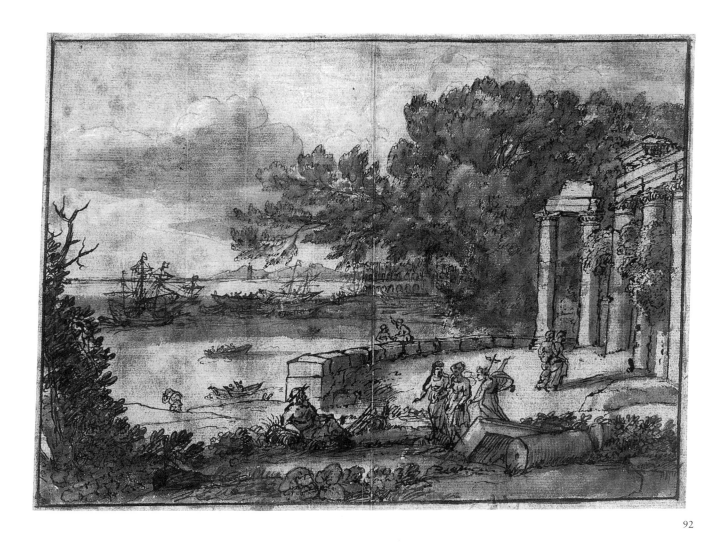

92. Coast View with Mercury and Aglauros

Pen and brown ink with brown wash on white paper, tinted with pale brown wash, edged with pen lines in dark brown ink and folded vertically through the centre, 203 × 267 mm

Provenance: bequeathed by Richard Payne Knight, 1824

British Museum, Oo.–6–120; RD.979

Claude often used the Liber Veritatis as a source for making later variants and copies when the original was no longer accessible. This composition, drawn in the cramped manner of the 1660s, has been directly copied from a drawing in the Liber (LV 70), recording a composition painted for Cardinal Rospigliosi in 1643. It also corresponds very closely to a more finished drawing in the Rospigliosi–Pallavicini collection in Rome (RD.980) and to an etching, in the same direction, by Dominique Barrière, dated 1668. Roethlisberger's suggestion that the drawing in Rome was made as the model for the etching is supported by the presence of four similar drawings of the 1660s owned by the Rospigliosi–Pallavicini families (RD.831, 879, 944, 981) all of which are repeated in etchings by Claude and Barrière. This close but more rapid copy may be an intermediary between the drawing in the Liber and the drawing in Rome, as Roethlisberger proposes, although in minor respects the drawing in Rome corresponds more closely to the drawing in the Liber than it does to the present drawing. Since Claude had the Liber to hand to adjust the details of the final drawing these anomalies may not be significant. The etching is certainly related closely to the Rospigliosi drawing in most respects although, again, in minor details, particularly on the right side, it is closer to this drawing and to the original in the Liber. It may be that Barrière consulted the Liber as well as the drawings, but it is also possible that the etching was based on a third lost copy. The reclining river god in the lower left reappears in a contemporary but otherwise unrelated drawing, formerly in the Wildenstein album (RD.877), which is probably not a preparatory study but a derivation from this group of works.

93. The Tomb of Cecilia Metella

Black chalk with pen and brown ink and grey-brown washes on a fine-surfaced, off-white paper, 177 × 252 mm

Inscribed in pen and brown ink, lower right of centre: *Capo da bove 1669./ Claudio fecit*; and on the drum of the tomb: *Caecilia* [.....]

Stamped: West (L. 419); Hall (L. 515); University Galleries (L. 2003); Dimsdale (L. 2426)

Provenance: (?)Johan de Witt; (?)his sale, 24 September–6 October 1696, lot 20 (last day); Jonathan Richardson, sen.; Thomas Dimsdale; Benjamin West; his sale, 1 July 1820, lot 65; Samuel Woodburn; Chambers Hall, by whom presented, 1855

Ashmolean Museum, 1855.55; RD. 1000

If this drawing was taken from nature, it would be remarkable among Claude's rare, late studies drawn in the open air for its careful rendering of detail and generally finished appearance. Given time and good weather, there is no reason why Claude should not have drawn this view, at least in part, from a seat on a bank of the Appian Way, looking to the south. But by the age of sixty-nine, Claude's walking tours must have become shorter and less frequent and it is more likely that it was drawn largely or entirely in the studio, imitating the type of naturalistic view of famous sites familiar in the etchings of Israel Silvestre. Roethlisberger has plausibly suggested that this drawing might be the view of the tomb with several small figures which appeared in the sale of Johan de Witt's library in 1696.[33] As the famous *Raadpensionaris* died in 1672, before the dispersal of Claude's drawings, and as Johan de Witt's son is not known to have collected works of art, Roethlisberger supposes that the forty-five drawings by Claude which appeared in this sale might have been added by the auctioneer.

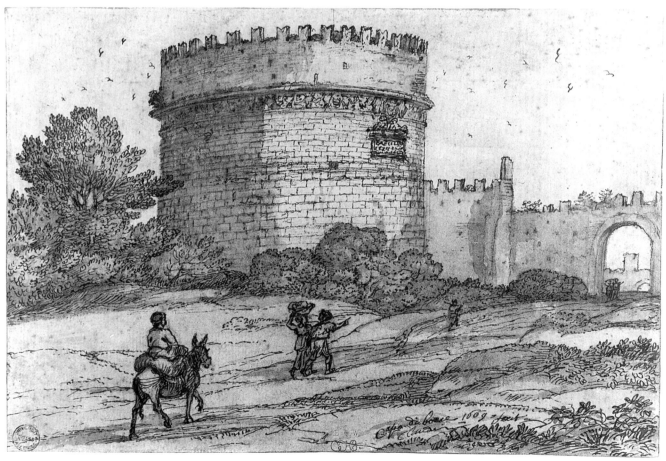

93

94

94. A Dove Nesting under Tall Plants

Black chalk with pen and brown ink on white paper edged
with a pen line in brown ink, 149 × 214 mm

Inscribed in pen and brown ink by the artist in lower left:
Claud fecit/ 1669

Provenance: bequeathed by Richard Payne Knight, 1824

British Museum, Oo.8–250; RD. 1002

The date 1669 also appears on a similar pen drawing in
Haarlem, showing a young girl seated below a plant with
large leaves holding a bird, probably a pet dove, on her
knees (RD. 1001). In this drawing, the dove is on a nest
while the girl is searching in the undergrowth. These
drawings help to date a group of similar drawings
featuring the girl, a dove or doves and plants with
large leaves (RD. 1003–6), four of which seem to be
marked with faintly off-set lines of writing. These are
fanciful, eccentric drawings, perhaps executed as studies
on a theme which had a particular significance for the
artist. Roethlisberger suggests that the girl may have
been Claude's ward, Agnese, who would have been aged

sixteen in 1669. The dove, in Christian art, is a symbol
of many things, notably of virginity and peace, but these
doves may simply have been a tame pair belonging to the
young girl. Six drawings in this series were mounted in
the last pages of the Animal Album, presumably because
the birds relate to the theme of the book.

95. Jacob Wrestling with the Angel

Black chalk with pen and brown ink with grey wash on white
paper, marked with a faint vertical line in black chalk on the
right, 65 × 104 mm

Stamped: Richardson, jnr (L. 2170)

Provenance: Jonathan Richardson, jnr; Francis Douce, by
whom bequeathed, 1834

Ashmolean Museum, 1863.23; RD. 1055

One of four small studies for the figures of Jacob and the
angel drawn in connection with a painting of 1672, now
in the Hermitage.[34] These studies, divided between the
British Museum (fig. 25), the Louvre, the Whitworth Art

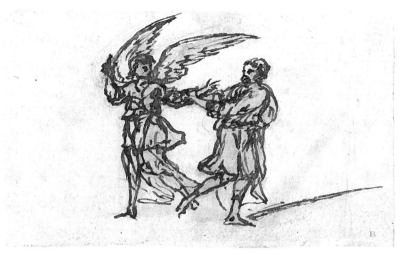

95

Gallery and Oxford, are similar in technique and were perhaps cut from a single sheet by Jonathan Richardson, who owned all four, or by a previous collector. The four drawings show Claude experimenting with the relationship between the two figures. In an early draft of the composition (RD. 1048) he showed the angel forcibly arresting Jacob in his flight. In the studies, the angel is shown tripping Jacob with a kick, no doubt in an attempt to explain the biblical account of Jacob's broken leg. In the final painting, the artist combined the angel in the drawings in the Louvre and in Oxford with the figure of Jacob in the drawing in the British Museum.

96. A View of the Aventine

Black chalk, pen and brown ink with brown wash on white paper, laid down on a mount within a band of grey-brown wash within an outer line and two inner lines in pen and brown ink, 192 × 264 mm

Inscribed in pen and brown ink by the artist in lower left: *al ponte rotte verso ripa grande/ facto alle 3 di novembre 1673/ Claudio fecit a Roma*

Stamped: Richardson, sen. (L. 2179)

Provenance: Jonathan Richardson, sen.; Maud Wethered, by whom bequeathed, 1991

British Museum, 1991–11–9––20; RD. 1082

This view of the Aventine Hill in Rome, seen from near the Ponte Rotto looking downstream, could not have been easily identified without the inscription. The drawing was made, presumably on the spot, in slack, rapid black chalk, recording no more than the merest indications of the view, which must have been finished later in pen and ink, omitting almost all the details of buildings on the hill. Fragments of columns, similar to those in the

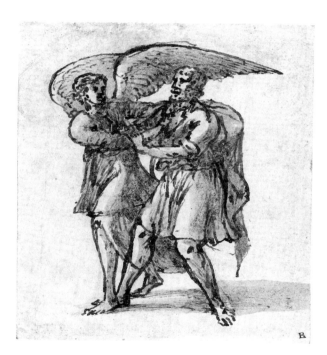

Fig. 25 *Jacob and the Angel*. Black chalk with pen and brown ink and brown wash. RD. 1054, British Museum.

foreground, once littered the left bank of the Tiber from the river to the lower slopes of the Capitoline. The construction on the right is hard to explain but it seems to have evolved from an earlier drawing of the Ponte Rotto which the artist has heavily cancelled with added masonry and foliage. The broken main arch and the subsidiary arch on the supporting pier are still visible beneath the later penwork. The spur, protruding into the river at this point, can only be the mud bank which appears against the bridge when the water level drops. The dark mound in mid-stream, immediately beyond, must be the remains of one of the piers of the Ponte Sublicio. These details and the precise date suggest that the outlines, at least, of the drawing were done from nature. There are no known drawings from nature that are dated later than this. It is not, however, a nature drawing, as such, but a view of Rome which, as Roethlisberger has pointed out, has been rearranged to

conform with the subject of *The Landing of Aeneas* (RP. 262). The buildings on the Aventine have been omitted in keeping with the story which is set in a time before Rome had been built. The Ponte Rotto, also, has been blotted out as an anachronism. The two figures, added below, may represent Pallas and Evander reacting with surprise at the sight of the galleys drawing towards land below the Aventine; in which case, the structure on the left may represent the altar of Hercules at which they were making sacrifice when the Trojan ships came into view. Without the date, one might have supposed that the present drawing was a preliminary idea from which the later composition developed; but the final composition had already been more or less established in a drawing in Stockholm (RD. 1081), dated October 1673, a month earlier than this composition. As it is, one must assume that it is a variant on the theme, drawn for its own sake.

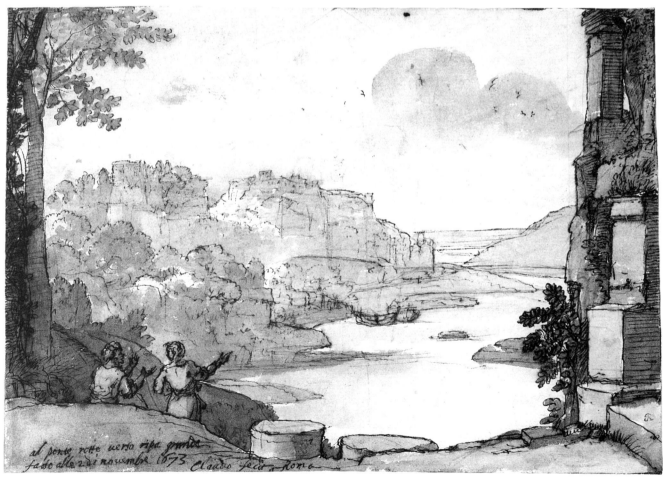

96

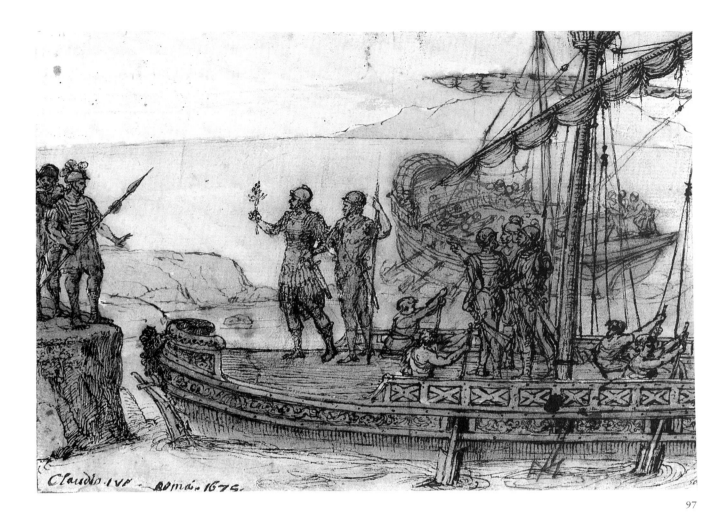

97. The Landing of Aeneas

Black chalk with pen and brown ink and brown wash on white paper, 185 × 255 mm

Inscribed in pen and brown ink by the artist in lower left: *Claudio. IVF. Roma. 1675*

Provenance: bequeathed by Richard Payne Knight, 1824

British Museum, Oo.8–269; RD. 1083

The development of *The Landing of Aeneas*, completed for Prince Gasparo Altieri in 1675, can be followed through a series of nine detailed drawings, dating from 1671 to 1675, only two of which, from the beginning and end of the sequence, are primarily concerned with the figures.[35] In addition, Claude drew at least three repetitions, including the drawing in the Liber. Roethlisberger has pointed out that the size of the painting and the date in March 1675 when the finished work was recorded in the Liber Veritatis make it certain that the painting must have been well advanced by the date of this drawing. It, too, could have been a repetition, taken from the painting, but it bears the all the characteristics of his preparatory studies, forming a bridge between the earlier drawings and the final composition. Aeneas, accompanied by a second figure, has a third companion in the painting, but is otherwise unaltered. In accordance with the text of the *Aeneid* and with the wishes of Altieri who specifically asked for 'the subject of Aeneas showing the olive branch to Pallas', he is shown holding out an olive branch to the approaching Arcadians. Pallas and Evander, standing on the shore, and the three soldiers standing by the mast, are similarly posed in the painting; although the space is more truncated here, there are fewer figures in the drawing and the second galley has been shifted into the background to fill the space without reference to its final place in the painting. By compressing the composition, Claude has not left sufficient room for the oarsmen beside the mast although their oars are still visible in the underdrawing. At this stage, prompted perhaps by Altieri, Claude realised that Virgil states unambiguously that Aeneas was standing, not in the prow, as he appears in all other preparatory drawings and in the painting, but on the stern, calling along the length of his ship to Pallas and Evander. The drawing attempts to take account of the text by converting the prow into a stern, complete with rudder, but leaving the

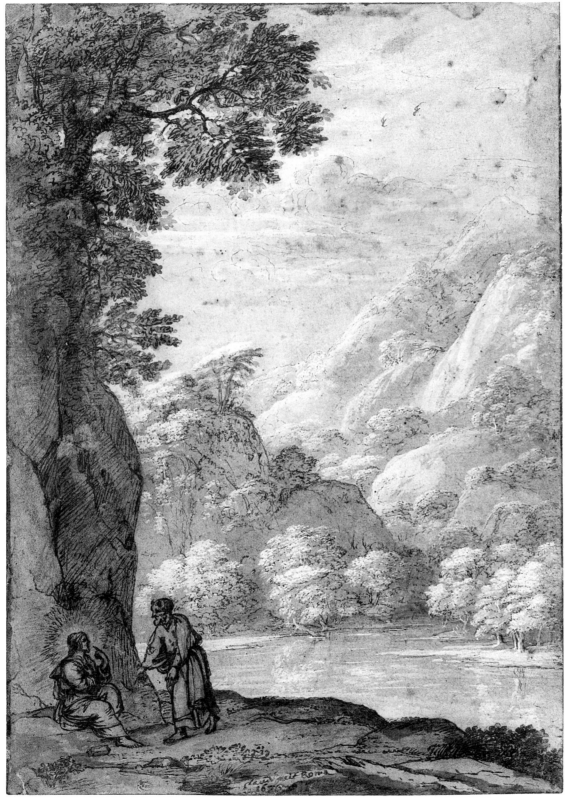

98

oarsmen facing in the wrong direction. This unhappy solution was abandoned in the painting in which the galley points towards the shore, prow first.

98. The Temptation of Christ

Pen and brown ink with brown and grey wash, extensively heightened with white body colour, on blue paper,
279 × 188 mm

Inscribed in pen and brown ink by the artist in lower centre: *Claudio fecit Roma/ 1676*

Provenance: bequeathed by Richard Payne Knight, 1824

British Museum, Oo.8–257; RD. 1092

There is no known painting by Claude which corresponds to this composition. It has been finished in so much detail, particularly in the background, that it was probably drawn as an end in itself. The shadows in the rocks are strengthened with the pen in areas of careful hatching. Cross-hatching, never common in Claude's drawings, is confined to tiny patches in the foliage. The extensive use of white body colour across the background, added with a careful stippled touch, gives the drawing the appearance of a small painting. Claude seems to have been attracted in the 1670s by the idea of

making independent drawings, highly finished, in a large upright format (cf. RD. 1019, 1020). Eckhart Knab has found the source of this drawing in a print by Hollar after a painting of the same subject by Adam Elsheimer.[36] Claude seems to have used prints increasingly in the 1660s and 1670s to provide him with the basic layout of the figures in a composition, but in this case he used it also as a source of foreground and background detail.

99. Landscape with Christ and the Magdalen

Black chalk with pen and brown ink and grey and blue wash, heightened with white body colour, on white paper tinted with blue wash, 163 × 284 mm

Inscribed in pen and brown ink, lower left: *1678 Roma*

Provenance: bequeathed by Richard Payne Knight, 1824

British Museum, Oo.8–265: RD. 1116

This is a preliminary study for Claude's *Landscape with Christ and the Magdalen* (RP. 272), now in Frankfurt, commissioned by Cardinal Spada as a pendant to Claude's *Landscape with Philip Baptising the Eunuch* (RP. 269). The blueness of the finished painting – a characteristic of Claude's late work – has been anticipated in the blue wash from which the outlines of the land-

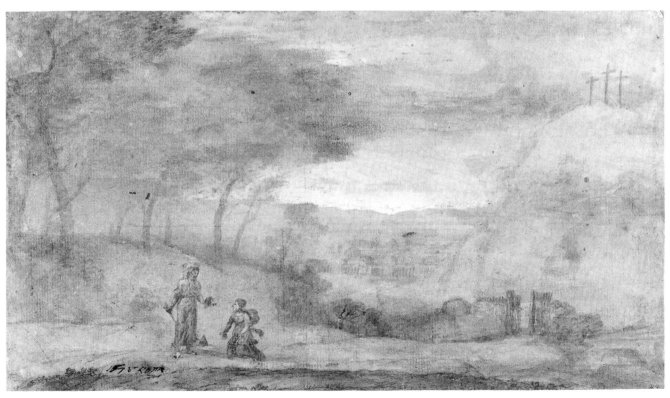

99

scape emerge in ghostly form. In the later studies (RD.1117–19), he diminished the dark curtain of cloud which melts into the darkness of the trees and spread the light more uniformly across the sky. The three crosses, which stand out as dark forms against the cloud, are less conspicuous in the painting. By contrast with other compositions from Claude's last years, which evolved through a process of reworking and rethinking, the composition of *Christ and the Madgalen* was decided quickly. The elongated format and the configuration of the trees and figures were determined by the earlier *Landscape with Philip Baptising the Eunuch*, completed for Spada in 1678 and, apart from the introduction of a large tree near the centre of the painting, there are few essential differences of detail between this early drawing and the finished work of 1681. The atmosphere, however, has changed. The final painting is a work of great beauty, more subtle and understated in its effects than the drawing, but lacking the sense of mystery and melancholy isolation which gives the study its particular poetry.

100. Landscape with Ascanius Shooting the Stag of Sylvia

Faint black chalk with pen and brown ink, brown wash and white body colour, oxidised, on off-white paper, foxed and pitted with several small losses, inscribed with diagonal and horizontal lines for transfer; laid on card backing within framing lines, 250 × 315 mm (sheet); 372 × 429 mm (backing)

Inscribed in pen and brown ink, at lower left: *libro.7.di/ Vigilio/ Claudio 1682*; in lower centre: *Come Ascanio caetta* [*il cervo*. painted out and reinscribed] *di Silvia./ figliola di. Tirro*; behind Ascanius: *Roma 1680/ CLAVDIO/I.V.F.*; above the long inscription at lower centre: *Ascanio* (painted out) and: *come* (painted out); the lower edge of the mount is inscribed in pen and brown ink: *Claudio Lorenese*; and *JB* (L.1419), in lower right and on the *verso* of the mount; the *verso* of the mount is also extensively inscribed by later hands

Provenance: Arthur Pond (L.2038); John Barnard; Lord Palmerston; Lord Northbrook: his sale, Christie's, 12 December 1919, lot 119; Horace Buttery; Mrs W.F.R. Weldon, by whom presented, 1926

Ashmolean Museum, 1926.1; RD.1128

This is one of three surviving studies for *Ascanius with the Stag of Sylvia*, Claude's last painting, dated 1682, now in the Ashmolean Museum.[37] The immediate pre-

cursor of this drawing is a finished composition study of 1678 at Chatsworth (RD.1127), a sheet of similar dimensions, rendered in the same filigree technique and similarly inscribed with the title from the *Aeneid*. Three different dates inscribed on the Chatsworth drawing suggest a longish period of work on the composition, from 1671 to 1678, culminating in a design which has the character of a final composition. Claude evidently felt the need for a stronger flanking element on the left side of the Chatsworth drawing since the later Oxford variant includes denser foliage on the left and a ruined portico, perhaps introduced, as Humphrey Wine has suggested,[38] to make a better pendant with *Dido and Aeneas at Carthage* (Hamburg, Kunsthalle) which was painted, like the Oxford painting, for Onofrio Colonna. The added tree, as Roethlisberger has observed, may have been based on a drawing of a tree in Berlin, dated 1678 (RD.1110), which is generally similar in outline and in the lace-like appearance of the foliage. Claude appears, however, to have had second thoughts, heavily deleting much of the foliage with white body colour and following this revision in the painting. He also reduced the size of the figures in the final work, introduced two extra figures and altered the stance of Ascanius who stands in the painting with his right leg thrust forward in a pose which suggests that Claude had little practical experience of archery. At this stage, too, Claude deleted a couple of words in the inscription for the sake of making a minor alteration to the text and changed the date to 1682, although the previous date, 1680, is still visible. The earlier date solves a puzzling feature of this drawing which is clearly a preparatory stage for the final painting although, if it dates from 1682, it presumes rapid progress on the painting between the beginning of the year, at the earliest, and Claude's death in November. A date of 1680 for the study also makes it easier to accept an inscription which was once visible on the back of the painting: *Quadro per l'Illme et excellmo Sig. Contestabile Colonna questo di 5 Ottobre 1681*, now covered by relining.[39] The inscription on the front of the painting, which is nearly identical to the title inscribed on this drawing, must have been added in 1682, after the composition had been completed. The drawing, too, was probably dated retrospectively to indicate the date of the final work on Colonna's painting.

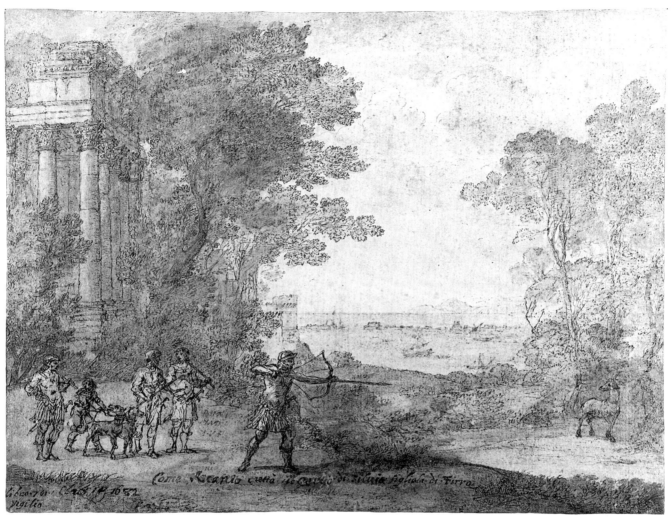

100

NOTES

1 E. Knab, 'Die Anfänge des Claude Lorrain', *Jahrbuch des Kunsthistorischen Sammlungen in Wien*, vol. 56, 1960, pp. 154–5.

2 M. Roethlisberger, 'Nuovi aspetti di Claude Lorrain', *Paragone*, no. 273, 1972, p. 26.

3 Knab, 'Die Anfänge', p. 98.

4 K. T. Parker, *Catalogue of the Collection of Drawings in the Ashmolean Museum*, vol. 1, Oxford 1938, no. 422.

5 M. Kitson, *The Art of Claude Lorrain*, Hayward Gallery, London 1969, p. 33.

6 P. Jean-Richard, *Maîtres de l'eau-forte XVI et XVIIe siècle*, Louvre, Paris 1980, no. 118.

7 M. Kitson, 'Swanevelt, Claude Lorrain et le Campo Vaccino', *Revue des Arts*, 1958, pp. 215–20; 258–66.

8 Ibid., p. 259.

9 Kitson, *The Art of Claude Lorrain*, no. 12.

10 M. Lavin, *Seventeenth-Century Barberini Documents and Inventories of Art*, New York 1975, p. 196.

11 M. Roethlisberger, *Claude Lorrain: The Paintings*, New Haven 1961, vol. 1, p. 128.

12 Kitson, *The Art of Claude Lorrain*, no. 11.

13 M. Roethlisberger, 'Dessins inédits de Claude Lorrain (Chamagne 1600–Rome 1682)', *L'Oeil*, May 1974, fig. 6.

14 J. B. Labat, *Voyages du p. Labat de l'ordre des ff. prescheurs en Espagne et en Italie*, Paris 1730, vol. 4, p. 214.

15 Kitson, *The Art of Claude Lorrain*, no. 51.

16 Mrs M. Pattison, *Claude Lorrain: sa vie et ses oeuvres*, Paris 1884, p. 257.

17 R. Keaveney, *Views of Rome*, London 1988, no. 54.

18 Knab, 'Die Anfänge', pp. 125–9.

19 *Viewpoints: Claude Lorrain: A Study in Connoisseurship*, De Young Memorial Museum, San Francisco (n.d.); the related painting of *Tobias and the Angel* has been published by Roethlisberger: 'Claude Lorrain. Nouveaux dessins, tableaux et lettres', *Bulletin de la Société de l'Histoire de l'Art Français*, 1986 (1988).

20 M. A. Fleury, *Documents du Minutier Central concernant les peintres, sculpteurs et graveurs au XVII siècle, 1600–1650*, vol. 1, Paris 1969, p. 142.

21 M. Roethlisberger, 'The Houghton Hall Claude', *Apollo*, vol. 131, 1990, pp. 300–303.

22 E. Knab, 'Die Zeichnungen Claude Lorrains in der Albertina', *Alte und Neue Kunst*, 1953, p. 150.

23 A. M. Hind, *Catalogue of the Drawings of Claude Lorrain Preserved in the Department of Prints and Drawings*, London 1926, no. 100.

24 *Im Licht von Claude Lorrain*, Haus der Kunst, Munich 1983, no. 49; M Roethlisberger, 'A new drawing by Claude and the problem of the modification of nature', in *Scritti di storia dell'arte in onore di Federico Zeri*, Milan 1984, vol. 2, pp. 623–5.

25 I. G. Kennedy, 'Claude drawings at the Hayward Gallery', *Master Drawings*, 1970, no. 4, pp. 416–17; *Seventeenth Century Art in Europe*, The Royal Academy, London 1938, no. 500; Parker, *Drawings in the Ashmolean*, no. 403; M. Chiarini, 'Claude Lorrain: the drawings', *Art Bulletin*, vol. 53, 1971, p. 289; Kitson, *The Art of Claude Lorrain*, no. 74.

26 R. Krautheimer, *Corpus basilicarum Christianorum Romae*, vol. 1, 1937, p. 20.

27 M. Roethlisberger, 'More Drawings by Claude Lorrain', *Master Drawings*, 1990, no. 4, fig. 4.

28 Ibid.

29 M. Roethlisberger, *Claude Lorrain: The Paintings*, New Haven 1961, vol. 1, p. 372.

30 M. Roethlisberger, *Claude Lorrain: The Drawings*, Berkeley and Los Angeles 1968, vol. 2, p. 330.

31 Hind, *Catalogue of the Drawings*, no. 125.

32 *L'ideale classico del seicento in Italia e la pittura di paesaggio*, Palazzo dell'Archinnasio, Bologna 1962, 2nd edn, no. 207.

33 M. Roethlisberger, 'Vente de Johan de Witt, Dordrecht 1696: quarante-cinq dessins de Claude Lorrain', *Gazette des Beaux-Arts*, vol. 128, 1996, pp. 285–6.

34 RD. 1054–6; M. Clarke, 'Claude's Jacob and the Angel: a further drawing', *Burlington Magazine*, vol. 122, 1980, p. 345.

35 RD. 1077–83; A. Zwollo, 'An additional study for Claude's picture The Arrival of Aeneas at Pallantium', *Master Drawings*, 1970, no. 3, pl. 26; M. Roethlisberger, 'Additional works by Goffredo Wals and Claude Lorrain', *Burlington Magazine*, vol. 121, 1979, fig. 38.

36 E. Knab, 'Die Zeichnungen Claude Lorrains in der Albertina', *Alte und Neue Kunst*, Vienna 1953, p. 159, n. 52.

37 RD. 1127 and 1128; M. Kitson, 'Marcel Röthlisberger, *Claude Lorrain: The Drawings*', *Master Drawings*, 1970, no. 4, pl. 44.

38 H. Wine, *Claude: The Poetic Landscape*, National Gallery, London 1994, p. 101.

39 J. Smith, *A Catalogue Raisonné of the Works of the Most Eminent Dutch, Flemish and French Painters*, vol. 8, London 1837, p. 334.

Bibliography

Michael Kitson's article in volume 7 of *The Dictionary of Art* (London, 1996, pp. 389–403) gives a succinct, detailed account of Claude's life and work and includes a useful bibliography. Marcel Roethlisberger's *catalogue raisonné*, published in 1961, remains the basic text for the study of Claude's paintings, but should be read in conjunction with the French translation of the *Opera Completa* in the edition of 1986, revised and extended by Roethlisberger.

Monographs and Catalogues of Paintings

Langdon, Helen, *Claude Lorrain*, Oxford, 1989

Pattison, Mrs Mark, *Claude Lorrain, sa vie et ses oeuvres*, Paris, 1884

Roethlisberger, Marcel, *Claude Lorrain: the Paintings*, 2 vols, Berkeley, 1966

——, *Tout l'oeuvre peint de Claude Lorrain*, Paris, 1986

Exhibitions

L'Ideale classico del seicento in Italia e la pittura di paesaggio. Palazzo dell'Archiginnasio, Bologna, 1962

The Art of Claude Lorrain. Hayward Gallery, London, 1969 (catalogue by Michael Kitson)

Claude Lorrain. Dessins du British Museum. Musée du Louvre, Paris, 1978–9

Claude Lorrain e i pittori lorenesi in Italia nel XVII secolo. Accademia di Francia a Roma, 1982

Claude Lorrain. Thomas Agnew and Sons Ltd, London, 1982

Claude Lorrain, 1600–1682. National Gallery of Art, Washington, 1982 (catalogue by Diane Russell)

Im Licht von Claude Lorrain. Haus der Kunst, Munich, 1983 (catalogue by Marcel Roethlisberger)

Claudio di Lorena y el ideal clásico de paisaje en el siglo XVII. Museo del Prado, Madrid, 1984 (catalogue by Juan J. Luna)

Nicolas Poussin, Claude Lorrain. Zu den Bilden im Städel. Städelschen Kunstinstitut, Frankfurt am Main, 1988

Claude to Corot. Colnaghis's, New York, 1990 (catalogue by Michael Kitson and Alan Wintermute)

Fransk Guldalder, Poussin og Claude og maleriet i det 17 århundredes Frankrig. Copenhagen, 1992 (catalogue by Humphrey Wine and Olaf Koester)

Claude: The Poetic Landscape. National Gallery, London, 1994 (catalogue by Humphrey Wine)

The Etchings

Lino Mannocci, *The Etchings of Claude Lorrain*, New Haven and London, 1988

The Drawings

Bjurström, Per, *Claude Lorrain Sketchbook Owned by Nationalmuseum, Stockholm*, Stockholm, 1984

Chiarini, Marco, 'I disegni di Claude Lorrain nel gabinetto nazionale delle stampe a Roma', *Bolletino d'Arte*, 48 (1963), pp. 372–41

——, *Claude Lorrain: Selected Drawings*, Florence and Philadelphia, 1968

——, 'Marcel Roethlisberger, *Claude Lorrain: the Drawings*', *Art Bulletin*, 53 (1971), pp. 257–60

Demonts, Louis, *Musée du Louvre: les dessins de Claude Gellée*, Paris, 1923

Dobroklonsky, Mikael, 'Drawings by Claude's pupil, Giovanni Domenico Desiderii', *The Burlington Magazine*, 57 (1930), pp. 109–15

——, 'The drawings of Claude Lorrain in the Hermitage', *The Burlington Magazine*, 103 (1961), p. 395

Fry, Roger, 'Claude', *The Burlington Magazine*, 11 (1907), pp. 267–75; reprinted in R. Fry, *Vision and Design*, New York, 1924

Harris, Anne Sutherland, 'Claude Lorrain et Pierre de Cortone', *Revue de l'Art*, 11 (1971), pp. 85–6

Hind, Arthur, *The Drawings by Claude Lorrain*, London and New York, 1925

——, *Catalogue of the Drawings of Claude Lorrain Preserved in the Department of Prints and Drawings*, London, 1926

——, 'Pseudo-Claude Drawings', *The Burlington Magazine*, 48 (1926), pp. 191–6

Howard, Deborah, '"Claude Lorrain: the Drawings", by Marcel Roethlisberger', *The Burlington Magazine*, 112 (1970), pp. 836–7

Kennedy, I. G., 'Claude drawings at the Hayward Gallery', *Master Drawings*, 8 (1970), pp. 415–20

Kitson, Michael, *Claude Lorrain: Liber Veritatis*, London, 1978

, 'Claude's books of drawings from nature', *The Burlington Magazine*, 103 (1961), pp. 252–7

, 'Three drawings by Claude', *The Burlington Magazine*, 104 (1962), pp. 66–9

, 'The place of drawings in the art of Claude Lorrain', *Acts of the Twentieth International Congress of the History of Art*, 3 (Princeton, 1963), pp. 96–112

, 'Marcel Röthlisberger, "Claude Lorrain: the Drawings"', *Master Drawings*, 8 (1970), pp. 402–9

, 'A small sketchbook by Claude', *The Burlington Magazine*, 124 (1982), pp. 699–703

, 'Claude Lorrain as a figure draughtsman' in D. Dethloff (ed.), *Drawing, Masters and Methods*, London, 1992, pp. 64–88

Kitson, Michael and Roethlisberger, Marcel, 'Claude Lorrain and the Liber Veritatis', *The Burlington Magazine*, 101 (1959), pp. 14–24, 328–37, 381–8

Knab, Eckhart, 'Der heutige Bestand an Zeichnungen Claude Lorrains im Boymans Museum', *Bulletin Museum Boymans*, 7 (Rotterdam, 1956), pp. 103–40

, 'Die Zeichnungen Claude Lorrains in der Albertina', *Alte und Neue Kunst*, 2 (1953), pp. 121–60

, 'Die Anfänge des Claude Lorrain', *Jahrbuch der Kunsthistorischen Sammlungen in Wien*, 56 (1960), pp. 63–164

, 'Stylistic problems of Claude's draftsmanship', *Acts of the Twentieth International Congress of the History of Art*, 3 (Princeton, 1963), pp. 113–17

, 'Observations about Claude, Angeluccio, Dughet, and Poussin', *Master Drawings*, 9 (1971), pp. 367–83

Knab, Eckhart and Widauer, Heinz, *Die Zeichnungen der Französischen Schule*, Vienna, 1993

Roethlisberger, Marcel, 'Notes on old and modern drawings: drawings by Claude Lorrain in American Museums', *The Art Quarterly*, 24 (1961), pp. 346–55

, 'Dessins de Claude Lorrain', *L'Oeil*, June 1961, pp. 54–9

, *Animal Studies From Nature*, New York, 1961

, 'Les dessins à figures de Claude Lorrain', *Critica d'Arte*, 47 (1961), pp. 16–26

, 'Bemerkungen zum Zeichnerischen Oeuvre von Claude Lorrain', *Zeitschrift für Kunstgeschichte*, 24 (1961), pp. 163–76

, 'Les dessins de Claude Lorrain à sujets rares', *Gazette des Beaux-Arts*, 59 (1962), pp. 84–95

, Claude Lorrain: *the Wildenstein Album*, Paris, 1962

, 'Claude Lorrain – ses plus beaux dessins retrouvés', *Connaissance des Arts*, December (1962), pp. 138–47

, 'Gellée-Deruet-Tassi-Onofri' in G. Kauffmann and W. Sauerländer, *Walter Friedlaender zum 90. Geburtstag*, Berlin, 1965, pp. 143–5

, 'Drawings around Claude. Part One: A group of sixty Grimaldesque drawings', *Master Drawings*, 3 (1965), pp. 369–80

, 'Drawings around Claude. Part Two: Drawings by Angeluccio', *Master Drawings*, 4 (1966), pp. 375–83

, 'Angeluccio', *Gazette des Beaux-Arts*, 69 (1967), pp. 129–38

, *Claude Lorrain: the Drawings*, 2 vols, Berkeley, 1968

, 'Additions to Claude', *The Burlington Magazine*, 110 (1968), pp. 114–19

, 'Aggiunte a Claude', *Paragone*, 20:233 (1969), pp. 54–8

. 'Claude Lorrain in the National Gallery of Art', *Reports and Studies in the History of Art*, 3 (Washington, 1969), pp. 34–57

, *The Claude Lorrain Album in the Norton Simon, Inc., Museum of Art*, Los Angeles, 1971

, 'Two drawings by Claude', *Master Drawings*, 9 (1971), pp. 159–61

, 'Nuovi aspetti di Claude Lorrain', *Paragone*, 173 (1972), pp. 24–36

, 'Neuen Zeichnungen von Claude Lorrain', *Du*, 33 (1973), pp. 508–17

, 'Dessins inédits de Claude Lorrain', *L'Oeil*, 226 (1974), pp. 30–7

, 'Additional works by Goffredo Wals and Claude Lorrain', *The Burlington Magazine*, 121 (1979), pp. 20–8

, 'A new drawing by Claude and the problem of the modification of nature' in M. Natale, *Scritti di storia dell'arte in onore di Federico Zeri*, vol. 2, Milan, 1984, pp. 623–5

, 'The drawing collection of Prince Livio Odescalchi', *Master Drawings*, 24 (1986), pp. 5–30

, 'Claude Lorrain: nouveaux dessins, tableaux et lettres', *Bulletin de la Société de l'Histoire de l'Art Français*, Paris 1986 (1988), pp. 33–55

, 'More drawings by Claude Lorrain', *Master Drawings* (1990), pp. 409–25

, 'From Goffredo Wals to the beginnings of Claude Lorrain', *artibus et historiae*, 32, (Vienna, 1995), pp. 9–37

Rosenberg, Pierre, 'Marcel Roethlisberger, "Claude Lorrain: the drawings"', *Revue de l'Art*, 14 (1971), pp. 115–16

Schade, Werner, *Claude Lorrain: Gemälde und Zeichnungen*, Munich, Paris and London, 1996

Zwollo, An, 'An additional study for Claude's picture, *The Arrival of Aeneas at Pallantium*', *Master Drawings*, 8 (1970), pp. 272–5

Concordance between Roethlisberger, Hind and this Catalogue

Roethlisberger 1968	Hind 1926	Title (as in this catalogue)	Catalogue Number	British Museum Inventory Number
	125	A Farmhouse by the Tiber	2	Oo.6–27
31		View of a Ruined Arch	1	
32		The Pyramid of Caius Cestius	3	
46	192	A Storm at Sea	4	1900–8–24–555
51	106	Cattle and a Hog	6	1895–9–15–916
64	199	Landscape with a Country Dance	7	1900–8–24–152
77		Landscape with Brigands	16	1957–12–14–9
78		A Watermill among Trees	13	
92	59	A Waterfall and Trees	15	Oo.7–209
97	54	A Grove in Shadow	18	Oo.6–101
108		View on the Tiber	8	
109		Path along the Tiber	9	
111	74	A View of Pine Trees	22	Oo.7–226
122	193	The Roman Forum	20	Oo.6–63
123		The Roman Forum	19	1957–12–14–15
130		Landscape with a Country Dance	25	1957–12–14–19
131		Dancers in a Grove	26	
134		Landscape with a Goatherd	29	1957–12–14–21
147	230	An Antique Herdsman	28	Oo.6–66
161	211	Pastoral Landscape with Figures and Animals	30	Oo.6–55
178	110	A Stream in Subiaco	23	Oo.6–71
261		Study of Four Sheep in Movement	50	
282	4	A Ship in a Storm	38	Oo.6–99
283	30	The Tomb of Cecilia Metella	37	Oo.7–228
290	212	An Artist Sketching with a Second Figure Looking on	36	Oo.7–181
291	42	Study of a Tree	39	1910–2–12–91
295		Study of an Oak Tree	40	Oo.7–224
302	94	Study of a Tree	41	Oo.7–173

Roethlisberger 1968	Hind 1926	Title (as in this catalogue)	Catalogue Number	British Museum Inventory Number
310	3	View of Civitavecchia	42	Ff.2–157
326		Pastoral Landscape with Castel Gandolfo	31	1957–12–14–41
328		A Herdsman with Seated Peasants	33	1957–12–14–42
329		Landscape with a Hunting Party	32	1957–12–14–43
347		The Flight into Egypt	11	
354		Farm Buildings under a Tall Tree	43	
356	27	The Tiber from Monte Mario Looking South	34	Oo.7–212
357		View of a Shrubbery with a Wall on the Right	35	
377		The Liberation of St Peter	51	1957–12–14–57
395	28	A Grove of Pine Trees with a Ruined Tower	44	Oo.7–230
401	203	A Study for a Composition	52	Oo.6–97
402		Landscape with a Country Dance	54	1957–12–14–58
414	85	A Ploughed Field with Artists Sketching under a Tree	46	Ff.2–158
417		The Edge of a Wood	47	Oo.7–223
422	33	A View of Distant Hills from the Edge of a Wood	49	Oo.7–221
429	8	A View of Tivoli from the Temple of the Sibyl	74	Oo.6–80
440	62	A Study of a Stream	24	Oo.6–73
443		A Road in Wooded Countryside	45	Oo.7–159
452	102	St Peter's Basilica, Seen from the Janiculum	57	Oo.7–150
459	202	St Ursula with her Companions	56	1866–7–14–60
480	13	The Fountain of Egeria	58	Oo.6–90
483	35	The Road to Subiaco	59	Oo.6–72
485	47	A Group of Trees	48	Oo.7–227
487		View of the Palatine	71	
491		Study for the Flight into Egypt	60	
504		Figures Disembarking at a Port	61	1952–1–21–47
515	185	A Group of Trees by a Roadside	77	Oo.6–44
516	152	Two Trees with Two Seated Figures	72	Oo.7–166
535	9	The Castle at Tivoli	76	Oo.6–78
555	201	A Group of Three Figures with Two Dogs	62	Oo.7–153
556		Landscape with Figures and Cattle Fording a River	63	1957–12–14–87
577		A Youth Playing a Pipe in a Pastoral Landscape	65	
587	82	A Bank of Trees	73	Oo.7–190

Roethlisberger 1968	Hind 1926	Title (as in this catalogue)	Catalogue Number	British Museum Inventory Number
593	208	Mercury and Argus	67	1895–9–15–898
599	84	A Hut by the Edge of a Wood	64	1895–9–15–897
619	101	St Peter's Basilica Seen from the Doria-Pamphili Gardens	66	Oo.7–151
622	100	The Palazzo del Sasso	70	1910–2–12–90
647		Landscape with John the Baptist and Two Angels	53	Oo.6–129
656	215	A Youth Helping a Girl to Mount a Donkey	68	Oo.7–137
664		The Penitent Magdalen	69	Oo.6–86
679	71	A Study of Trees	82	Oo.7–171
687	214	Figure Studies	78	Oo.7–140
689		Figures Disembarking on a Shore	75	Oo.7–160
700		Two Figures, One with a Fishing Rod, Seated by a Tree	80	
704	154	Travellers on a Road below a Large Tree	84	Oo.7–207
723	99	The Church of Sant'Agnese with a Herdsman in the Foreground	81	1895–9–15–905
817	265	Queen Esther at the Palace of Ahasuerus	83	Oo.7–229
824	153	A Bank of Trees	85	Oo.7–186
868	166	Three Figures on the Banks of a River	86	Oo.8–242
882		A Scene of Sacrifice in Antiquity	87	
901	169	Study of a Large Tree	89	Oo.7–184
908		Farm Buildings by the Tiber	88	
933		Landscape with a Herd of Deer	90	
970	285	A View of a Coast	91	Oo.7–233
979	279	Coast View with Mercury and Aglauros	92	Oo.6–120
1000		The Tomb of Cecilia Metella	93	
1002	113	A Dove Nesting Under Tall Plants	94	Oo.8–250
1055		Jacob Wrestling with the Angel	95	
1082		A View of the Aventine	96	1991–11–9–20
1083	303	The Landing of Aeneas	97	Oo.8–269
1092	305	The Temptation of Christ	98	Oo.8–257
1116	312	Landscape with Christ and the Magdalen	99	Oo.8–265
1128		Landscape with Ascanius Shooting the Stag of Sylvia	100	